Art and Animals

D0705575

Art and...

Contemporary art can be difficult. Reading about it doesn't need to be.
Books in the Art and... series do two things.

Firstly, they connect art back to the real stuff of life – from those
perennial issues like sex and death that trouble generation after
generation to those that concern today's world: the proliferation
of obscene imagery in the digital age; our daily bombardment by
advertising; dubious and disturbing scientific advances.

Secondly, Art and... provides accessible theme-based surveys which
energetically explore the best of contemporary art. *Art and...* avoids
rarefied discourse. In its place, it offers intelligent overviews of art –
and the subjects of art – that really matter.

Art and Animals

Giovanni Aloi

I.B. TAURIS

LONDON · NEW YORK

Published in 2012 by I.B.Tauris & Co. Ltd
6 Salem Road, London W2 4BU
175 Fifth Avenue, New York NY 10010
www.ibtauris.com

Distributed in the United States and Canada Exclusively by
Palgrave Macmillan, 175 Fifth Avenue, New York NY 10010

Copyright © Giovanni Aloi 2012

The right of Giovanni Aloi to be identified as the author of this work
has been asserted by him in accordance with the Copyright, Designs
and Patents Act, 1988.

All rights reserved. Except for brief quotations in a review, this book,
or any part thereof, may not be reproduced, stored in or introduced
into a retrieval system, or transmitted, in any form or by any means,
electronic, mechanical, photocopying, recording or otherwise, without
the prior written permission of the publisher.

PB ISBN: 978 1 84885 525 0
HB ISBN: 978 1 84885 524 3

A full CIP record for this book is available from the British Library
A full CIP record for this book is available from the Library of Congress

Library of Congress catalog card: available

Typeset in Rotis by Dexter Haven Associates Ltd, London
Printed and bound in Great Britain by TJ International, Padstow

MIX
Paper from
responsible sources
FSC
www.fsc.org FSC® C013056

To all *Antennae*'s contributors and
readers around the world

Contents

List of Illustrations

Acknowledgements

The generosity and support of many people has very much contributed to the writing of this book. My gratitude goes to Chris Hunter for his never-ending support and assistance. I am especially grateful to those colleagues who have spent time and care in offering advice in relation to my work on this book: many thanks to Steve Baker, Rod Bennison, Ron Broglio, Carol Gigliotti, Jennifer Parker-Starbuck, Helena Pedersen, Bryndís Snæbjörnsdóttir, Mark Wilson and Andrew Yang. Thanks are also due to all artists who kindly collaborated on this book through the contribution of images, interviews and extracts, and most especially to Mark Dion for helping me summarise the main threads of this book over a truly interesting conversation. I would also like to thank warmly all *Antennae*'s contributors and collaborators for helping me over the years in gathering a vast amount of precious information on the field of animals in art that has surely benefited this book.

Finally, my thanks to Liza Thompson and Philippa Brewster at I.B.Tauris for their helpful guidance and professional advice.

Preface

Why Look at Animals Now?

The animal looks at us, and we are naked before it. Thinking perhaps begins there.

Jacques Derrida, 'The animal that therefore I am', 1997[1]

This is a book about *unlearning*, but it is not a self-help book. Over seven chapters it presents a series of challenging questions about the animal's presence in contemporary art as seen through the new and original perspectives of a number of innovative artists. As a result, it may lead to the undoing of old habits: old habits revolving around our relational modes with the animal, that in turn inform the ways in which we relate to other humans and that ultimately affect the entire planet.

Painted or sculpted, animals have been a pillar of classical art, but in recent years they have literally invaded the gallery space: taxidermied, in formaldehyde, or alive; these encounters with animals are consistently different from those proposed by past representations, for they raise a number of new pivotal questions. The animal body, the animal voice, the animal gaze and the animal trace are, in contemporary art, all new questioning entities. But what questions do they pose? Upon witnessing this animal invasion, one may ask: why now? There isn't a straightforward answer to this. But for the time being let's say that a multiplicity of events and shifts in philosophical and cultural perspectives have progressively made way for the animal to reach the core of the debate in contemporary art practice.

We come to life surrounded by animals. They're among the first things we reach for as they hover over our cots in the shape of colourful toys; as stuffed teddies they spend the night with us, making us feel safe and warm; thereafter, as we grow older, they are ever-present through illustrated books, photographs, wildlife documentaries, films, as pets and pest, at the zoo, in the city, in the countryside, as entertainers or sports partners. Partly, it may be

because animals are such an integral part of our daily lives, from the very beginning, that we somehow end up taking them for granted, and that we come to see them as accessories to the human condition.

Through the challenges raised by post-colonial studies, the concept of otherness has become central to the contemporary debate. The binary oppositions of ideals that kept Western civilisation stable in illusory definiteness are splintering, raising the possibility for a radical and critical revision of our certainties. The woman, the slave, the queer, the black and the savage have all been re-learnt through a continuous and infinite process of unlearning and reconfiguring. It therefore follows that the animal, the ultimate *otherness* of the animal, another subject of power relations, would also become part of the discourse. The challenge posed by the animal, however, is a radical one. Unlearning the animal means effectively to suspend one's knowledge of nature in order to reconfigure it, or perhaps to let it reconfigure itself; it means to deconstruct the certainties offered by nature, in order to acquire a critical awareness of the relational modes we establish with animals and ecosystems, and simultaneously to find the courage to envision new ones.

Unlearning Through Art

My 'year of unlearning' of the subjects of the animal and nature was 2004. During that winter, Olafur Eliasson's *The Weather Project* 'brought the sun' inside the Turbine Hall at London's Tate Modern. The installation featured a massive, semicircular, suspended form made up of hundreds of extremely bright mono-frequency lamps. The ceiling, having been turned into a mirror, completed the form into an extremely bright disc, while virtually exploding the already gigantic space of the Turbine Hall into a something of a baroque *trompe l'oeil*. Experiencing the amplified, eternal sunset proved overwhelming, so much so that audiences' behavioural responses dramatically shifted from the conventionality of gallery-visiting to a less formal relation. Some sat on the ground, lay on their backs to relax, or played as if outdoors – instinctive responses seemed to momentarily override conformist patterns.

Weather is a very English affair, of course. The eighteenth-century writer Samuel Johnson famously remarked, 'It is commonly observed, that when two Englishmen meet, their first talk is of the weather; they are in haste to tell each other, what each must already know, that it is hot or cold, bright or cloudy, windy or calm.'[2] However, things are slightly different today, and casual comments about the weather have acquired a more uncomfortable undertone. Through the 1980s and 1990s the hole in the ozone layer became a piece of contemporary mythology. Only 'seen' on TV and newspapers through computer-generated imagery, it seemed too far removed from the hustling and bustling of our industrialised daily lives to represent a real threat. We listened to the alarming reports, but didn't really think we would ultimately pay a price. It meant the end of the 1980s fashion for excessively sculptural

hairstyles, on the assumption that restraining our use of CFCs could help – but that is as far as we went in our worrying. Then, with the new millennium came the threat of global warming,[3] heralded by short-term prophecies of devastation. Apocalyptic images of London and New York flooded by raising sea levels or coated in layers of ice began to circulate, bringing the mythical tale of imminent eco-disasters much closer to home than ever before. Things changed. Global warming is a symptom of the inadequacy of our current relationship with nature; a confirmation that ecologically, the industrial model cannot be supported by the planet; and as an index of this crisis, it simultaneously proposes an invitation to change our ways before it's too late.

Indeed, through awe and wonder, the spectacle offered by *The Weather Project* also delivered an environmentalist subtext. As the artist explains, 'I came up with the idea in January when it was snowing in London one day and warm the next and people were talking about global warming.'[4] Paradoxically, Olafur got us standing in front of an artificial sun, as – intoxicated by its beauty – we became oblivious to the fact that its very hypnotic appeal reassessed the fact that our distancing from nature may be a very real thing. In the futuristic visions of the film *Blade Runner*, following a nuclear apocalypse, the sky is constantly obscured by plumbeus clouds – it perpetually rains. Would Olafur's sun be the only one people ever saw if those circumstances became real? Most disturbingly, in the film, animals have become an extreme rarity and have largely been replaced by mechanical replicants. Considering current fears that we may be on the brink of witnessing a sixth mass extinction, one driven by human activities, we are left to wonder whether the film's fictional vision had prophetic overtones?

Through the mist which filled the Turbine Hall, and which largely contributed to the sublime effect of the work, Olafur also subtly conjured the seemingly indissoluble overlapping of nature and technology which so characterises modernity and postmodernity and that may be the result of, in the words of Donna Haraway, our acquired posthumanist cyborgian status.[5] Technology has historically and conceptually played a pivotal role in our distancing from nature and in distinguishing us from the animal. It is therefore rather fascinating that Olafur's proposal of an artificial sun should affect human behaviour in such intense ways that only the *authority of nature* would be expected to command. What does this effectively tell us about the contemporary essence of the human condition?

Art and Animals

Also in 2004, while searching for a comprehensive and reliable text on the methodologies of artistic analysis (something for students to use as reference text), I encountered *The Methodologies of Art: An introduction* by Laurie Schneider Adams. First published in 1996, the book has since become a classic of its kind. Towards the beginning, in a chapter ambitiously

titled 'What is art?' Adams initiates a discussion of 'the artistic impulse'. In the attempt to answer such question in just over ten pages, the author defines art as what 'separates the human from the non-human':

> Animals build only in nature, and their buildings are determined by nature. These include birds' nests, beehives, anthills, and beaver dams. Molluscs, from the lowliest snail to the complex chambered nautilus, build their houses around their own bodies and carry them wherever they go. Spiders weave webs, and caterpillars spin cocoons. But such constructions are genetically programmed by the species that make them, and do not express individual and cultural ideas.[6]

This passage, along with the rest of the author's argument, left me quiet cold, for I found proclaiming the uniqueness of art as a human prerogative by comparison to the 'lack of abilities' of animals rather hollow. The author supports the well-known case for human superiority over comparative animal inadequacy, and identifies art as the noble differentiating feature of the secular division between human and animal. It is a statement designed to stroke readers' egos, suggesting that their interest in something noble, like art, furthers their own nobility by implication. But if anything, this passage posits art as something 'smaller' than I knew it to be. Nevertheless, the fact that such an argument would find a comfortable place at the beginning of a very popular book designed to introduce students to a new subject – and therefore to shape their initial knowledge of it – troubled me.

The 'animal doesn't do art' innuendo gathers momentum through the chapter, as we are informed that 'Spiders, unlike humans, are not inspired by aesthetics or narrative ideas. They neither observe the environment nor make a conscious choice to create the abstract geometry of their webs. An artist, on the other hand, might observe a spider's web and transform it into a work of art.'[7] What Adams fails to recognise is that the word 'art' entails a complex system of negotiations that goes well beyond the creation of an object. However, if we consider *creativity* as the universal originator of all art, then we find that animals are surely capable of displaying that, at times in ways that indeed border on the understanding of the creative in humans. One example among the many is provided by male Vogelkop Bowerbirds, which employ the use of arches to support large barn-like structures which they adorn with flowers, leaves and other found objects in order to attract females. Individuals of this species favour different colour arrangements, and females seem to pay keen attention to the quality of the ornamentation before settling with one partner.[8] Without having to look hard into ethological accounts, Adams could have also found many examples of mammals who have picked up pencils and brushes to create compositions of lines and colours on paper and canvases. (See the work of Desmond Morriss 1956-58.)

Preferring to ignore these examples, Adams's argument positions the animal as passive and oblivious to its environment, in opposition to the active and creative artist, who keenly observes their environment, understands it and is able to transform it into art, something

that in the Aristotelian view improves nature. Aside from the many misconceptions Adams proclaims, what she fails to recognise is that the spider's web has a practical, material purpose and that as such its comparison with the creation of a work of art, something that by definition serves no practical purpose – at least in its classical or more traditional inception – is structurally unsound. Adams's assertion that animals are genetically pre-programmed, and therefore incapable of making art, reflects the essence of the widespread relational modes we have established with them – modes driven by an overly determined need to separate ourselves from them at all costs, even if that entails arguing the absurd and denying evidence.

Discounting the abilities of animals as 'programmed' and 'unconscious' is something ingrained in Western culture; to force specific human abilities onto animals in order to relentlessly produce skewed evidence of human superiority is a typical anthropocentric disease. Famously, in order to confirm animals' inferiority, Descartes argued that their behaviour is instinctive, that they lack adaptability and of course language. Similarly, Heidegger's idea that animals are 'poor in world' saw them lacking the ability to conceive of an object as something more than a functional entity, while men are seen as 'world forming' and therefore capable of creating art out of what the animal clumsily, 'simply makes'.

In the attempt to subvert these concepts, the animal has insistently sneaked through the pages of key continental philosophers. Deleuze and Guattari, Derrida, Nietzsche, Bataille, Cixous, Irigary and Adorno have all at some point encountered the animal in their writing, and have found it not to be the 'one that lacks', but a questioning and challenging entity, instead. Within this new and challenging positioning, art can play two key roles – either to separate or unite. This is why this book is about unlearning; about unlearning the separatist approaches we know well, and about discovering the uniting ones, for it is through these that we might avoid a future similar to that represented in *Blade Runner.*

Untangling the Web

The year 2004 was also the one in which Agamben's *L'Aperto: L'Uomo e l'animale* was translated into English and published as *The Open: Man and animal.* The book addresses the issue of the human–animal divide, and treats the subject as a defining argument in the contemporary philosophical debate. Agamben asks,

> What is man, if he is always the place – and, at the same time, the result – of ceaseless divisions and caesurae? It is more urgent to work on these divisions, to ask in what way – within man – has man been separated from non-man, and the animal from the human, than it is to take positions on the great issues, on so-called human rights and values.[9]

Interestingly, it is halfway through *The Open* that we find the question of the spider and its web surfacing again. Agamben claims that the spider has no knowledge of the fly's size, but that it is able to weave its web in such way that the insect will be caught in it. He concludes that the world of the spider and that of the fly are 'uncommunicating and yet perfectly in tune that we might say that the original score of the fly [...] acts on that of the spider in such a way that the web the spider weaves can be described as "fly-like"'.[10] To Agamben, the web expresses 'the coincidence of this reciprocal blindness' as *the open* is shaped by a functional rhizomatic unity between animal and animal, and animals and environments.[11] The philosopher's understanding of spider, web and fly echoes Bataille's conceit of the animal as 'water in water', in which the animal is something indissolubly connected with everything else around it and, according to von Uexküll, is tangled in a web of captivations of which the animal has no awareness — in opposition, it is through consciousness that humans conceive the world as separate.[12] Agamben's vision of this relationship is problematic, for it echoes Heidegger's idea that the animal has no ability to grasp its own essence. And as Ron Broglio rightly points out, '[t]o call the spider and fly relationship "absolutely uncommunicating" misses the shifts in species over time and limits what we call communication'.[13] Moreover, which species of spider is Agamben referring to? Some tropical species of spiders like *bolas spiders* (Araneidae family) and *gladiator spiders* (Deinopidae family) actively use silk to create sticky hunting tools that they throw at prey. How does the behaviour displayed by these spiders challenge Agamben's view? Would a sound scientific understanding of these relationships move us to a more productive position than Agamben's, or are there contributions specific to the artistic and philosophical spheres that may complement 'scientific truths'? This is an area of contention. Which animal does philosophy speak of when it utters the word 'animal', a literary one or an animal made of flesh and bone? And what consequences may be involved in not distinguishing between the two?

As discussed by Jean-François Lyotard in *The Postmodern Condition*, 'science does not represent the totality of knowledge',[14] and the post-Enlightenment prominence science has carved for itself in the understanding of natural phenomena may not suffice to understand the animal today, not so much because its evidential validity can be brought into question, but because its suitability as a comprehensive approach to the capturing of the complexities of nature is open to reconsideration.

Agamben's argument aims, however, at more than understanding the animal alone; he effectively attempts to discuss how human essence is defined against that of the animal, and how this affects human relationships. In Agamben's view, the human–animal dichotomy is created and perpetrated by the *anthropological machine*, the process of translating nature into culture whose functioning in modern times through political, scientific and ontological constructs on the one hand looks for connection between human and animal through scientific enquiry into evolution and on the other adopts the construct of animality to render the human non-man: 'the Jew, that is, the non-man produced within the man, or

the *néomort* and the overcomatose person, that is, the animal separated within the human body itself.'[15] It appears clear, following this line of thought, that the re-visioning of our relationship with animals does not simply involve understanding animal life beyond its biological or ethological functioning, but also entails risking the human. The possibility of this risk was initiated by Bertrand Russell in 1913, when in his famous *Theory of Knowledge* he radically proposed a 'doubting' of our understanding of knowledge in the light of the fact that the 'animal practices inference.'[16] What is of paramount importance to the urgency of the animal question is that, now more than ever before, finding new perspectives from which to understand life may radically change who we are, where we are going and who we are going there with, for global warming, environmental decay and mass extinction are all clear indices of the wrongness of our approaches. Such are the challenges posed by posthumanism, in which the disintegration of the subject, as understood in humanist terms, reverberates into a network of technological interconnectedness that may ultimately modify our biological constraints.

Can art then contribute to the defining of new and multi-focal perspectives on nature and the animal in order to move us beyond ourselves? This book discusses a number of works of art which, in one way or another, attempt to do just that by questioning our existing relationships with animals to suggest alternative opportunities for the future. This is not a book on animal liberation or animal rights, but it is one on unlearning the animal as we know it through contemporary art. If, as Derrida said, 'The animal looks at us, and we are naked before it. Thinking perhaps begins there,'[17] we can add that art begins there too, as naked we painted the animal on a cave wall. There is something to follow...

Chapter 1

Caught up in Representation

Only occasionally, without a sound, do the covers of the eyes slide open – an image rushes in, goes through the tensed silence of the frame – only to vanish, forever, in the heart.

(R.M. Rilke, *Der Panther*, 1907)[1]

In 1992, Damien Hirst's *The Physical Impossibility of Death in the Mind of Someone Living*, a tiger shark submerged in formaldehyde and housed in a large glass case, hit the headlines. The work generated great controversy, and among other things it was responsible for bringing the topic of animals in contemporary art to wider audiences. Most notably, the British tabloid *The Sun*, reported the famous story titled '£50,000 for fish without chips'[2] humouring at once the work, its alleged artistic qualities, and the seemingly absurd value assigned to it by the art market. Whether we like it or not, the artwork has already secured its place in the History of Art book, while simultaneously finding a space in the minds of the many who know it, without even having seen it in the flesh. From the perspective of this book's subject, the work brings to the fore a number of issues related to the presence of the animal in contemporary art.

There are a number of fundamental differences between the representation of animals in art from the classical to the romantic, the modern and the postmodern periods. The main difference between the traditional representation of animals in art and the use Damien Hirst makes of the shark lies in the fact that the animal we see in *The Physical Impossibility of Death in the Mind of Someone Living* is an animal body, not the man-made depiction of one. We are all familiar with the multitude of works featuring animals that have helped define the canon of one of the lower genres in the history of painting, but the presentations of *real* animal bodies in art is a much newer occurrence. As such, it does not entirely function within the

paradigmatic set in which the painted representations of animals operate. The tiger shark in Hirst's work was a natural body now preserved in formaldehyde, and it therefore belongs to the tradition of natural-history museum preservation, not that of classical art. However, upon being relocated from the museum's vaults to the gallery space, this body becomes interlinked with the heritage and aura of the art object. It is stripped of its scientific value and finds itself caught up in a web of representational references. The shark is *made of flesh and bones,* but is not alive, and therefore it can easily be classified as object. An interesting comparison could be here drawn between Hirst's shark and a famous painting by John Singleton Copley, *Watson and the Shark,* from 1778. Let's, for instance, argue that Hirst's shark is the *real thing* and not a representation, and that therefore this substantial difference adds something to his work that Copley's painting can never quite capture. What is this something? And does this something tell us anything more about the shark that Copley's painting could not convey? The many formulations of postmodernism all overlap in the outlining of the crisis of representation that so greatly pervades most contemporary artistic production. In postmodern art, unmediatedness is a relevant value, the assumption being that art and life are both fiction that can intertwine in the creation of visions which by nature are open-ended and undetermined. In this merging, is it therefore ever possible to escape the work

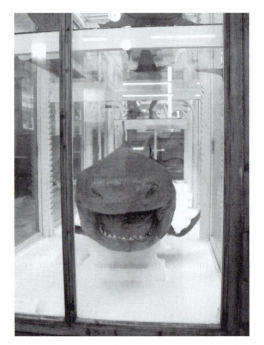

of representation? Perhaps it would be more appropriate to argue that postmodernism is in perpetual conflict with representation itself in the same way that a pianist's improvisation can relentlessly attempt to shy away from harmonic balance, just to find that the mere act of juxtaposing notes has inadvertently outlined a different kind of harmonic structure. This is to say that for as much as Hirst's shark may seem unmediated because it is presented as *real,* the artist has taken a number of decisions which all do, in one way or another, bring the animal body closer to the paradigmatic set of more traditional art.

The history of animals in painting began in the Palaeolithic period (32,000 years ago),[3] and it is not known why men started to look at animals and then paint them on the walls of caves.

1. *Shark* (Display cabinet at Museum La Specola, Florence, Italy) (Photograph Giovanni Aloi 2010).

Drawing animals would then constitute a tool towards the understanding of them. But what other reason brought man to paint animals? Assumptions are all we can draw, and it is difficult to admit that there is something rather dramatic about the amnesia that erased from our minds the original relational mode we entertained with animals. A sense of having lost an original connectedness with nature seems forever gone, as we can't remember or clearly reconstruct the grounds on which this relationship may once have existed. It has been claimed that cave paintings may have served a divinatory role, whereby the drawing of animals would have resulted in fruitful hunting. Others have claimed that the images were instead part of shamanic rituals, in which the animals painted do not refer to *animals in flesh and bone* but to 'spirit-animals', mediating and reconciling human experiences in nature.[4]

From this point onward, until the romantic period, whatever the real purpose of the cave painting was, we find that the animal in art substantially came to inhabit two extremely opposed categories: that of food and that of god. In Egyptian art, for instance, gods were frequently pictured with animal heads: Ra had the head of a falcon, Thot that of an ibis and Bastet that of a cat, while it is of course worth remembering that the supremely important job of moving the sun in the sky was carried out by a scarab (dung beetle).

In Greek mythology, the chimerical combination of human and animal was also a persistent presence: the Minotaur, the Gorgon and the Sphinx are only a few among many examples. The transformation of humans into animals, most notably by Zeus in order to fulfil his lustful desires, have become a staple of classical mischievousness. It is, however, between 186 BCE and 281 CE that we find a consistent shift in our relationship with animals through the celebrated Roman entertainment of public animal slaughtering. From this point onwards, the history of human–animal relationships can indeed be read as a quest for control over the strange, the exotic and the unknown, a phenomenon that historically resurfaces in different forms and media through the spectacle of game hunting, the performative ritual of the *corrida*, the assembling of dioramas in natural-history museums, and the opening of zoos through the appropriations of imperialist Europe.

The Sublime Animal

Let's now return to Hirst's shark, as we bear in mind that the relational platform on which modern human–animal relationships are formed is largely informed by the historical development briefly outlined above. As mentioned earlier, despite its cutting-edge appearance, Damien Hirst's shark restages a relatively traditional encounter with the 'animal in art' based on the notion of the sublime. It does so by invoking in the viewer primordial and overwhelming responses triggered by the presence of one of the most dreaded natural predators. It has been argued by Paul Crowther that contemporary art has mainly endorsed two aspects of the sublime.[5] One revolves around the responses induced by the romantic legacy established

by the stormy landscapes of W.J.M. Turner, the spiritually imbued scenes of Caspar David Friedrich and the crisp paintings of wild animals by Sir Edwin Henry Landseer. The other is more directly linked to the 'shock factor' caused by the imminence of utter destruction. The latter is of course something Damien Hirst's shark quite clearly relies on.

In Hirst's vision, it was essential that the shark be 'big enough to eat you'[6] in order to achieve the desired effect. When looked at head on, the shark is meant to trigger pure 'animal fear' in the viewer, suggesting an instinctive connection with our prehistoric ancestors, for whom nature was not a subjugated external entity in which to indulge, but an all-encompassing system of life and death, where death could come at any time, in the shape of a larger predator. This overwhelming sense of fear that metaphorically removes us from the top of the food chain entirely functions on the dynamics of the sublime, especially on the evoked sense of impotence experienced in front of a potentially deadly force of nature. However, in this conception, the sublime only functions when the viewer is at some distance or protected from the source of overwhelming fear; therefore, safe from destruction. A certain pleasure can be found in panic. This is the overriding paradox that in Hirst is embodied by the glass tank, the element that visually prevents the shark from 'killing' the viewer.

From this perspective, the glass functions similarly to a painterly surface: a closed surface that confines the subject in traditionally illusory representational dimensions. Despite all this, Hirst's shark gives us the opportunity to experience an intensity that a painting cannot quite conjure: that is the encounter with the animal matter. Facing the shark, the viewer is directly confronted by it. In this specific case, it is not the eyes but the mouth that becomes the most eloquent signifier in the relational. Here, the animal body has almost entirely ceased to be that of an animal, only being such from a morphological perspective. Immersed in its perpetual bath of formaldehyde, a liquid substance that symbolises the subjugation of the animal, the shark's body is stripped of its animality and allowed only to summon fears in humans. By animality, we here mean all the biological and behavioural traits along with the complex interconnectedness with other animals and environments that make the animal much more than a preserved dead body. As such, the abrasive presence of this animal is undeniable, but simultaneously fundamentally hollow. Do we learn anything new about sharks by standing in front of this work? In *The Physical Impossibility of Death in the Mind of Someone Living*, the little we already know about these animals is reassessed through the violent 'reality check' staged by the artist. What the work moreover reveals is the extent to which our knowledge of the animal is constructed by pop-cultural and literary sources.

In front of Hirst's shark, it is impossible to escape the haunting memory of Steven Spielberg's *Jaws* (1975), one of the most successful films of all time, and which forever cast a shadow on happy seaside summer holidays. Culturally, the film has, through the defining of iconic imagery and the use of a highly engaging soundtrack (one which at times resembles the sound of a terrorised speeding heartbeat), set a stereotypical identity for the shark by which, broadly speaking, the animal is perceived as nothing more than a death-machine to

fight and kill. Paradoxically, all this happened through the making of a film in which the shark itself is almost completely absent, as the purpose-designed mechanical shark designed for filming constantly malfunctioned, forcing Spielberg to redraw large parts of his storyboard and use camerawork capable of conjuring the presence of the animal.[7]

Specimens and Trophies

The achieving of the impossible, also echoed in the title of Hirst's work, is key to the seemingly indissoluble development of knowledge through technological advancements that saw a progressive distancing from nature in the Victorian period. Then, colonial expeditions brought back to Europe exotic animals that nobody, or very few, had ever had the luck to see in the flesh. These opportunities were offered by the technological developments that made ships larger and faster, and allowed for live animals to be transported from extremely remote locations.

The element of the spectacle is paramount to the understanding of animal interrelationships in the 1800s. This is something that will be fully explored in the next chapter, but for the time being it is important to take into account the ambivalent and contradictory manifestations of animal relations in this period, as these most define our approach. To this purpose, Hirst's shark at once encapsulates the two main embodiments of these manifestations: the specimen and the trophy. Many animals were brought to Europe in the name of scientific research. Some were displayed in natural-history museums as a source of education and entertainment. Hirst presents the shark in compliance with this tradition, submerged in formaldehyde; the animal is a museum specimen that viewers look at for entertainment and, to some degree, for education. Looking at animal bodies on display, it is easy to forget that behind the acquisition of these there lies a thriving hunting business which at times has depleted many areas of species. The emergence of the animal trophy is emblematic of the 1800s, and the human–animal relationship that shaped it. Hirst's shark can indeed also be seen as a trophy, especially if it is taken into account that Hirst commissioned the killing of the fish especially for the piece, with the explicit request that the shark be a large one, in order to trigger the desired effect.[8] Within the artistic system of sourcing and delegating in which Hirst exists as an artist, the animal can be understood as his personal trophy. It can be read as a masculine statement of power addressing the art world at large, 'An artist capable of bottling a shark is more dangerous than the shark itself' being the message delivered to the contemporary viewer. Most interestingly, the work also relies on the trope which in popular culture links the shark to capitalism, something which clearly can be read as a tongue-in-cheek self-referential comment about the artist's own approach to making art, which relies heavily on commodification and market power. Using the animal body in art, whether alive or dead, is an implicit attention-grabber. This is effectively what substantially differentiates Hirst's piece from Copley's painting and any other painting of sharks. The publicity artists garner from the focus on animals as main

subject of their works can define the success of a career. The art involving animals that this book is concerned with typically displays a critical approach to the subject, and tries to untangle the multi-layered problematics involved in our relationship with animals. Many contemporary artists have, for instance, recently revisited the ambivalent practice of taxidermy and its function as creating specimens in natural-history museums and trophies in the hunter's home, in order to deconstruct the origins of our modern relationship with animals for the purpose of developing a more self-aware approach in the future.

One such example is that of artist France Cadet, who in 2008 created a robotic installation titled *Hunting Trophies*, in which a number of robotic animal heads were mounted on the wall in the tradition of taxidermy-trophy. The interactive installation featured animatronic animal heads equipped with sensors triggered by gallery visitors. As in Damien Hirst's shark, the artist took care to display the heads at eye level, so as to stage a reciprocal and direct encounter – the heads would suddenly move upon being approached, surprising the viewer. Cadet's animals are generally represented in robotic guises in order to comment on the Descartian influential view that animals are no more than machines with a complex assemblage of parts. However, their 'trophy-heads' status also addresses the current posthumanist enthusiasm for the triangulation between animals, machines and humans that in philosophical realms proposes an abandoning of anthropocentric certitude.[9]

The use of live or dead animals in contemporary art also raises a number of ethical issues that we will consider further throughout the book. But for the time being, it is worth noting that France Cadet's robotic creations, in their effective directness, do without the involvement of any live or dead animal, and therefore without any animal killing. Of course the same may not be said for Hirst, where the killing of a wild animal was commissioned expressly for the creation of a work of art that was sold by Saatchi in 2004 for $8 million.[10] The killing of animals will be discussed at length in Chapter 6, but it is worth pointing out here that the live presence of animals in the gallery space, something that has become increasingly common, also entails a set of specific complications.

Alive and Kicking

It is interesting to note that the first live animals to appear in the gallery space belonged to the categories of 'the pest' or 'the edible', the categories of those whose killing is 'unproblematised' by the conventions of everyday life. Let's, however, take a cautious approach, for as we will see later the controversy generated by works of art including other animals can indeed be overwhelming for both audiences and artists. The live animal entered the gallery space as early as 1934, with Philip Johnson's installation at MOMA, titled *America Can't Have Housing*, which featured cockroaches. These are very specific insects, almost universally considered pests, and therefore less ethically entangled than other animals. In 1938, Dali

presented *The Rainy Taxi* at the International Surrealist Exhibition at the Galerie des Beaux-Arts in Paris. The exhibition was curated by Duchamp, who decided to place *The Rainy Taxi* at the entrance of the gallery for maximum impact. The piece comprised a taxi inside which, through a system of tubes and pumps, rain poured on a blond mannequin and a driver with a shark's head. Inside the car crawled live snails.

It was in 1938 that Dali, following a meeting with Freud, developed an interest in snails, which he saw crawling on a bicycle outside the psychoanalyst's house. In Dali's surrealist symbolic adoption of the snail, the animal plays an ambivalent role shaped by the formal peculiar qualities which makes it unique: its frailty and yet stone-like appearance; its soft slimy body which recalls the essence of human mucus tissue and therefore sexuality. In Dali, the representation of animals is staged in psychoanalytical terms – the animal is wholly a symbol.

These early examples of art involving live animals consistently captured audiences' imagination and gave way to a slow but steady increase in animal presence in modern art. But what does it mean to present a live animal in the gallery space? How does the live animal body function within the politics of the exhibiting space? What does it come to represent, and how is signification affected by the livingness of a work of art?

Animal Ontology

One of the first artists to dig at the root of these questions was Richard Serra, who in his 1966 exhibition *Live Animal Habitat* in Rome, displayed cages occupied by live and taxidermied animals (hamsters, hens, doves and a pig).[11] Serra's comments are particularly helpful to the understanding of the piece:

> I was using paint with a certain disdain, with the attitude that any material was as good as any other material. And once you find that you're not using paint for its illusionistic capabilities or its color refraction but as a material that happens to be 'red', you can use any material as equally relevant. I started using a whole load of materials. I was living in Fiesole outside of Florence at the time and I started using everything that was in the parameters of my surroundings: sticks and stones and hides. I did a whole show of 22 live and stuffed animals.[12]

In this statement, Serra, today one of the most successful sculptors of his generation, reveals a rather specific understanding of the animal, and one shared by many still. The animal is perceived as a material to be used in the work of art, like pigments, or a simple found object, like any other inanimate object that could become part of any artistic compositions. However, and perhaps most importantly, this animal staging, within the context of artistic practice, represents a departure from the bidimensionality of painting and the fixitude of sculpture, and was designed to access a new representational realm.

For undisclosed reasons, the artist neither includes this early project in the catalogue raisonné of his sculptural work, nor does he entertain the idea of having it restaged today.[13] Perhaps Serra has not forgotten the controversy which followed the exhibition and which saw the owner of the gallery La Salita end up in court. Interestingly, the summon was not imposed on charges of animal cruelty, as one might assume (there was no running water in the gallery space), but on the grounds that the gallery was displaying 'materials which infringed the granted commercial license held by the venue'. The owner was eventually acquitted.[14]

From an art-historical perspective, the exhibition surely crossed the boundaries of what had been previously attempted, and was only the first of a list destined to grow. It is worth pointing out here that Serra's preoccupation with nature, the 'real', and its indissoluble overlap with the representative realm, concretising in the use of animal as material, was entirely framed by a humanistic approach. The focus here was on human perception of nature as resource to utilise.

The legendary installation *Untitled (12 Horses)* (1969) by Jannis Kounellis further articulated Serra's concerns through a more critical approach to the subject. It was originally staged at the Galleria L'Attico in Rome, and consisted of a group of 12 live horses tethered to the gallery walls. At the time, the piece shook the art world's established paradigms, and as a result it is today regularly restaged as one of the most iconic art installations.

The relevance of *Untitled (12 Horses)* lies in its open text, offering multiple interpretations, as well as in the offer of the paradoxically intense encounter with the live horse, an animal made familiar through the history of painterly representation, which suddenly is here revealed in a different light. So there it is in flesh and bone: the animal that in the mythical world pulls Apollo's chariot; the one upon which emperors, warriors and noblemen forever ride immortalised for posterity; the emblem of strength; the physical extension of man's power – few animals have acquired such layered signifying charge in the history of representation.

In the tradition of painting, the horse's presence mainly embodies men's physical and cognitive extension, rarely finding the role of sole independent protagonist. That centuries of paintings could create an image of the horse that mediates our experience of the animal through the lenses of nobility, stature, heroism and drama can be productively contrasted with the experience one has when confronting the live horse. The installation unequivocally revealed that two horses, one painted and one alive, could in theory occupy the same gallery space and yet be two very different animals. Paradoxically, to twentieth-century viewers, it was the live horse that was the striking unfamiliar novelty. To the average eighteenth-century viewer, however, it might have been the glossily painted animal that would have been the far less common experience. *Whistlejacket* by George Stubbs (1762) is a groundbreaking exception to this paradigmatic set, in that it is the first painting to address the animal as undisputed subject. This portrait of the horse heralds for once a very personal history of success: Whistlejacket was an ace racehorse. Of course it could be argued that the animal's identity is here intrinsically bound to human activities (racing) and something that may

have no value to the horse. However, for once in the history of art we have an animal-subject with a name, proudly posing alone. Outlined against a plain background, the horse is the only focus. To make things even more challenging, Stubbs painted the animal on a scale traditionally reserved for history painting, and managed to capture an unusual and unsettling intensity. However, this result may be partly accidental, as another artist was going to paint the figure of King George III to complete the painting originally commissioned by the Marquess of Rockingham. However, it seems that Rockingham was so pleased with the image of the horse that he decided to abandon the original idea.[15]

In any case, for Kounellis, prominent artist of the Arte Povera movement, the departure from traditional pictorial and sculptural representation also allowed for the possibility of a 'different type of presence of the animal in art'. As Steve Baker argues,

> The postmodern animal is there in the gallery not as a meaning or a symbol but in all its pressing thingness. Symbolism is inevitably anthropomorphic, making sense of the animal by characterising it in human terms, and doing so from a safe distance. This may be the animal's key role in postmodernism: too close to work as a symbol, it passes itself off as the fact or reality of that which resists both interpretation and mediocrity.[16]

Part of the beauty involved in a work like *Untitled (12 Horses)* lies indeed solely in the wonder of the encounter with the live animal, which unlike the painting of *Whistlejacket* smells, makes unflattering animal noises, looks slightly threatening, produces excrement and urinates. This encounter triggers a series of considerations. Most importantly, it questions our knowledge of the horse as, paradoxically, its persistent presence in art seems to have distanced us from the live animal rather than establishing closeness. Among other things, Kounellis's work shows the secular limitations involved with painterly representation, highlighting the fact that animals are more than 'beautiful bodies' and that their essence is best captured when other sensory receivers are also triggered. For as much as it may reveal something more about 'animality', *Untitled (12 Horses)* also still speaks of affairs that are predominantly of human concern, as the work can easily function as a riposte to the aseptic nature of the white space of the art gallery, its universalist claims and proposed utopian neutrality. It is interesting to note that Baker's proposal that the postmodern animal opposes symbolic interpretation may be difficult to attain fully. Further symbolic levels are indeed rendered as we consider the number 12 (horses) as a signifying element within the composition. This lends itself to religious association – the 12 disciples – or can be understood in reference to the months of the year, and reminds us that upon entering the gallery space the animal's struggle with the entanglements of representation automatically begins – whether it be alive or dead.

An *Anima(l) Mundi*

The performative work of Joseph Beuys clearly aimed at furthering the proposal initiated by the installations of Serra and Kounellis. However, it did so through a genuine interest for the natural world that the artist developed at an early age. Beuys, now one of the most notorious names in art, forged his pseudo-scientific attitude to research in the natural field by taking notes and cataloguing examples of his local fauna and flora. Upon deciding to become an artist, a choice made later in life, Beuys made animals one of the main focuses of his practice. Although his early approaches to research followed the scientific methodology, involving observation, experimentation and recording of data, Beuys's studies would resolve in a somewhat romanticised vision of nature populated by symbols and poetic interpretations. Most notably, in 1969, he formed *A Party for Animals*, 'in representation of those who do not have a voice', while in the 1970s he became one of the founders of the German Green Party.

It is in his quasi-performative work *I Like America and America Likes Me* (1974) that Beuys pushed the boundaries of what had been previously achieved in the presentation of the live animal in art, and he did so by spending one week in the company of a coyote in a gallery in New York. At the René Block Gallery, Beuys and a coyote were separated from the audience by a metal chain-link barrier, transforming the exhibiting space into a cage. On one side of the barrier, the identity of both subjects was heavily brought into question through the shamanic rituals performed by Beuys and by the traditional symbolic Native American context symbolised by the coyote. Perceived as a shadowy deity, an outsider, a playfully amoral transgressor and impersonator, often of other animals, an interstitial creature able to move freely between the worlds of the everyday and the sacred, the coyote was in Native American tradition, 'the spirit of disorder, and the enemy of boundaries'.[17] For Carl Jung, the coyote was an archetypal trickster figure, an *anima(l) mundi*, while Donna Haraway identifies the animal as a 'creature of mediation' in a way similar to the cyborg and the dog.[18] An animal symbolically traversed by a range of potential becomings, the coyote also is a wild dog, a status that from multiple perspectives further complicates its function within the work. 'In symbolic terms,' Serpell claims, 'The domestic dog exists precariously in the no-man's land between the human and the non-human worlds. It is an interstitial creature neither person nor beast, forever oscillating uncomfortably between the role of high-status animal and low-status person.'[19]

As a wild dog, or 'under-dog', the coyote thus is also ridden with elements of its underlying canine nature, however exacerbated by its wild essence these may be. Beuys's human signification within the performative space was also further problematised by the presence of objects used to perform basic shamanic rituals that would be enacted on a daily basis. Copies of the *Wall Street Journal* were being delivered daily to the enclosure and left in a bundle on the floor. On many occasions, the coyote urinated on them or just violently shredded them. These actions ironically lent themselves to symbolic interpretation, the animal embodying the incompatibility of nature and man-made systems, and on another

level symbolised the 'revenge of nature' against the subjugating and commodifying values of capitalism.

A blanket of grey felt, an archetypal material recurring obsessively in Beuys's work, one linked to personal experience of trauma, allowed the artist to conceal his human body, transforming it into an unidentified mass. The performance continuously shifted between the contingent and the purely symbolic.[20] However – and this is key – through his anonymous and neutral self-styled shamanic presence, Beuys established a link with the animal which was described by Caroline Tisdall as a mutual, creative co-evolution, a *conjunction oppositorum* of the marginalised for collective contemplation. The shaman, it is worth here remembering, is a highly transitional figure, one capable of entering a trance in order to undertake journeys forbidden to common mortals and explore the depths of entities inconceivable to the human mind. Thus in the exhibiting space, the trickster figure of the coyote, along with its multiple layers of wild-canine complexity and the shamanic aura with which Beuys invested himself, merged to generate a creative drive of some description. The identities of animal and man, obliterated by layers and shamanic performativities, generated a vacuum through which a merging of animal and man took place. Beuys explained that 'The coyote did not simply feature in the work as one of the props presented in the space but it instead turned out to be an important co-operator in the production of freedom, where the animal enabled the artist to edge closer to that which the human being cannot understand.'[21]

Through its multi-layered historical and psychoanalytical contextual trail, the animal becomes an unstable being (at least in its signifying role), a creature of mediation, however one that, within the syntagmatic structure of the work, also stands in for the ancestors of Native Americans. The coyote was considered a pest by white Europeans, and as such was exterminated in an analogous process to that which wiped out Native American cultures. Its presence is extremely tangled in a historical and cultural signifying web – it is anything but free. Ultimately, these significations are reinforced by the title of the piece, where *I Like America and America Likes Me* anchors the presence of the coyote to an effective metaphorical embodiment of pre-colonial America, more than to that of an animal defined by its own animality. With its symmetrical title, the piece offers readings charged with political provocation and historical referentialism that threaten to overshadow the value of the metaphysical encounter between human and animal and the resulting inter-species relation generated from this interaction. In any case, Beuys was a pioneer of this now rather established genre. The examples which followed it developed on a much more critically aware platform and attempted to place the animal in a more central place.

The Animal Gaze

It is around the same time, 1976, that the academic world took up the question of the animal in a serious way. Thomas Nagel's interest in the perceptual and subjective world of the animal was exemplified in the famous essay 'What is it like to be a bat?', today considered a classic in the repertoire of early-posthumanist philosophy.[22] At the beginning of the 1980s, it was another essay, 'Why look at animals?' by art historian John Berger that brought the animal to the centre of the theoretical artistic debate. Berger argued that the complex dynamics between animals and visual representation are not only the result of our relationship to nature, but that visual representation is also the driving force behind what shapes our relationship to nature.[23] Berger's concern lay in the loss of meaningful connections to nature and the resulting inauthenticity of the animal imagery with which we surround ourselves. In contemporary culture, he argued, the act of looking at the animal and being looked back (or not) plays a pivotal role in places like the zoo. Most interestingly, the author put forward the thesis that in our capitalist society animals have disappeared in their essential original form and have been replaced by symbols. However, Berger does not suggest alternatives to this state of affairs, and the claustrophobic and bleak climax the essay reaches prompted a wave of speculation that contributed to the generating of different perspectives on the subject.

Nature Documentaries: Representing the Wild

One of the most interesting contributions that followed as a result in the artistic field was offered by an unlikely feature-length film by video artist Bill Viola, titled *I Do Not Know What It Is I Am Like* (1986). Viola has, since the mid-1970s developed an international reputation as one of the most sophisticated and experimental video artists on the scene. His use of film as artistic medium is based on a critical discourse that actively employs the nuances and idiosyncratic qualities of film to explore the metaphysical in order to develop self-knowledge. In *I Do Not Know What It Is I Am Like*, the gaze of the video camera offers a view of nature that violently diverges from the tradition of wildlife film, a genre as old as cinema itself (the first wildlife film being made in 1895).

The fascination with wildlife film is a complex phenomenon. As argued by Cynthia Chris in her book *Watching Wildlife* (2006):

> the genre shifted from a framework in which the animal appears as *object* of human action (and in which the animal is targeted as *game*), to an *anthropomorphic* framework, in which human characteristics are mapped onto animal subjects, to a *zoomorphic* framework, in which knowledge about animals is used to explain the

human…We look not only at animals to learn about them, but we also look through animals for ourselves.[24]

Chris's statement is indeed key to the essence of many wildlife documentaries and the representational choices they operate. It is in the pseudo-realism presented by the filmic language of the nature mockumentaries *True-Life Adventures* Disney produced between 1948 and 1960 that the threat presented by anthropomorphic frameworks could be discussed. The documentaristic genre, at least in principle, presupposes a level of veracity in the portrayal of the facts it presents. Today's audiences are aware that through filmic syntax and editing everything can be recontextualised in a steep departure from the originally filmed footage. The institution of the nature documentary, like that of the natural-history museum, is expected to present 'true portrayals' of animal life. However, in the light of what we have already discussed, it is worth considering that the representation of truth may constitute an oxymoron. We may argue that there are elements of truth, at least of factual evidence, involved in representation but that these too are entangled in the flux of narrative structures, framing and cropping, which automatically affect the nature of these elements. From this perspective, Walt Disney's mockumentaries removed the credible premise of the nature documentary, and turned the genre into an anthropomorphic tale in which narrations and scene-staging drastically reinvent the lives of animals. As Steven Watts, author of *The Magic Kingdom: Walt Disney and the American way of life* (2001) argues, 'Reactions to the films suggested that nature did not really appear on its own terms. Instead it was a kind of cultural canvas upon which Disney and the American audience painted an array of Cold War concerns and values.'[25]

How would audiences interpret these documentaries, and what knowledge of the animal would be created through the enactment of these representations? The writing of one critic for the *Los Angeles Times*, highlighting the huge success of the films, claimed that 'Walt Disney, having captivated the world as the Master of Fantasy, now has become, by the greatest contradiction of the age, the Master of Reality.'[26] The issue of animal life and filmic representation is particularly complex, and the validity of knowledge created through the filming and editing of animal life is constantly under question. The camera only shows us a partiality of animal life, that which the researchers and crew understand as relevant for being in keeping with the scientific preoccupations of the time they live in. Of course, of the hundreds of hours of footage shot, we only get to see those key moments which, spliced together in one way or another, create narratives that audiences can understand and relate to. Wildlife documentaries are as a result populated by thieves, love-cheats, murderers, opportunists and heroes, all framed by a subtle but pervading anthropomorphic lens. Directors and producers have control over this, of course, but it is worth remembering that at the heart of their concerns lies the need to find a difficult balance between audience-appeal and scientific objectivity, the factual and the fictional, the informational and the exciting. It was indeed the 'scientific value' of the Disney films that came under scrutiny in the 1980s. Disney's

manipulative approach was deemed extremely distortive, and among other things, created the myth of 'lemming mass suicide', as portrayed in *White Wilderness* (1958).

In wildlife film, the animal is captured in its most active life-moments, giving birth, coming to life, mating, fighting, migrating, feeding, etc. Action is the key element that keeps the viewer watching; therefore on screen the life of the animal is never silent nor still for too long. This of course constitutes a misrepresentation in itself, as the animal is rendered as a relentlessly 'acting-being'. The 'meditative moments', the most emblematic ones, which see the animal doing nothing from the outside, are routinely cut out. However, those are the moments in which the animal most vividly escapes the clichés and stereotypical entrapments of representation. These entrapments are also typical of the cinematic representing of human life. In films we string together only the segments and events that advance the dramatic narrative. This is why animal documentaries, being made for human consumption, force the animal into a narrative format built around human conventions. Most notably, it was Andy Warhol who challenged this cinematic convention through the infamous series of black and white silent films he created in the 1960s, and where nothing seemingly happens on screen for hours.

In *I Do Not Know What It Is I Am Like*, Bill Viola captures exactly those silent and quiet moments that animals do indeed experience, and uses the gaze of the camera in order to stare at them through long unedited takes. The animal seemingly does nothing through the whole film; however, it is because of this apparent nothingness that, ceasing to perform for our entertainment, the animal speaks more loudly of an animality, an animality that is not 'function' but just 'being'. What is going through the mind of a bison grazing as a storm approaches? The image suggests that the bison simply *is*, and this simple/complex notion is much more tricky to come to terms with than one may assume. In one of the most emblematic sequences in the film, Viola points his camera towards the eyes of an owl and slowly zooms in until the reflection in the animal's eye reveals the artist's presence. The owl looks back, upending the convention of film in which the animal (and the human) is looked at but ignores us; the artist presents an unsettling and intense moment. What does the animal make of Viola's presence, and his camera?

Inside Out

Adaptation to our surroundings has been a constant conditioning factor in our relationship with animals. Once we passed into the Neolithic age of settlements and developed the agrarian systems that eventually supplanted the wandering hunter-gatherer model, our new lives, in permanent homes, radically affected our view of nature and the non-human animal in general. The newly acquired concept of 'house' irreversibly changed our views of the world. If before we looked around us, from that point onward, we started to look at nature through the frame of a window – an early, symbolic ancestor of the painting's frame. Moving

inside the house meant that we began to conceive nature as that which lies outside and beyond the village, rather than something of which we are an inextricable part.

Simultaneously, the development of agriculture deeply modified our relationship with nature, introducing concepts of control and exploitation. Nature became a resource to manage, and animals became part of a perspective of consumption and utility. This dualistic shift of the Neolithic age is the very matrix of human separateness from nature. Subsequently we find the intensity of this shift running right through the Greek (Plato and Aristotle) separation of the soul from the tangibility of the body, and still sweeping through the sixteenth and seventeenth centuries, where René Descartes re-emphasised the dichotomisation of nature and culture and the separation of mind from nature on the basis that, because our minds are capable of contemplating nature, nature must reside outside us, as separated.

In 1997, Carsten Höller and Rosemarie Trockel brought an original and thought-provoking installation to *Documenta X*. There, a symbolic house-space, complete with back garden, was filled with live pigs. The role of the pig in this piece is significant, given the larger practical and symbolic meanings with which the pig is freighted. For example, it is worth mentioning that the pig is one of the animals bred by humans entirely for the sake of its meat. It is fed predominantly on garbage in order to make it fat. It becomes dirty because it is kept in a sty. It is made lazy because it is confined. Then, after having imposed these impacts on the development of an otherwise wild animal, we use the name 'pig' in order to insult other human beings.

That the pig could be confined to the back yard and fed on waste meant that it was not only an extremely economic source of meat, but also an aid to human hygiene. The pig's use as 'dustbin' provided its owner with a primitive type of refuse disposal, as voraciousness and filthiness, imputed to the pig-nature, was reinforced in the interests of human appetites and the desire for cleanliness.

Ein Haus echoes the exclusive nature of our consciousness, which allows us to experience the world as outside ourselves, and therefore as separate from nature. It questions a vast set of definitions of locations. It represents a historical transition as well as a contemporary condition. It questions our position and the animal's position in the encounter, and in doing so comments on the incongruous specificity of this encounter. By including live pigs, *Ein Haus* also raises a set of questions. The pig is a domesticated species. It is not conventionally or universally considered a pet, and it is no longer identifiable as a wild animal. The permanence of pigs' ancestors in the back gardens of our ancestors triggered a singular form of evolution. No longer fit to live in the wild, evolved through millennia in a deterritorialised existence, the contemporary pig dramatically poses the question of its own identity as it simultaneously questions our own. Where does the pig end, and where do we begin? Who is predominantly shaping whom in this co-existence?

This encounter carries with it a sense of anxiety, unearthing a number of pivotal questions: questions of a political kind; questions of ecological and social division, and not least of epistemological critique; what is inside and what is outside? *Ein Haus* invites us to

re-think the *alterity* of animals in terms of proximity rather than distance. It reminds us of a specific closeness to the animal that we once experienced. This closeness, for the general Westernised individual today, is rarely if ever experienced in reality, but rather comes in the form of a constructed collective *cultural memory* of the pig as a farmyard animal…even though none of the pigs we encounter in the fast-food and supermarket chain in the form of ham or bacon are sourced from such a place as our 'memory' imagines.

The installation's layout, with its partitions (house-space and back garden), directly references the dualistic matrix that characterised the Neolithic age. In the same space it incorporates the subsequent shifts of its historical evolution, and in its layout we recognise the dichotomous concepts of human/nature division, mind/body separation, nature against culture and art's departure from the everyday.

Ein Haus also offers itself for a range of interpretations and critiques of the art world's affairs, even if the presence of the live animal in art, this time, is predominantly non-symbolic. But there is a twist: in this house filled with pigs we watch the animals from behind a thick one-way glass posited at one end of the house-space. This barrier makes us invisible to the pigs; it prevents their sounds and odours from reaching us. Here, we are the only ones allowed to look; the relationship is dramatically asymmetrical. There can never be recognition and communicative meeting of the eyes. This glass is an *ontological membrane* – a surface that exemplifies the dynamics between signifier and signified and that comments on the

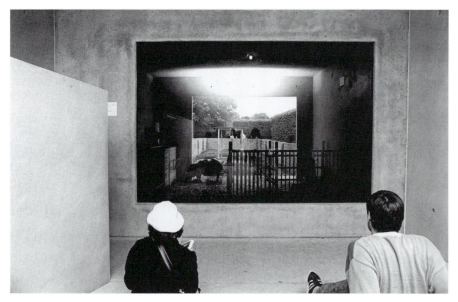

2. Carsten Höller, Rosemarie Trockel, *Ein Haus für Schweine und Menschen / A House for Pigs and People* (1997).

one-directional relationship we have thus far established with animals. Not confronting the pig's gaze facilitates its physical and intrinsic objectification. The distance imposed by the one-way glass – as like in Hirst, a metaphorical as well as a physical imposition – allows us more easily to transpose the living 'animal pig' from life to the 'supermarket shelf' as food: a disembodied slice of meat.

Following Berger's argument, we could claim that the industrial slaughterhouse has greatly furthered this distancing, so that all we're left with is the fictional representations, the talking animated pig in films, and Miss Piggy. The encounter with the animal seems to entail the temporal valence of the glimpse. The animal always seems to be posited on the horizon, constantly receding upon approach, and to confine it physically in the gallery space does not prevent this uncanny condition from occurring.[27] We could argue that in its multiple levels of interpretations *Ein Haus* stages a striking commentary on this condition.

Höller and Trockel's *Ein Haus* does not seek to offer or suggest an alternative to the complexity of this one-way modality, but the piece could be understood as a statement on our relationship with animals, especially those with which we have lived in proximity for thousands of years and to which we should have developed a closer bond. More than any other work involving animals previously devised, it could be said that *Ein Haus* was clearly informed by the philosophical speculation of Nagel, Berger and Derrida, and that it also aimed at readdressing the shortcomings of earlier artistic work including live animals. As Carsten Höller explained, 'Trockel and I never saw animals as 'materials' to work with, in the traditional sense. We believed more in their qualities for us humans as a largely dysfunctional mirror in the frustrating quest of trying to see ourselves, or better: as evidence for the inability to understand.'[28]

In this instance the work's primary objective is that of addressing our relationship with animals, and as far as possible the animal has not been used as a symbol to anything else, but its past historical proximity with us, a reminder of a different relational stage now widely abandoned.

Human-Animal Studies

Taking into account the ever-increasing number of influential texts and works of art critically addressing our relationship with animals, it is unsurprising that we find in the late 1990s the emergence of the academic field of human–animal studies. In an approach analogous to that employed by feminist theorists who look back at historical developments to readdress the relationships between women and the societal structures they lived in, so human–animal studies proposes a critical approach to the re-evaluation of the relationship between humans and animals. The result is a complex, multidisciplinary movement determined to explore new possibilities for understanding animals as subjects rather than objects.

As a young academic field, deeply involved with revisionism at one end and simultaneously attempting to embrace the challenges posed by posthumanism at the other, internal fragmentation and disagreement among scholars is inevitable. A large number of publications directly related to the development of this field has been used for the writing of this book. With specific regard to the visual arts, Diana Donald's works on animals in art in the early-modern period – *Picturing Animals in Britain: c.1750–1850* (2007)[29] and *Endless Form: Charles Darwin, natural science, and the visual arts* (2009)[30] – and Steve Baker's *The Postmodern Animal* (2000)[31] have largely contributed to the mapping and contextualising of animal-centred artworks in modern and contemporary art. Aside from developing a number of innovative approaches to the discussion of the presence of animals in contemporary art, Baker's book also struck a chord with practitioners interested in the subject. One of the most interesting aspects of human–animal studies in the arts, again another similarity to gender studies, is indeed that of the crossovers between art practice and theoretical approaches that see artists, many of whom will be discussed in this book, actively involved in the field, participating in the discussion through the creation of challenging works that directly address new perspectives on animality. It is in this context that we also find the emergence of *Antennae: The Journal of Nature in Visual Culture*, the first experimental, independent academic journal to focus on the subject with the aim of broadening participation in the field.

The Pig Issue

One of the artists whose career has been informed by the field of human–animal studies is Kira O'Reilly. Her work as performance artist challenges the concepts of self, identity and body, and has recently decidedly taken an 'animal turn'. In August 2008, O'Reilly brought her performance *inthewrongplaceness* to the Newlyn Art Gallery in Penzance, where it was received with widespread criticism from animal-rights activists, who branded the work 'sick'.[32] In this controversial performance, O'Reilly invited one person at a time to watch her stage a 'crushing slow dance' with the body of a dead pig. O'Reilly's skin tone matched that of the pig closely enough to generate an unsettling continuity between the body of the animal and hers. The performative act, a continuous repositioning of the artist's body and that of the pig, revolved around ideas of identity and animal relations, closeness and distance, suggesting that for us the animal is effectively always a discursively dead object to manipulate, regardless of the morphological similarities that may indeed suggest the possibility for different relational approaches. *inthewrongplaceness* was in fact largely informed by O'Reilly's experiences as a resident artist in a laboratory working with pig tissue, and stemmed from a genuine need to explore further her relationship with the animal.

In this piece, the pig does not function as a defined symbolic entity, but it is a body, the body of the *other*. That the pig's body is strikingly close to ours, so much so that the animal's

organs have been used in transplants, adds a consistent layer of complexity to the meaning of closeness within the work. Following the sensationalist attention of the national press, O'Reilly received aggressive and negative correspondence. Many of her critics had not even seen the piece. As the artist recalls,

> I received a huge amount of highly aggressive emails to which I didn't respond. The one I did respond to was a really gracious and highly critical email from someone in the USA, who runs a pig sanctuary. I corresponded back and they were surprised by my take and withdrew much of their anger, but also made the suggestion that I work with live pigs.[33]

The result of this exchange was a work titled *Falling Asleep With a Pig* (2009). This work saw the artist and Deliah the pig sharing a dwelling for 36 hours on a hay-covered floor. This time, the discursiveness between the animal and human bodies was played on substantially different grounds, Deliah being alive and therefore able to act as a subject within the piece. The work could also be read as a new take on *Ein Haus*, ten years after its original staging. In *Falling Asleep With a Pig*, the one-way glass sheet emblematically dividing animal and human 'has been lifted', proposing a direct inter-species relationship that may not solely exist on the grounds of the gaze and its objectifying powers.

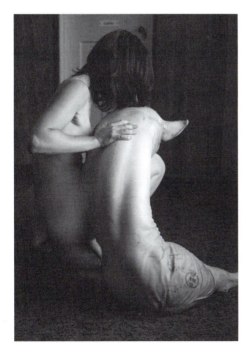

3. Kira O'Reilly, *inthewrongplaceness* (2006).

O'Reilly saw in the act of falling asleep a universal communality between man and animals, grounded in the mystery of what happens in the minds of both beings in that state. A slightly different second staging of the work, following O'Reilly's increased interest in the field of human–animal studies resulted in an adjusted structure, as suggested by Donna Haraway, one of the most prominent writers in the field of posthumanism. Haraway, also a key figure in human–animal studies, noted that the piece, as originally designed, prevented Deliah from reaching all areas of the enclosure, and a ramp was added, so that Deliah and the artist had equal access to all areas.[34]

In working with a live animal in the gallery space, O'Reilly also found herself thinking more closely about the suitability of the gallery space for these purposes.

The shortness of the live performance also commented on the 'wrong placeness' of the gallery for life and living, that it really is a place for dead or inanimate things. [...] The 21st century gallery is severely limited in its possibilities and it imposes its own discursive mode for bodies be they human, non-human animal or across both animal kingdoms and interkingdoms.[35]

The Challenges of the Living

O'Reilly's concern with the limitations imposed by the gallery space and its suitability for the living has been shared by other artists, like George Gessert:

The first time that I exhibited hybrid irises in San Francisco the curators had to install windows in the gallery, because the space had too little natural light for the plants. [...] After I had transported pots of irises to the gallery, a heat wave struck, and temperatures climbed into the nineties. Before the opening, the plants bloomed out. I had promised flowers, but presented instead a not very interesting mass of seedpods and grassy leaves. Someday, perhaps, there will be new kinds of art spaces to accommodate non human life, spaces that combine features of galleries, gardens, menageries, and wilderness.[36]

Gessert's account particularly focuses on the biological needs of live organisms in the gallery space and the challenges involved in meeting such requirements. However, as argued by artist Mark Dion, working with nature is highly problematic in our time, whether the artwork involved incorporates live organisms or simply represents them through more traditional media.

For the exhibition *The Greenhouse Effect* (2000), held at the Serpentine Gallery in London, Dion drafted *Some Notes Towards a Manifesto for Artists Working With or About the Living World*. The manifesto, structured over 20 distinct points, outlined the ethical and moral stands a contemporary practitioner should consider in engaging with the subject of nature. Some of the points directly address practical concerns. In point four of the manifesto, for instance, Dion claims that 'Artists working with living organisms must know what they are doing. They must take responsibility for the plants' or animals' welfare.'[37] Other points are instead directly concerned with the outlining of a more generic and theoretical understanding of nature.

Nature and Culture

The exhibition, held at the Serpentine Gallery in London's Hyde Park, was inspired by the work of geographer and architect Frank Stainbridge (1776–1860), who upon returning to England from travels in the tropics began constructing a greenhouse especially designed for the keeping

of the countless exotic varieties of plants he had collected. The greenhouse was described as being 'equal to masterpieces of art, capable of arousing original sensations in even the most jaded viewer'.[38] Unfortunately, this marvel was soon damaged by a winter storm, resulting in the death of the tropical plants inside it. Instead of attempting to bring new specimens back to England again, grief-stricken Stainbridge worked with a few skilled craftsmen to create an exact copy of each plant, resurrecting his greenhouse through simulacrum. Stainbridge explained that his aim was 'neither art nor even beauty but the fabrication of a novel and different, a man-made nature, free from decay and depredation'.[39]

Whatever Stainbridge thought of the nature he created, it is indeed clear that he produced art, essentially for the reasons he brings forward to claim exactly the opposite. The creation of a utopia that transcends the laws of nature but that simultaneously so closely resembles it through hyperrealism in order to deceive perception is art, and postmodern art at that. Tragically, the second greenhouse was set alight by a religious fanatic who believed the fake plants to be an insult to the original creation of the Lord. Stainbridge's misfortune invites reflections on the nature of art and nature itself, asking us to focus on the borders where one bleeds into the other. Art, classical art more specifically, could be indeed understood as a form of preservation: preservation of beauty, preservation from decay and death.

A multitude of works of art could be discussed in order to support this argument, and in both Gessert's statement and the tale of Stainbridge's greenhouses we find a reminder that art's predominant secular preoccupation has indeed been that of controlling nature – a very Western obsession still alive today.

In an installation from 2006, artist Paola Pivi brought over forty white animals in a disused warehouse in Milan. The animals were free to roam in the space as they pleased, while in one corner, a warplane lay upside-down as a ruin. Entitled *Interesting*, the piece presented an upside-down plane symbolising conflict between cultures, the assumption here being that warplanes enter the scene when dialogue between different cultures fails. The animals are presented here as the opposite of culture, white and seemingly connoted as innocent, yet they too belong to the category of those with whom language is not a communicative opportunity. At times, we are under the impression that when the live being enters the gallery space, it does so in order to take part in a reparatory ritual, an attempt to reunite us forcefully with nature through the converging of nature and culture (represented by the white, sterile and highly rationalised architectural space of the gallery). The separation of nature and culture, something that *Ein Haus* unequivocally represents through the use of the one-way mirror, is a deeply ingrained Western condition.

The cultural schism between nature and culture dates back to the philosophy of Aristotle, who saw nature as entirely distinct from technology, and was further complicated by Immanuel Kant, according to whom culture enables us to understand nature as a purposeful system while allowing us to become independent from it.[40] Our purpose and moral vocation is, in Kant, independent from nature, and our ability to curb nature is also a manifestation

of our separateness from it. Jean-Jacques Rousseau instead provided a view of nature as the true and tangible, favouring it over culture as the true teacher of life, insomuch as he looked at a hypothetical 'state of nature' (a synonym of anarchy).[41]

In his manifesto, Mark Dion also addressed the nature and culture philosophical divide. In point two he asserts that

> A. Humans do not stand outside nature: we, too, are animals, a part of the very thing we have tried to control, whether for exploitation or protection.
> B. Just as humanity cannot be separated from nature, so our conception of nature cannot be said to stand outside of culture and society. We construct and are constructed by nature.[42]

The Greenhouse Effect

The Greenhouse Effect exhibition – through the inclusion of works of art where the artefact, through mimesis, replaces the natural – also aimed at questioning further the boundaries of this troubled dichotomous relationship. There is in fact a twist to the Stainbridge story. Examination of his correspondence revealed that, for unknown reasons, the first greenhouse too contained a number of perfectly crafted, artificial specimens that were placed among the live plants. Maybe Stainbridge secretly enjoyed testing the observational skills of the visitors. Nobody ever noticed anything out of the ordinary. However, as if this was not enough, things become further tangled as we learn that, for some obscure reason, the first greenhouse may not have been damaged by a winter storm, as officially claimed, but by Stainbridge himself. Evidence shows that Stainbridge, before destroying the greenhouse, removed many of the tropical plants from the structure, and that these were re-housed in the new greenhouse along with many more crafted copies.[43] In conclusion, neither of the two greenhouses, then, were really 'wholly nature' or 'wholly culture'; the boundaries of 'what is what' were cleverly blurred through artistic craft, mimesis and juxtaposition of the natural and the man-made.

The first greenhouse was understood by its visitors (as it was claimed by Stainbridge) to be populated exclusively by live plants, the second to be entirely filled with replicas. What is important here is that visitors never realised the incongruities involved in either. This indiscernibility is singularly in tune with the postmodernist understanding of simulacra, where, according to Baudrillard, 'It is no longer a question of imitation, nor duplication, nor even parody. It is a question of substituting the signs of the real for the real.'[44] In the case of the plants in both greenhouses, artificiality and naturalness never cooperated in validating each other's essence. This impossibility of distinction between reality and representation therefore caused an ontological collapse where only simulacra were left. Did Stainbridge do it for the pleasure of deceiving visitors with his artistry? Or was the simulation a way to create an ideal utopia, much the same way Frederick Law Olmsted did when designing Central Park in New

York, or the way Disney does when it landscapes the artificial realities of its funparks? The difference between the motive of creating utopia and the pleasure of deception is interesting, as even the introduction of live plants into unnatural juxtaposition in a greenhouse constitutes a form of utopianism. The Victorian conservatory in many ways functions like wildlife documentary films by presenting a series of nature's 'greatest hits' collected in an unlikely proximity that does not reflect the unmediated essence of natural forested environments.

The creation of objects of natural semblance by the hands of artists indeed makes a rather problematic statement. As contrived as it may seem, the *alleged* separation of nature from culture allows us to acquire a fictitious sense of certainty about human existence. Through our 'departure from nature', man developed the opportunity to create and invent things that are changeable. In opposition, nature became the certainty, the fixity and the cyclical repetitious truth upon which we can rely in order to continuously produce fluid and open cultural grounds. As long as it is separate from cultural standpoints, nature functions as a much-needed stable point of reference.

Mimesis in classical art also functioned as a tool to reassure viewers that nature was mastered through knowledge and the ability to reproduce it in detail as a painting or sculpture. However, in these creations the distinction between culture (the art object) and nature (the living being) was still clear. At the Serpentine Gallery, located in the middle of Hyde Park in London, the natural-looking artefacts inside the gallery space presented in *The Greenhouse Effect* also implicitly questioned the veracity of the nature that visitors could see outside the large windows that open onto the park. If what is inside the gallery (culture) looks exactly like the plants and animals outside in the park (nature), then what is culture and what is nature? Would we be able to consider the park nature anyway, especially in view of the fact that it is the product of human gardening and landscaping, and that all trees and shrubs on view were selected by humans? The points of reference begin to collapse. Is the squirrel caught in a moment of perfect stillness on the tree branch in the park alive or taxidermied?

The tangled relationship between the animal and the work of representation is at the core of the surfacing of the animal in contemporary art practice. A traditional painting representing a shark and the seemingly more cutting-edge work of artist Damien Hirst may indeed share many more similarities than one would at first glance assume. The secular tradition of animals in paintings, with its predominant reliance on symbolic signification has greatly informed our expectations of what the animal ought to do in the representational field, and some challenging artworks have attempted to subvert such a system.

Indeed, it is when artists create objects that entirely and too faithfully reproduce the natural that we are left puzzled by the conflation of nature and culture. Instantly, everything is brought into question in an unsettling way, at least in art. What is real and what isn't? And ultimately, is there such thing as 'the real', even when discussing nature?

Chapter 2
Taxidermy
Subjugated Wilderness

Taxidermy is, I suppose, an act of homage. Preserving wildlife is one way of showing respect for animals. Visual art for me is a well-mounted and artistically presented creature. Respect for nature is for me to save a creature that would otherwise decompose.

(Don Sharp, founder member of the Guild of Taxidermy)[1]

Hiroshi Sugimoto takes photographs of dioramas in natural-history museums using the original black and white photographic technique of the daguerrotype pioneered by painter and physicist Louis Daguerre in 1837. The artist's practice is strongly informed by history, the concept of memory and the passing of time, as he employs photography as a critical tool for interrogation of reality and illusion. 'I made a curious discovery,' says the artist,

> while looking at the exhibition of animal dioramas: the stuffed animals positioned before painted backdrops looked utterly fake, yet by taking a quick peek with one eye closed, all perspective vanished, and suddenly they looked very real. I had found a way to see the world as a camera does. However fake the subject, once photographed, it's as good as real.[2]

In his extensive series titled *Dioramas* (ongoing from 1974), Sugimoto translates the three-dimensional formal elements of the diorama into black and white, flattened images enhancing the continuity between animals' forms and painted backdrops. Through this process, he excludes all signs of the museum context from the framing, freeing the image from much of its historical and cultural layers. At once, the photographs heighten the illusionistic ambition of the dioramas but extrapolate the natural vision from the Western-cultural context that created them, metaphorically returning the animals and landscapes to nature in the form of a memory (suggested by the use of black and white). As a result, these

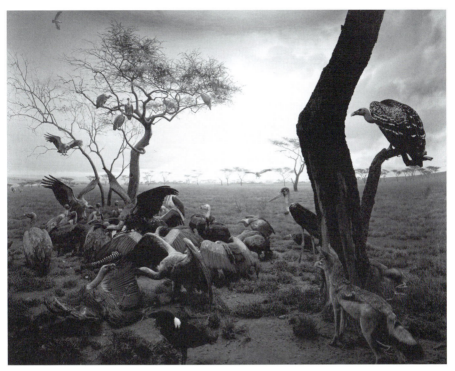

4. Hiroshi Sugimoto, *Dioramas, Hyena Jackal Vulture* (1976).

images exist in an even more ambiguous place than their original three-dimensional referents. Read through Roland Barthes's argument that 'not only is the photograph never, in essence, a memory... but it actually blocks memory, quickly becomes a counter-memory',[3] we see Sugimoto's images becoming imbued with a sense of anxiety for a complete 'loss of nature' slowly in time, to be replaced by photographic documentation. The photographing of taxidermied animals harks back to the tradition of Victorian wildlife photography, in which stuffed animals were placed in natural settings in order to overcome the technical limitations imposed by extremely long exposure-times. In mid-1800s, no photographic camera or film was able to freeze the natural movements of a live animal.[4]

The Glass in Between

The rhetoric of wildlife photography is discussed in the seminal essay 'Why look at animals' (1980) by John Berger, who claims that this genre paradoxically separates us from nature while simultaneously providing an illusory proximity. Berger argues that 'the camera fixes [the

animals] in a domain which, although entirely visible to the camera, will never be entered by the spectator.[5] Animals captured in wildlife photography, like those arranged in a diorama, therefore make a claim of proximity through a constructed signification that effectively establishes a distance between us and nature, for the image we see has very little to do with nature itself. From this perspective, we could then argue that the sheet of glass separating us from the animals in the diorama (similarly to the lens of the camera), is the embodiment of this deceitful condition. Photographer Diane Fox, an expert in the photography of dioramas, at a certain point in her research turned her attention to this glass sheet and enhanced its presence through a focus on reflections, framings and imperfections in order to reorganise the syntax of the diorama and unveil its fragmented and constructed nature.

A strong enthusiasm for Victorian taxidermy is clearly back, at least in the realm of contemporary art. In stark opposition to the trend that has recently seen natural-history museums around the world discarding their collections of specimens, some contemporary artists seem to have picked the stuffed animals straight out of the museums' rubbish bins. As a result, encountering a taxidermied animal at an art exhibition has now become a more frequent occurrence. However, it has to be pointed out that this revival of taxidermy is not a hollow trend but a highly intriguing and layered revisionist phenomenon.

Taxidermy's earliest appearance in the gallery space dates back to 1955–59, as part of *Monogram*, a *Combine* by artist Robert Rauschenberg. Although an isolated instance and

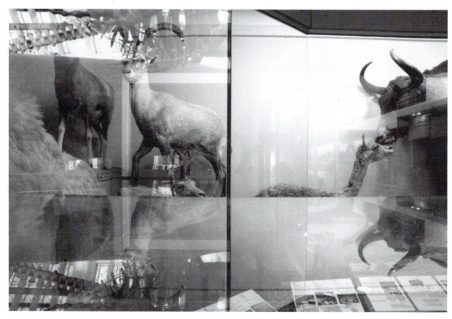

5. Diane Fox, *Untitled* (2007).

very much a precursor, this work presenting an angora goat standing on a raft covered in commercial signs, newspapers and paint, and encircled by a car tyre, captures the essential anxiety which most contemporary taxidermy will come to embody in the 1990s and 2000s. Through his reinvention of collage in a three-dimensional form, Rauschenberg produced an animal form that is a 'found object' like all the other man-made materials gathered in the piece, which all suggest the overbearing essence of capitalism in everything around us. Interestingly, in early Christian art, the goat was frequently used as a symbol for the damned, and, as we will see, the surfacing of taxidermy in contemporary art has little to do with the grandeur of nature's beauty but becomes a painful reminder of our difficult relationship with nature itself.

Taxidermy emerged in the eighteenth century, and gathered momentum as the industrial revolution recklessly redesigned the boundaries between the wild and the urban, nature and culture. With the expansion of cities and the shaping of new social realities also came the need to bring nature back into the lives of those who might otherwise have had no opportunity to engage with it. Paradoxically, this distancing from the animal world imposed by modernisation coincided with the rise in popularity of the natural-history museum as a place of encounter between rationalised nature and audiences. Taxidermy then assumed the role of referent for a distant nature functioning as the still and silent token for the exotic and marvellous life forms that inhabited faraway lands – worlds admired and treasured as much as mystified and misunderstood. European navigators played a key role in the importing of fauna and flora from India, Africa and South America. A driving force of colonisation and imperialism, these voyages simultaneously opened imaginative windows for North American and European audiences who wanted to escape from the grim environs of capital cities. The Victorians were extremely fascinated by the unusual and colourful bodies of exotic animals, which metonymically also functioned as place holders in the mapping of the land incorporated by the Empire.

Today, we have begun to see taxidermy as a bio-product of this socio-historical scenario capturing the utopian positivistic visions of the time. Most taxidermy has come to symbolise the intense thirst for knowledge and stability in a world that was changing too fast, too soon, as well as uncannily portraying the deep socio-cultural anxieties that also marked the development of this period. The subverting intensity of Darwinism, the revelatory slant of psychoanalysis, the weakening of the hold of religion on the masses, the development of science through technological innovation, the rising interest in Japonism, the surfacing of primitive art and the spreading of Theosophy in artistic circles, all contributed to a deep questioning of Western certainties and fostered a desire to understand and control the known, and moreover the unknown. To audiences of the nineteenth century, a taxidermied animal was the tangible proof of the greatness of nature. It became an unproblematic object to be admired; the manifestation of the subjugation of nature that man alone is capable of.

'The wonders of nature' were a great attractor by the nineteenth century, whether in the form of zoos, aquariums or taxidermic displays. This rise in popularity went hand in hand with the development of natural history itself, which at the end of the eighteenth century became a discipline through the methodological contributions of new naturalists like Buffon and Linnaeus. It is, however, fair to say that, back then, the subject's boundaries were rather undefined and that the spontaneous and at times naïve enthusiasm for nature (typical of Victorian approaches) primarily engaged audiences by means of the spectacle.[6] In the nineteenth century, the diorama effectively combined nature and entertainment, and most interestingly it also indissolubly brought together nature and artistic practice. The term diorama derives from Greek, 'dia' ('through') and 'orama' ('to see'), and it was first used by Louis Daguerre.[7] His early dioramas were produced around 1822, and mainly consisted of painted sheets of translucent fabric featuring naturalistic images on both sides, which, seen from a distance and illuminated by sunlight, would create illusions of passing seasons and the changing of light between night and day. These first experiments proved successful with audiences. However, in order to maintain interest, Daguerre soon implemented three-dimensional objects, and reportedly once even included a live goat.[8] As Daguerre's fame grew through Europe and North America, so did the interest for this new form of entertainment that combined painting, theatre and the realist syntax of photography. It was not until 1889, however, that the diorama entered the natural-history museum as a legitimate educational tool, thanks to Carl Akeley, an American taxidermist, sculptor, biologist, conservationist, inventor and nature photographer.

Akeley was a pioneer in his own time. He worked with newly invented technologies, and was driven by the ambition to bring the majesty of African mammals to the audiences of the Milwaukee Public Museum. In her seminal essay 'Teddy bear patriarchy: taxidermy in the Garden of Eden' (1994), Donna Haraway discusses, among other things, the origin of the nineteenth-century diorama, suggesting that

[a] diorama is eminently a story, a part of natural history. The story is told in the pages of nature, read by the naked eye. The animals in the habitat groups are captured in a photographer's vision and a sculptor's vision. They are actors in a morality play on the stage of nature, and the eye is the critical organ.[9]

The Animal, the Camera and the Gun: Constructing Nature

The relationship between the animal, the camera and the gun, as Haraway argues, was pivotal to the creation of dioramas. Hunting was the only means of providing the skins, which would ultimately become the essence of the taxidermied specimens. Both the gun and the camera's shooting are metaphorically merged in the moment the animal is killed to be preserved as an

image, for posterity. The shot that kills the animal allows for the preservation of its surface, its appearance, and simultaneously relegates it to the realm of representation. What makes this particular shooting different from the common hunting one is the quest for perfection that causes the trigger to be pulled. Only the perfect specimens, those representative of our own idea of perfection in nature, can be considered fit for purpose. Following this consideration, it becomes evident that the diorama embodies a violent subjugation of nature, a typically masculine endeavour, a manifestation of the deep desire to possess and control nature, arresting life in a three-dimensional photographic capture designed to educate and inspire while also demonstrating human supremacy over nature. Akeley's hunting expeditions were charged with a deep passion that kept the man going back to Africa in order to capture the most perfect examples of what he saw there. 'Taxidermy was the craft of remembering this perfect experience. Realism was a supreme achievement of the art of memory, a rhetorical achievement crucial to the foundations of Western science.'[10]

Interestingly, a number of female contemporary artists (some of them non-Western) have recently turned the camera lens back to the diorama in the attempt to undo the intended seamless continuity with life that makes the display so seductive through its utter artificiality. This is, of course, the context within which we also find the work of Hiroshi Sugimoto and Diane Fox, already discussed at the beginning of this chapter.

Unlike those who first created these scenes, these artists work outside the diorama's representational plane, on the other side of the glass, and it is through the conscious referencing of this defining distance that they deconstruct the illusion, in order to re-arrange the diorama's contemporary signification. These artists bring the original shot of the diorama back into the camera obscura, back to its production stages, in order to reconfigure the image. It is clear, in contemporary art practice, that the taxidermied animal – and with it the diorama – no longer yields a cultural transparency to nature, as it was in the nineteenth century, but that our critical approach and historical awareness has now radically changed our rapport with both.

In the photographic work *Fables* (2005–9) by Karen Knorr, taxidermied specimens have 'escaped the diorama' and have claimed the sumptuously decorated interiors of the Musée Carnavalet in Paris. In these images, the painted landscape of the natural-history display has been replaced by the wallpapers and furniture of this neoclassical museum – the *rationalised* (neoclassical architecture) and *irrational* (animal) are here at odds. Within the architectural space, animals become part of the rationality and order of the Enlightenment while referencing the historical tradition of elitism, subjugation and exploitation that also underlined the positivistic slant of the period.

Daniëlle Van Ark's photographic project, *The Mounted Life* (2007) aims at further shattering the illusory aura of the diorama by turning her camera to those specimens that, for one reason or another, did not make it to the public display. The taxidermied animals that populate Van Ark's work are charged with a sense of melancholia. Lost in dark

6. Karen Knorr, Fables - *Reception* (2006).

utilitarian storage rooms and basements, away from sunlight, lying on shelves or wrapped in cellophane, these animal bodies are stuck in a representational limbo. Their surroundings, in these images, matter as much as the carefully painted landscapes of the dioramas in which the animals that managed to make their way upstairs are arranged. Van Ark's photographs unsettle the confident illusory aura of the specimens as their lifelike realism is here replaced by fragmented and contradictory scenarios. Now, like in any other archive, these objects have lost their connections to the worlds in which they once belonged. They exist in a doubly suspended time dimension as permanently still animal bodies housed in a space where time is also suspended. In Van Ark's images, like in those by Knorr, the animals are deterritorialised. The first chapter of *Theory of Religion* by Georges Bataille speculates that the animal 'is in the world like water in water'.[11] This statement tries to capture the immanent state of animal lives in indissoluble continuity with the natural world they are in, something we humans have allegedly lost. Van Ark's as well as Knorr's animals have been representationally removed from this continuity, and as such their awkwardness is augmented, posing questions on the overall significance and necessity of the killing of animals for the purpose of museum

display. These images function as a further reminder that the diorama is an assemblage, and that before all parts are composed together into a harmonious whole each single animal had an existence that transcended the concept of specimen. It is indeed this tension presented by the taxidermy model, a tension that also permeates taxonomy, which is largely key in the current artistic appropriation of taxidermy itself.

The Natural Object: Cabinets of Curiosities

The collecting of animals and natural objects first appeared in Italy as a result of the unprecedented humanist development that shaped the Renaissance and became an activity of choice among the educated elite. Collecting and displaying natural objects not only contributed to the personal enrichment of the Renaissance man, but it also enhanced his reputation.[12] It is at this very early stage of the development of collecting that the *natural object* finds its way into the cabinet of curiosities along with the *art object* and the antique. This is a key moment in the formation of knowledge of the natural world for the humanist sphere, as it could be argued that the seeming disjointedness with which objects are gathered in the Renaissance cabinet of curiosities is counterbalanced by a set of assigned values shared by all objects presented there. The natural object has formal and structural features that are shared by the artistic object and the antique one. They all indeed share similar formal syntaxes, possess similar aesthetic qualities and are equally, albeit in different ways, entangled with the concept of time. Inside the cabinet, our objectival relationship with nature is fully established on the grounds of this overlay of transferable attributes that all contents share.

The cabinet of curiosities is in itself an exhibiting device with a complex essence – its past rooted in the religious reliquary and its present fuelled by a theatrical merging of imaginative storytelling and aristocratic taste for self-mythologisation. Upon entering the cabinet of curiosities, the object is invested with an aura produced by deterritorialisation. It is when the object is decontextualised from its natural setting that it opens itself to multiple significations, as it can form new connections from which alternative meanings develop.

The work of American artist Mark Dion is consistently informed by the tradition of the cabinet of curiosities and the display methodologies of the natural-history museum. The seemingly random gathering of taxidermied specimens and everyday objects that constitute his work aims at unveiling the ideological approaches that underpinned such collecting and ordering systems. Inside his cabinets the exhibited objects establish polysemic, interwoven networks that, bending the rigour of scientific taxonomy, allow us to develop a critique of the conventions that govern these. In *Theatrum Mundi: Armarium* (2001), a collaboration with Robert Williams, Dion created a three-section cabinet, with the left and right sides titled 'culture' and 'nature' respectively. The centre portion, meanwhile, houses a homo sapiens skeleton. The side sections of the cabinet deliberately unsettle the category of

knowledge as established points of reference in Western culture, prompting the viewer to question the certainties which would assign the displayed object to one or another category. Here, the man-made antiquarian object, contemporary plastics and stuffed animal toys along with taxidermied animals are gathered in this condensed representation of the world.

Jorge Luis Borges's essay 'The analytical language of John Wilkins' (1942) famously includes the description of a certain Chinese encyclopedia titled the *Celestial Emporium of Benevolent Knowledge*, in which animals are divided into:

> (a) those that belong to the emperor; (b) embalmed ones; (c) those that are trained; (d) suckling pigs; (e) mermaids; (f) fabulous ones; (g) stray dogs; (h) those that are included in this classification; (i) those that tremble as if they were mad; (j) innumerable ones; (k) those drawn with a very fine camel's-hair brush; (l) etcetera; (m) those that have just broken the flower vase; (n) those that at a distance resemble flies.[13]

Michel Foucault opens *The Order of Things* (1966) with this passage, and recounts that in reading it, all the familiar landmarks, all the ordered surfaces and all the planes with which we are accustomed to tame the wild profusion of existing things shattered, revealing the inherent impossibility of thinking outside such limitations.[14] This concept is at the core of Dion's work, especially in the suggestion it makes that we discover and think the world outside pre-established categories, while recognising the intrinsic urge we have to categorise and classify. Above the central section of the cabinet, the one containing a human skeleton, proudly sits a magpie. Here, this bird symbolises the relentless compulsivity for collecting coupled with the underlying irrationality that pervades such practice. The magpie is notoriously attracted by surface-values like colour and shine. The bird's methodology reminds us of the paradoxically arbitrary nature of collecting, hinting at the varieties of criteria that could be privileged in the construction of new taxonomies and questioning the certainty that some objects are effectively of more value and relevance than others. As Dion explains,

> Curiosity cabinets constitute a new field of research for art history. Simultaneously, the fact that some artists work on the history of museums, enables us to perceive these installations in a different way. As far as I am concerned, this is a questioning and a reorientation of those cultural models, and this is expressed visually. Perhaps, the acceptance of the ready-made, conceptual art and installation art have allowed us to productively re-investigate early collections. I remain uncertain of how it differs from the Surrealist's interest in the Wunderkammer. However, it is clearly a model which escapes the same old dreary fictions.[15]

Between the Rational and the Surreal

Other contemporary artists have also focused on the challenges posed by taxonomy and the fictitious notion of *certainty* in culture. Let us return to the taxidermied animal and its uncanny *thingness*, something related to the ambiguity of photographic suspension, and that makes the body a perfect surrealist vehicle for dreamlike scenarios and alternative realities. Simultaneously 'alive' and dead the taxidermied animal body can easily transcend temporality and disrupt the predictable linear development of narratives. Artist Tessa Farmer has created her very own alternative reality combining taxidermy and fairies in mesmerising displays that relentlessly oscillate between the naturalistic and the dreamlike, the poetic and the horrific. The displays she creates willingly confuse the taxidermied, the alive and the dead. Her tableaux hark back to the Victorian understanding of taxidermy as a highly romantic form and combine this with the early-modern interest for the supernatural. The interest in fairies was so pronounced during the fin-de-siècle period that as late as 1920 images of presumed real fairies caused a major stir in England. In many cases it was photography's deceptive ability to merge the animate and inanimate that concocted impossible credibility.

The shots in question were taken by Elsie Wright, a then 16-year-old girl with a passion for photography. The images, initially meant as a private memento, leaked and captured the imagination of many spiritualists like Sir Arthur Conan Doyle (more famous for writing Sherlock Holmes), triggering speculation on the plausibility of fairies' existence as based on photographic evidence.[16] It seems somewhat ironic that a man who created a character famous for logical deduction would be swept up in the supernatural. However, that photography's mechanical eye could see more than the human was a widespread belief in the Victorian age – this was supported by a multitude of images of presumed ghosts created through double exposures and expert 'dodging and burning' taking place in the darkroom.

In Tessa Farmer's suspended tableaux, it is the combination of the fairies juxtaposed with the taxidermied animal bodies or desiccated insects that legitimises their existence. Within this framework, and quite appropriately, Farmer describes

7. Tessa Farmer, *Little Savages* (2007).

herself as a Victorian naturalist who has discovered the fairies as natural beings, and who engages in the practice of classifying them. The fairies are made of plant roots and insect parts, and measure not more than 8–10mm. It is when leaning forward to gaze at such disconcerting scenery, like looking through a peephole, that the fairies appear utterly present, in continuity with the realism of the taxidermied bodies that surround them.

Another artist engaging with the deceptive dead/alive ambiguity of taxidermied animals is Polly Morgan, who in 2006 brought taxidermy to the pages of the tabloids by selling one of her pieces to model Kate Moss.[17] Morgan's take on taxidermy is to subvert its original function through the same technique that historically aimed at preserving the illusion of life indefinitely. So in many of her works the animal, usually a bird, appears dead rather than frozen in lifelike action. A large part of Morgan's work is clearly informed by Surrealism, and more specifically by uncanny works like Dali's *Lobster Telephone* (1936) and the painterly tradition of the still-life, which also featured dead birds and small mammals lying on tables. Due to this set of references, the taxidermied animal encountered in the work of Morgan is charged with symbolic, romanticised tones. Here, the animal, like the magpie sitting on the old bakelite phone (*Someone on the Phone*, 2006), functions on symbolic grounds, suggesting the bearing of bad news and following the tradition of Dali's readymades.

Dutch artists Afke Golsteijn, Ruben Taneja and Floris Bakker (going by the group name Idiots) have developed an international reputation for their use of taxidermy in highly surrealist scenarios mixing art and craft in original ways. One of their most famous works is *Ophelia* (2005). On the gallery floor, the upper part of the taxidermied body of a lioness suggests an animal contentedly snoozing, caught somewhere in between life and death. However, the bottom part of the body dissolves into shiny drops of gold. Fantasy and reality are here again inextricably interlinked as literary references (the title of the work references Shakespeare's dramatic character) shift representational clarity into further uncertainty. Of Ophelia's suicide, we only know that she took her own life by using the weight of gold jewellery to drown herself in a pond.[18] Poetic intervention is key in the work of these artists, as the taxidermied animal here works as a vehicle of the romantic, the surprising and uncanny. Perhaps more interestingly, the artists also read the piece as a contemporary commentary

8. Idiots, *Ophelia* (2005).

for they explain that 'Ophelia is about the old power of nature and the new power of money and gold that consumes everything'.[19]

The taxidermy work of contemporary artist Thomas Grünfeld also operates on similar grounds to provoke in the viewer a combination of attraction and revulsion and to trigger questioning on the nature of art, the state of artistic objects in general and nature as a cultural construct. Grünfeld's work started from a reflection on the anti-aestheticism of the 1980s and an ironic critique of 'Gemütlichkeit' (a typically German kind of cosiness), that produced the tradition of hunt trophies as well as that of the eighteenth-century cabinets d'amateurs. Both absurd and disconcerting, Grünfeld's sculptures disturb us as much by what is shown as by what they suggest. Artists have traditionally used images of hybrids in response to times of crisis, or to give embodiment to the irrational. From the chimeras of Greek mythology to the creatures on The Island of Doctor Moreau (1896), to more recent sci-fi and fantasy movies like The Fly, hybrids have always inhabited our collective, cultural imagination. As such, Grünfeld's Misfits can be thought of as a monstrous manifestation of the times we live in: the visual synthesis of the clashing of overshadowing anxiety and positivist optimism triggered by technological advancements; the fear of a progressive distancing from nature, bearing consequences we can barely imagine; the fear of a genetically modified nature that may get irreparably out of control. His Misfits are reminiscent of early 'natural histories' in which exotic animals were described as combinations of already known animals. For example, the 'camelopard', now known as the giraffe, was described as having the height and neck of a camel, the head of a stag, although somewhat smaller, the teeth and feet of an ox, and a leopard's spots. Technically, Grünfeld's Misfits are 'taxidermy collages', echoing the old tradition of combining different animal body parts in the attempt to generate physical evidence of the existence of fantastic creatures.[20] This effectively is the main strength of these works, as they paradoxically assert nature as the only remaining certainty in a cloned and man-manipulated world, while simultaneously challenging this certainty through the disturbingly credible presence of these impossible animals. The Misfits are seamlessly stitched together with great care, determined in their attempt to claim through a sense of structure and natural harmony their legitimate place as specimen in the taxonomy of natural history.

The Specimen

The specimen also is a deterritorialised animal body that has acquired the status of species representative through a state of isolation and preservation in the scientific cabinet. The specimen is entirely a thing of zoological reference. Technically, this is called the 'holotype': a physical example used to formally describe the species it represents. As a species representative, the holotype is anonymous, and it is in its utter perfection that we find the confirmation of its universal anonymity. It embodies the canon of the species of which it is a

9. Thomas Grünfeld, *Misfit (rooster/calf)* (1999).

representative. It is an animal without a personal history: it's a flat reference, a blueprint. Like the canon established to set the standards in classical painting, architecture and sculpture, the fixity of best proportion, clarity of lines, volumes and colours are set in the holotype.

Mark Fairnington's large-scale photo-realistic paintings of zoological collections explore the image of natural-history specimens in storage and displays. A large part of his work involves focusing on taxidermied mammals and birds, and also insects. The artist photographs individual specimens under a high-definition electron microscope at different degrees of magnification. The photographs are then reassembled through painting in order to create an enlarged and meticulously precise image of the original specimen. The result is extremely fascinating, as the beauty of the specimen itself becomes amplified. However, it soon becomes clear that the artist is not interested in the perfect and unblemished specimen, but that instead he is in search of the minute ruinations and imperfections which may return the specimen from his indexical role to its corporeal animality. Slight marks, broken legs and ruined wings signify the passing of time and the work of decay where bacteria, parasites and oxidation obliterate the utopian perfection expected of the specimen. The body in question thus acquires an identity and is acknowledged as something not fixed but in flux. It reveals a personal story of some description, one that clashes with the anonymity required of the

specimen. Fairnington's paintings challenge the possibility of an image of the specimen as re-presented in the natural sciences in ways that express our understanding of the changing relationship between humans and the natural world.

A Matter of Time and Place

nanoq: flat out and bluesome (ongoing since 2001) is the title of a four-part project by artist duo Bryndís Snæbjörnsdóttir and Mark Wilson. The project aims at unveiling the cultural intricacies hidden in our unfolding historical and contemporary cultural relationships with polar bears. Over three years, the artists located 34 specimens of polar bears housed in private and public UK collections. They then proceeded to photograph each specimen in what had become its 'unnatural habitat': private homes, museum displays, storage rooms or workshops undergoing restoration. It was of paramount importance to the artists also to gather as much information as possible about the provenance of each bear, and of how and when it arrived in the UK. One component of the project involved the curating of a very successful itinerant exhibition that gathered a selection of relevant documentation and images along with some of the catalogued specimens, conflating each image with a text outlining the very individual *cultural history* of that particular specimen. Another component brought together ten of the polar-bear specimens in question and isolated them collectively as a single exhibit. This ambitious project not only addressed our complex relationship with wildlife and museum display but simultaneously addressed a complex layering of historical, moral and ethical sets of issues which all resounded with rather disturbing contemporary echoes. To the artists, the project addresses the troubled two hundred years through which these animals were killed, while simultaneously providing the opportunity for a different reading and contextualisation of the taxidermied specimens.

nanoq inescapably alerts us to a sense of guilt for the indiscriminate killing which took place in the past. However, the polar bear has more recently also become the representative icon of global warming. This, of course, mobilises another layer of cultural and material meaning along with the already complex conflation. With the Arctic cap melting at considerable speed, not only are polar bears seeing their natural habitat literally dissolving, they are effectively drowning as the distance between receding ice-sheets increases. The taxidermied polar bears exhibited in the exhibition resonate with our contemporary sense of this and much more. The trophy, the souvenir, the obsession for the exotic, the idea of status symbol and the uncomfortable legacy of an imperial past are all invoked, and invite our scrutiny through the body of the taxidermied polar bear. In this case too, it is the displacement of the taxidermied animal that enables the above-mentioned conceptual departures to surface. For it is only when the bears are removed from their original exhibiting context as educational objects in the museum, extravagant furniture or trophies that the uncanny presence of a multitude of polar bears in one room

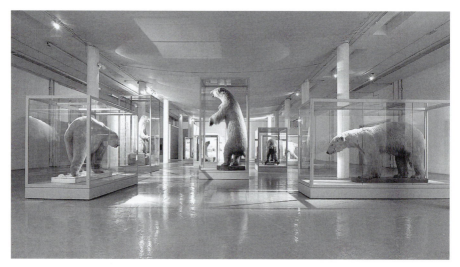

10. Bryndís Snæbjörnsdóttir and Mark Wilson, *nanoq: flatout and bluesome* (2004).

becomes disconcerting. The unusual title *nanoq: flat out and bluesome* captures the very essence of the project. Here, 'flat out' is in reference to the flatness involved in the representation of the animal, while 'bluesome' suggests melancholia related to the killing of the animal and its misplaced and at times forgotten existence as a taxidermied piece. The tracking down of the bears is something Snæbjörnsdóttir and Wilson describe as a 'cultural hunt', an action that in a number of ways echoes the original expeditions, which under the name of science and education brought these animal bodies to the collections of the eighteenth-, nineteenth- and twentieth-century museums. Yet, the artists acknowledge that the hunger for the trophy and a reputation for heroism was very often the motivation for individual hunters. This drive is at length discussed by Donna Haraway as the defining factor behind the selection of a suitable specimen. The character of the specimen, its aggressiveness and resistance to being killed played a key role, at times as important as the aesthetic quality of the animal. 'The killing itself had to be accomplished as a sportsmanlike act. Perfection was heightened if the hunt were a meeting of equals.'[21] Before becoming a scientific specimen, the animal body is therefore intrinsically a trophy; at times, if it is not destined for a museum collection, it will remain so. As the artists inform us, many polar-bear specimens were often set in aggressive poses in acknowledgement of their 'wild' essence, so as to preserve or suggest something of the occasionally unavoidable heroic confrontation that came to freeze the animal in time.[22] This complex relationship was largely anticipated by still-life paintings of the seventeenth and eighteenth centuries, where dying or dead animals would simultaneously connote the privileged aristocratic social classes who could entertain themselves with hunting, as well as capturing the dexterity and braveness involved in the confrontation with the prey.

One of the main aims of *nanoq* is to reveal that these bodies are not to be understood as animals but instead as cultural objects – tangible and uncomfortable documents of a difficult past history, one that comes back to haunt us today. Inside the natural-history museum or mounted on the wall as a trophy, these objects' claim of animality is much amplified and supported by the context in which they are exhibited. However, once this is removed, their *thingness* becomes more visible. As Garry Marvin explains,

The history of the polar bears of *nanoq: flat out and bluesome* begins not with their lives, but with their deaths. Although these bears were born of particular parents, inhabited particular places, experienced some sort of family life, played, hunted, perhaps raised their own offspring, we have no access to those lives except as knowledge of how polar bears in general live.[23]

These animal-objects replaced the existence of the live animals as a result of the encounter with the human; forever extrapolated from natural contexts and subjugated by cultural constructs, the taxidermied animal only preserves the surface of the real animal. As Snæbjörnsdóttir and Wilson explain, 'When thinking about the inside of the animal, it is seen as a carcass, often as meat for consumption whereas human animals are seen as having "a soul" and an imagined interiority.'[24] *nanoq* aims at the surface of the animal, its skin, in order to identify new and challenging productivities. In Ron Broglio's view,

Taking surfaces seriously re-evaluates the derogatory claim that animals have only impoverished interiority and thus live on the surface without the self-reflexivity of thought. [...] Since these animals are not considered to have an interiority, which is the unique quality of humans, and since they don't speak in our language, their inside is already made an outside, a mere surface to be exposed for human use.[25]

This problematic *flatness* is captured through photography and taxidermy in a very analogous way. In semiological terms, both media present the viewer with indexical signs, the category of signs which have a direct connection to the objects they stand in for. As the indexical sign bears this strong connection to the real object, in this case the animal, it is capable of making such an object vividly present. However, as has been argued, this presence is a representation moving through a cultural system of meaning, and it indeed hides an absence. The photographic component of the project captures the extensive degree of deterritorialisation that the taxidermied animals have endured. Their white fur, which functioned as a mimetic tool through the icy planes of the Arctic, makes the animals painfully visible in the interiors of their displays. In these photographs, the polar bears become another object in the room, a centrepiece at times, a trophy, or a forgotten relic at others, a souvenir.

The Trophy and the Souvenir

The trophy and the souvenir both are romantic and highly sentimentalised objects that dangerously tend to lean towards the kitsch. The kitsch object is a self-declaring entity, one that brazenly claims to be beautiful, deep and qualitatively imbued, but that simultaneously betrays its claims through the unoriginality and aesthetic deficiencies that unequivocally distance it from the valuable thing. The taxidermied trophy is an object that, once properly mounted, allows the hunter to relive the moment of the kill and provides evidence of the bravery and dexterity involved in the task. As such, the trophy follows a specific iconography, one incorporating as many variants as there are animal groups. In the case of the bear, the animal is characteristically set upright, similar to a human, enhancing size and suggesting sheer force, while bringing the animal onto a par with the hunter. The mouth is usually set wide open, the fangs well visible, the claws protruding. Some of these attributes are fictional and depart from the natural behaviour the animal would enact upon confrontation. Similarly to the dynamics involved in the souvenir of famous monuments, the object standing in for the original thing functions at its best when it is at great distance from the original – this is when it triggers memories and emotions charged with deep popular romanticism. The trophy-bears are visual objects of desire, souvenirs of a too-distant natural world, one that the majority of us will never directly experience.

Interestingly, one of the most captivating images produced for *nanoq* is that of a polar bear recently purchased (1999, from Deyrolle Natural History Shop in Paris), and unlike the oldest taxidermied bears it is mounted in a slightly playful and benign pose.[26] This bear looks down towards its right paw, almost as if delicately inspecting a now absent natural object. In this image, more than in others, we find that the double indexicality of taxidermy, captured through the medium of photography, generates the singularly credible illusion that the bear we are looking at is indeed alive and that it may have moved before and after the moment in which the shutter lifted and fell.

Botched Taxidermy: The Problem with Beauty

Possibly because it persistently reminds us of the unnecessary animal killing which preceded it, the trophy has surely become the most intensely questioned taxidermy genre in post-colonial studies. As we have just seen, artists Snæbjörnsdóttir and Wilson have brought to the surface the uncomfortable truth behind the taxidermy body of polar bears through a multi-layered recontextualisation of cultural objects and subversion of the idea of specimen. However, other artists working on this subject have adopted a range of communicational tactics that involve the defining of new aesthetics which are devised to engage the viewer on predominantly emotional levels. In *The Postmodern Animal* (2000), Steve Baker contextualised

a series of works of art by different artists, presenting the reconfigured body of animals as 'botched taxidermy', stating that these pieces essentially function as 'questioning entities'.[27] In stark contrast to 'realist taxidermy', which aims at preserving the animal's beauty and perfect form, botched taxidermy summons an abrasive and uncomfortable presence. According to Baker, 'The problem with art's more straightforwardly realistic, or beautiful, or sentimental representations of animals is that our very familiarity with them renders the depicted animal effectively invisible.'[28]

Beauty in art is largely a postmodern problem. Since art and nature collided through the development of classical art, the concept of mimesis actively contributed to the selection and composition of those formal elements that capture the essence of what is considered beautiful – thus natural and artistic beauty indissolubly merged for centuries. Beauty became one of the paramount elements of art, functioning as the main vehicle through which meaning was conveyed. In the published lectures *Discourses on Art* (1790), Reynolds holds that 'perfect beauty' lies in the artist's creation of a composite representation, combining the most beautiful characteristics of the type of thing represented.[29] Beauty is also Immanuel Kant's prime criterion for aesthetics. In the *Critique of Judgment* (1790), he argues that aesthetic judgements are not bound to the realm of knowledge and of that which can be known, but instead are based on instinctual and intuitional realms. Thus, to Kant, a true judgement of beauty is disinterested, or in other words not attached to knowledge but completely detached pleasure.[30] The problem with beauty and early-modern art begins here. It is towards the mid-nineteenth century that beauty in painting encounters its first challenges at the hands of Realism, through the gritty portrayal of peasant life by artists such as Jean-François Millet and Gustave Courbet. Subsequently, Post-impressionism and Expressionism further mined beauty's domain in favour of a different engagement with the emotional and instinctual. However, what effectively takes place at the turn of the century is also a rewriting of the very concept of beauty itself. Beauty ceases to be a concept that travels from form to content, and becomes instead a latent element underlying distorted forms and clashing colours. Beauty changes and is changed – it is articulated through a new lexicon, one that stretches it so far and wide as to effectively shatter its traditional essence into a multitude of minute fragments. It is with Picasso's *Demoiselles d'Avignon* (1907) and through the representation of a specific kind of female nakedness, that of the prostitute, that the classical idea of beauty is pulverised. From this point onward, beauty is perceived as a facile access-point to art, old, unchallenging, unsophisticated, emotive and uncritical – an obstacle to late-modern and postmodern thought. Clement Greenberg's famous statement, 'all profoundly original art looks ugly at first'[31] possibly best captures the overall attitude towards aesthetic judgement in the late-modern period.

Furthermore, according to Arthur Danto,

The great consequence of beauty having been removed from the concept of art was that whether to use beauty or not, became an option for artists. But that made it

clear, or ought to have made it clear, that when and how to use beauty were matters governed by certain rules and conventions. That made a prediction that beauty was going to be the defining problem of the 1990s fairly chancy.[32]

It is not therefore much of a surprise to see that the presence of the animal in art also is at this time informed by such theoretical frameworks. The realism of competently executed taxidermy, as we have already seen, preserves the beauty of the original animal and claims a transparency by which the technique erases its own history of production. In respecting the original harmonic compositions of lines and volumes, tones and textures, and (in the best cases) presenting the animal in a naturally plausible pose, taxidermy supplies us with a 'predictable animal'. One that offers a superficial engagement, one that blends with a multitude of already-seen similar animals and that, on the grounds of its aesthetic beauty, pleases the eye but does not challenge the brain. The botched taxidermied animal upsets this harmony through its loud demand for attention, not because of its overwhelming beauty but for the opposite: its abrasive incoherence. It demands attention because of its unexpected *wrongness*, its involuntary comic value, its will to upset order and classification, its reluctance to comply with the conformity of expectations. In a nutshell, botched taxidermy asks the viewer to work harder at undoing original meaning while preventing the opportunity for perceiving the animal body as a romantic and nostalgic safe retreat. Botched taxidermy relies on the *abject*. According to Julia Kristeva, the abject is 'what disturbs identity, system, order. What does not respect borders, positions, rules. The in-between, the ambiguous, the composite.'[33] It is somewhat visceral, and as such it preserves something of what existed in the archaism of pre-objectal relationships.[34]

Artist Angela Singer has developed a solid reputation built on a body of work that reinvents the trophy into an object of pain and shame. Her practice calls into question the unnecessary violence humans subject animals to, as well as the notion that humans are inherently separate from, and superior to, other species. For years, her work has revisited the boundaries of the trophy and the Victorian diorama in order to assault our preconceived perception and understanding of animals. Singer does not allow herself to work with living animals, nor have living creatures been killed or otherwise harmed for her art, as all the animal parts she uses in her work are from donated trophies. Her uneasy relationship with hunting and the everyday contradictions involved with moral and ethical stands related to animal lives and deaths have clearly played a pivotal role in her work as an artist. As a result, her work is difficult but immediate, abrasive but engaging. Her interventions on the taxidermied animal bodies are sometimes subtle, other times brutal, usually unpredictable and often arresting. At times her recycled taxidermy drips blood-like wax, at others the original animal skin has been stripped altogether to reveal the support underneath it.

The artist calls her technique '*de-taxidermy*', as effectively the making of her work first involves the undoing of that done by the taxidermist. In this subversion, she strips the animal

off layer by layer. The process begins with removing fur, feathers and skin, then the stuffing. Sometimes the final stages involve the sculpting of a structure to replace the existing one. In stripping back the concealing work of the taxidermist, Singer is keen to reveal bullet wounds and seams. These are always hidden in realist taxidermy, and their re-emergence functions similarly to a scar on a human body: they are memories of a trauma, a reminder of the violent act which brought the animal body in front of us in the first place. The visibility of these marks, coupled with the addition of other materials, triggers a series of questions: why is this animal dead? What am I asked to see, other than its dead body? A keen animal-rights activist, Singer honours the animal's life by resurfacing the killing. 'Working with the history of each particular animal,' she says 'I aim to recreate something of its death by hunt.'[35] Ultimately, for Singer, the main purpose is to 'make the viewer consider the morality of our willingness to use animals for our own purposes'.

Sore (2002–3), is surely one of her most intense works. In this piece, the viewer is required to look at the piece very carefully, as the animal-form almost disappears in the blood bath which has replaced its skin. It is a painful object to look at, one that universally stands in for all other animal killings. The piece came out of a conversation the artist had with the hunter who shot the animal. 'He explained that after he shot and skinned the stag, the antlers were sawn off. Antlers contain a blood reservoir, when cut blood spurts forth drenching hunter

11. Angela Singer, *Sore 1* (2002-3).

and stag.[36] The iconoclastic drive that defaces the taxidermied animal in botched taxidermy effectively destroys an object of desire and unequivocally replaces it with a disturbing one.

As previously mentioned, the trophy and its subversion in art is a very complex cultural phenomenon bringing together hunter, prey, artist and audiences in a layered relationship of power and subjugation, subversion and liberation. Initially, during the second half of the nineteenth century the trophy was a rather private phenomenon exhibited in homes, for family and friends to enjoy. It was at Crystal Palace in 1851 that Rowland Ward (the owner of a legendary taxidermy shop in Piccadilly called The Jungle) set up a large display of trophies for the wide audience to enjoy, largely contributing to its success as a must-have item among specific social elites.[37] Taxidermy became detached from the event of hunt and death, its products circulating as exotic commodities. Not all animals, as we said, are suitable trophies. Some, like mice, hens, frogs and pigeons will never be. Historically, the imposing and grandiose presence of the animal played a large role in its suitability for such purpose (an **overriding** preference for male trophy individuals is also a custom).

The animal trophy must embody the essence of the wild and the 'difficult nature' in which the confrontation with the hunter took place, thus reassessing the strength and courage of the hunter himself. Ultimately, and this is shown by the multitude of black and white images from the 1800s, (still a genre existing today), the shot immortalising the hunter and the prey (before it is taxidermied) symbolically merges both in the paradox that the hunter venerates the animal while partaking in its physical destruction. The physical appropriation of the animal bodies in these images is much more than a validation of the originality of the killing, as the hunter, upon killing the animal, intrinsically and implicitly claims for himself the symbolic qualities attributed to the wild animal. In consideration of this complexity, it becomes perhaps easier to understand why not all animals function well as taxidermied trophies.

Through the late 1990s artist Jordan Baseman taught himself taxidermy to produce a number of striking pieces that often deployed the skins of domestic animals discovered as roadkill around his studio in East London. In 1997 he created *The Cat And The Dog*, a work involving taxidermy that became particularly controversial. Technically the piece retains the essential traits of the trophy. Two mammals have been skinned, their skins stretched flat and pinned to the wall, while their heads retain a three-dimensional solidity. Mostly, it is the heads, being of a cat and a dog, that challenge the legitimacy of these trophies as such. There is something intrinsically wrong about these trophies, although technically there is nothing wrong. It's just that the two animals in question are not bears or tigers, they are neither wild nor fierce or aggressive. These are 'empty trophies', as the artist remarked, empty in the sense that they do not bear the emotional bond with the hunter previously discussed, but also empty in that pets are often used as a status symbol of apparent wealth. Here too, a bond of ownership is established, however it is here expressed through the wrong syntax, and because of that, it becomes disturbing, as it troubles the set of significations involved.

In *Be Your Dog* (1997) Baseman created a tiara-like object using the top part of the scalp of a dog. The finished piece hangs uncased on the wall of the gallery space. This again could be considered as an object of desire gone wrong. The object's design reminds the viewer of an accessory that might complete an animal party-dress, perhaps a female one, and suggests that the pet dog is an identity-defining object meant to communicate something about the owner, just as a brand of car or the Louis Vuitton purse might. As such, the dog is but one step removed from the more literal *accessory* suggested by the dog-tiara. Sexy, macabre, grotesque and comical, this object carries an appeal, as exhibiting it outside a case titillates our curiosity to try it on. *Be Your Dog* echoes both, the tradition of using certain animal body parts in fashion (the fox being the most evident example) and the Surrealist inventiveness that brought us such uncanny works as *Object* (1936) by Meret Oppenheim, where a teacup and saucer were covered in the fur of a Chinese gazelle. As a result of this transformation, an object originally associated with feminine decorum was transformed into an ambiguous one, in which structural and textural surfaces combined to create an erotically allusive piece of tableware.

Difficult Pets

Though we have used animal furs as clothing since prehistoric times, it is with the introduction of textiles and the development of many vegetable and synthetic fibres that animal fur and skin acquire a more peculiar role in our cultural understanding of fashion materials. It is when it becomes an option to wear other, non-animal, materials that choosing it becomes ridden with entanglements of cultural references, such as the fetish in motorcycling and bondage. The controversial Dutch performance artist TINKEBELL has become famous for challenging people's hypocrisy on a range of subjects, ranging from sexual behaviour to animal use and consumption through the creation of highly unsettling works and shocking performances. One of her recent pieces, *Popple* (2008) is a reversible taxidermied dog that can be turned inside-out into a cat. The artist created the piece to highlight the consumptive attitude that modern culture has taken in relation to pets. In this work, the taxidermied object symbolises the utter commodification of the animal. Inspired by a teddy bear with a reversible bag marketed in the 1980s, the work alludes to recent pet engineering. 'Mankind has been trying to dominate the animal kingdom for millennia and this ongoing endeavor will eventually result in the perfect pet. A pet that can be adjusted to the wishes and desires of its owner. A pet that will be the perfect accessory in daily (social) life.'[38] The object, one that many have found too disturbing, combines the tradition of the reversible fashion item with the playful convenience typical of the old fashioned doubleface stuffed animal toy which allowed children to play with two toys in one. The reversibility of cat into dog also ironically comments on the exclusivity of one or other animal in one given household as a

cultural cliché. Here *Popple* makes it possible effectively to 'own both'. In 2004, TINKEBELL made a purse out of her dearest cat Pinkeltje (*My Dearest Cat Pinkeltje*). Pinkeltje was a 'depressed cat' who couldn't be left at home alone, the artist claims. By killing her and making her into a purse, TINKEBELL could carry her always with her.[39] Predictably, this object generated very heated responses (all documented in her book *Dearest TINKEBELL*) and was entirely designed to bring to the surface the inherent hypocrisy embedded in our relationship to animal skins as used in the fashion industry. The commodification of animal skin in the production of fashion accessories is something that popular culture still seems to find acceptable. Culturally, some animal skins have been intrinsically associated with the making of specific objects, and even if the effective bond between the material and the object is arbitrary, rather than necessary, we tend to subscribe to the logic of such expectations. When these expectations are betrayed by the subversive use of materials we find ourselves in a situation that reveals the constrictions through which we think of animals in our daily lives. Although in recent years campaigning against the use of animal skins and furs in the fashion industry has effectively invited a radical re-think on this use of animals, the demand for these materials in the making of bags, coats, wallets and shoes is still strong. The heated reaction *Pinkeltje* received is an integral part of the project itself. The artist created the piece to obtain a reaction that in turn, through the nature of the comments it triggered, questioned our ethical and moral stand on the subject. The bridging of the status gap between pet and the animal for consumption captured in the making of a single uncanny object proves irremediably upsetting. Just take into consideration for instance the Disney animated film *One Hundred and One Dalmatians* (1961),[40] in which Cruella de Vil abducts a litter of puppies to craft herself a fur. It seems clear that the use of Dalmatian puppies is here instrumental to the delivery of a more universal message against exploitation in general. It is the shifting of a pet to 'fur animal' that is here proposed as a certain equaliser. Who in the audience would not find this disturbing? The presentation of puppies as a resource for fur implicitly questions the supposed rationality behind the killing of other animals, but most importantly functions in the film as a catalyst, crowning Cruella de Vil as one of the most vile villains in the history of film.

Likewise, *Pinkeltje* directly addresses our set of values towards animals: why is it acceptable to make a handbag out of a cow but not out of a cat? The obvious answer to this question is that in Western culture, a cat clearly belongs to the category of pet and as such the cat and the dog do not overlap with the edible or wearable; they do, however, strangely overlap with the experimentational in scientific laboratories. It is worth here remembering that a pet is a companion species with a history of shared understanding and communication. Therefore it is its proximity (cultural and physical) that makes this killing and the making of this object highly problematic. As Erica Fudge notes in her book *Pets* (2008), anthropomorphism is a key component of human–pet relations. 'For some pet owners,' she explains, 'a particularly strong kind of anthropomorphism is embraced in which the pet is positioned and referred

to as "fur baby" and the human owners regard themselves as "parents" to that "baby.""[41] As Berger notes, 'The pet completes [its owner] offering responses to aspects of his character which would otherwise remain unconfirmed.'[42] Thus we could argue that the pet exists in its own special category, close to the human – a category of proximity where boundaries are extremely blurred. Pets provide a sense of security in supporting our identities and in providing a tokenistic illusion that our relationship with nature can indeed be harmonious. This causes *My Dearest Cat Pinkeltje* to be so extremely charged.

In 1994, Nina Katchadourian's *Chloe* was booted out of a show at the San Diego Museum of Natural History as deemed offensive and inappropriate for its audience. The work was initially commissioned as part of a project inviting a selection of artists to create site-specific work engaging with the museum's collections. The artist decided to focus on certain sets of contradictions, and decided to explore this subject through pets. 'To me, pets have always presented interesting questions around the natural and the unnatural. I found myself wondering if people ever preserved domestic animals this way. It turned out that people did, and I found a taxidermist in the San Diego area who sometimes stuffed people's pets.'[43] The artist borrowed Chloe, a Papillion lapdog from a local taxidermist, and contacted the former owner in order to recreate the dog's home environment, including a description of her favourite pillow on which she liked to sleep. Katchadurian then proposed to exhibit the animal in the museum in the same way in which other species are, in a vitrine, with signage indicating Latin name, habitat, etc. However, the museum's curators found the display distasteful. The artist argued that the canid in question was not dissimilar from the coyote that was housed in a nearby vitrine. However, the museum decided not to include the piece, fearing it may create confusion in the public and upset children. This instance is of particular relevance from a number of perspectives, as it not only reminds us that our relational bonds with animals are particularly complex and that it may be fine to taxidermy one animal but not another, but moreover reminds us that the issues related to the modality of display are key to our responses. It is indeed true that in recent years the business of taxidermying cats and dogs for mourning owners has blossomed into some form of art, especially in the United States. It is also true, however, that these pet-objects, at times fitted with a vibrating motor (cats) and a pump to simulate restful breathing (dogs) are designed for private enjoyment only, where they function as transitional objects. Exhibiting them in a public space would raise a substantially different set of preoccupations in audiences culturally unfamiliar with such an approach.

Following on from the discussion on representation and the complexities nature poses within this context, this chapter has further explored the idea of mediatedness through a focus on the constructed essence of taxidermy and the diorama, something that all of us, at least as children, have spent some time gazing at in wonder. Whether perfectly realistic or botched, reclaimed or newly crafted, the taxidermied animal body has become an uncomfortably questioning entity, one that directly appears to embody the incongruities and contradictions that have shaped, and continue to shape, our difficult relationship with nature. Through a

discussion of the cabinet of curiosities, the specimen, the souvenir and the trophy we have been able to appreciate the value of the innate need we have to construct fixitude and certitude in the natural world, despite this being against its ever-evolving essential agency. This very need for stability pervades our everyday approaches to animals, and has been challenged by artists working with taxidermy through different approaches such as the surrealist and the botched. Evidence that sensitivities towards the gratuitous use of animal skins have been shifting over the past few decades was offered in an unwittingly comic interview given by Alaska's former Governor Sarah Palin, in which she is seen comfortably reclining over a bearskin serving as a questionable sofa-throw. The work of artists challenging taste and culturally established norms through the taxidermying of pets contributes to a further questioning of the boundaries between animal and animal, and human and animal, a focus that will be further discussed in the following instalment.

Chapter 3
Levels of Proximity

Well of course, we are meat, we are potential carcasses. If I go into a butcher's shop I always think it's surprising that I wasn't there instead of the animal.

(Francis Bacon)[1]

At 89 Seventh Avenue South in Greenwich Village, New York a new pet store is the talk of the town. It is October 2008 and we are standing outside what is suspiciously called *The Village Pet Store and Charcoal Grill*. Shoppers arriving in the hope of finding a new animal-friend may be left disappointed, for this is no conventional pet store. It is in fact the first US installation by graffiti artist Banksy, who has developed an international reputation based on a marketing combination of dense mystery and skilled street-art-making. Banksy's first stencilled graffiti appeared on the streets of London in the early 1990s, and ever since his reputation as an unconventional, norm-challenging artist has firmly placed him among the few epoch-defining artistic personalities currently alive.

From the outside, *The Village Pet Store* looks like a conventional shop, meticulously resembling the predictably familiar appearance of the pet store: animals, cages, tanks, fish bowls, pet food, etc. However, the shop intentionally betrays its bid for normality in its name. 'Pet Store' and 'Charcoal Grill'? Why would the two be combined in one premises? The association between bookshops and cafes is an established one, but a pet store and a restaurant? What an uninviting proposition. It does not take much imagination to envision the serious hygiene issues that would arise from such a combination. However, this is just for starters, and upon entering the shop things become more and more disconcerting. Inside, in a surrealist twist, it is not tropical fish or goldfish we find in the tanks but swimming fish fingers. These are animatronics that in an extremely realistic

fashion aim to reconnect food with the animals it comes from – the result is unsettling but simultaneously intriguing.

Turning to the reptile section in the hope of finding a lizard or a snake, we are instead further unsettled by the sight of hot dogs wiggling about the terrarium. In another enclosure, chicken nuggets have feet, and like 'processed (but alive) chicks' lower their heads into ketchup dips while being surveyed by a reassuringly normal-looking mother hen. Is this the secret wish of McDonald's come true? In this shop, the more you look, the more you see. The rest of the pet store is entirely populated by pet-food creatures: salami and American-style bolognese sausage symbolise the super-processed low-quality foods produced by rampant consumerism. Here and there, we seem to spot some more normal-looking animals too, but it is only a matter of surface, as these astonishingly convincing animatronics also act in unusual ways. A grey monkey in its cage sits in front of the TV (watching other monkeys having sex!), wearing headphones and holding a remote control. The more you look around, the more it appears clear that nature is the absent referent in this context, and that all we see is super-processed food and psychotic pets engaging in human activities.

12. Banksy, *The Village Pet Store and Charcoal Grill* (2008).

Aside from functioning as a highly entertaining immersive experience, the pet store raises a manifold of questions as it relentlessly critiques our approach to nature, animal treatment, consumerism and food consumption in our time through the conflation of the pet, food and technology. The fact that all 'food-pets' featured here belong to the category of highly processed is not a coincidence. For as far as this installation can be experienced as an oddity, some sort of cabinet of curiosities, Banksy is here making a rather sharp commentary on the everyday distancing between ourselves and animals, highlighting the paradox involved in the relationships we establish with pets and reminding us that the food we buy was once alive. This process of active forgetting is highly encouraged by supermarkets through the removal of animal imagery altogether wherever possible, generating the impression that meat grows directly in

the polystyrene containers in which it appears on the shelves. This distancing from the real animal facilitates our consumption by constructing meat as separate from the animal from which it originates, aiding the disentangling of moral sets and ethical considerations that may otherwise interfere with our customs.

In *The Village Pet Store and Charcoal Grill*, these processed food-pets reclaim, to a certain degree, their animality through the (simulated) reacquisition of animal behavioural traits. This reacquired animality is, however, that of the pet, developed – as previously discussed – in proximity to the human and built on shared communicative systems and rituals, not that of wild animality. The implication is, of course, that pets have been 'processed' through consumerism to suit our taste and that they have become items for consumption, products of our society, for our society. As a result, the closeness we share with them may seem comforting, and can certainly be fulfilling, but further investigation unveils complex entanglements. In her book *When Species Meet* (2008), Donna Haraway instances a good case in point, of what she calls the 'global-companion animal industry', highlighting the challenges presented by the pet-food business and the contingent realities associated with it.[2] How disturbingly similar are the pet store and the supermarket in this respect? And most importantly, how relevant is it that our relationships with food and the pet both commonly begin in a shop, under the spell of consumerist desires? It is perhaps no coincidence that these ideas are brought to the surface by the most irreverent pop artist on the contemporary scene.

Though humour plays a big role in *The Village Pet Store*, the medicine indeed stays bitter. People are enthralled by the show, many take pictures, many more take videos with their phones; kids smile in wonder, but deep down the shop is pervaded by an underlying sense of horror. One piece in particular demonstrates Banksy's awareness of the intricate argument he portrays. In a room, a leopard calmly rests alone on a dead tree stump. The animal has its back turned to us and dangles its tail in an unequivocal naturalness that reminds us of the twitching of a dozy animal. The door is unlocked, allowing us to enter and to get extremely close. There is a glimmer of hope, mixed with a hint of terror, that this wild animal, at least, may be a real one. But as we walk around it, to see its face, we find that this is a hollow skin lined on the inside with red fabric to suggest flesh and blood. The head is completely absent.

The Politics of Meat

Our distancing from nature, our commodified relationship with pets and our approach to food production and consumption (along with a subtle critique of the functioning of the art world) are all painfully captured in *The Village Pet Store and Charcoal Grill*. Ultimately, the pet store embodies the paradoxical scenario of animal commodification as defined by the clashing of narcissistic fictions of pet lovers who are also meat eaters – a set of apparent contradictions which consumerism foments.

The ideas of animal-processing, mechanisation and movement as key elements of this installation are also suggestive of the historical turning point that saw our relationship with animals change dramatically. It was in 1913 that Henry Ford set in motion the first example of car assembly-line production in Dearborn, Michigan.[3] This model was largely based on the functioning of the vertical abattoirs that since the 1850s had been in operation in Chicago and Cincinnati disassembling animal bodies for the fast-growing meat industry.[4] Antonio Gramsci extensively discussed industrialisation in a passage from his prison notebooks titled 'Animality and Industrialism': 'The figure of the animal as a mimetic automaton capable of copying the same simple physical task over and over again' like the automatic animals in Banksy's installation, is accepted critique of an American industrialism that 'strips its labor of skill and intellectual agency reducing it to the brute repetition of mechanical motions'.[5] The mechanisation of disassembling animals in the 1850s is not, however, a simple matter of speed and practical evolution in meat-production methods but also functions, as argued by Nicole Shukin in her book *Animal Capital* (2009), as a glimpse of the cinematic revolution to come. It may sound rather disconcerting to us today, but guided tours of Chicago's meat-packing houses were a regular occurrence in the mid-nineteenth century, and later apparently became as popular as rides in the newly invented Ferris wheel. According to Shukin, the growing interest in the viewing of the disassembly of animals through the mechanised speed of conveyor belts generated a singular overlapping of the meat industry with the entertainment one.[6] The reduction of animals to meat, as spectacularised by the development of the business of **slaughterhouse** touring, created a new visual realm, one based on the mass killing of animals, designed for the visual as well factual consumption by the masses.[7]

Through slaughterhouse tours and the work of spectacle, as audiences stood on galleries watching the fast-moving show of animal dismembering, the *otherness* of the animal dramatically acquired newly objectified values. This was a landmark moment in the consolidation of animal subjugation, at which an all-consuming human gaze became functional to the extracting of further commodity value from animal bodies. It is within this context that Damien Hirst's sliced bodies of cows and pigs preserved in formaldehyde can be most productively read. *Mother and Child Divided* (1993), for instance, comprises a two-part display of a cow and calf, both divided in two symmetrical halves cut length-wise and placed in four glass cases. The cases containing each half are placed to allow just enough space for a person to walk in between, so as visually to pass through the animal. Of course the encounter with severed cows in the gallery space is bound to provoke strong emotional responses; however, it is the friction between the attraction and revulsion generated by the display that makes the work worthy of attention. Here the temptation to walk between the two halves is undeniable, so much so that gallery visitors often spontaneously form an orderly queue at one end of the piece in order to experience the spectacle of the open animal carcass. From that perspective, from the inside, the animal presents its complex network of organs, one that simultaneously seems here to function as a piece of abstract beauty

while reminding us of the undeniable biological similarities we share with animals. In the formaldehyde vitrine, the animal itself becomes a kind of diorama, displaying an unfamiliar hidden world that has been brought into the museum and put on display for visitors to see. Instead of the high plains of Africa, this far-off environment is imported from the killing factory of the meat-processing plant, and its geography needs not be recreated through models and diorama paintings, but through mere stripping away of the concealing layers of skin and bone that hide the landscape inside. At once, like at the slaughterhouse tours, we are caught in an overpowering spectacle triggered by the anatomical overlapping between animal and human that meat so clearly suggests through its material presence. However, there is more to the work, as *Mother and Child Divided* reminds us of the closeness between us and animals while performatively alluding to the brutal separations of 'mother and child' that are at the core of the meat industry's day-to-day operations. This work is indeed a questioning entity. What is this urgency of seeing we experience in front of it? What do we expect to see? And what do we effectively happen to see instead?

The extensive symbolic values meat can acquire when employed as a medium in contemporary art practice are multifold and fluctuate according to a number of variables. For instance, in the seminal work by Carol J. Adams, *The Sexual Politics of Meat* (1990), we find that meat, from a feminist perspective, is understood as a 'symbol for what is not seen but is always there – patriarchal control of animals', as from this perspective Adams examines the gender, race and class implications of the history of meat-eating culture.[8] In her work from the late 1980s, feminist artist Helen Chadwick operated a figurative reversal of what came to be the main body of artistic patriarchal conventions in photography and painting. Her *Meat Abstracts* (1989) subverted the normative convention that through these media we explore 'from the outside' at the surface, and reversed this notion by creating abstract black and white images with meat parts – the inside.

Meat, on the inside, is where the animal and the human merge indiscernibly, seamless in colour and texture, formally overlap, indissolubly. In 2002, Chinese artist Zhang Huan took part in the Whitney Biennale with a contribution (*My New York*) that involved wearing a suit made of fresh cuts of meat stitched together. Wearing the item, the artist walked down Fifth Avenue, releasing white doves from a cage: a Buddhist gesture of compassion. To the artist, working with meat symbolises skinning his own body so that the flesh visible on the outside symbolically overlaps with his own. The work was his first after the 9/11 attacks, and represented a message of support to the citizens of New York, to whom he 'opened himself bare'.

In 2004, Marc Quinn created 14 bronze casts of carcasses of various 'animals for consumption' for his exhibition *Flesh*. Through a highly skillful use of bronze, and directly channelling the symbolic layers of meaning that the use of such material conjures, Quinn played with the conventions of classical sculpture and elevated the animal carcasses to the historically heroic and the monumental. The animal body and the human one collided through the tradition of classical portraiture in sculpture. As the artist explains, 'Somehow

all life is the same. All life has the same origin. It has to because there is nowhere else for it to come from. Human beings are very grand and think they're above everything but in fact we're connected to everything else.'[9]

It is by removing the skin, along with it its prescribed values, that roles are allowed to flux and merge. In 1989, Janis Kounellis presented to the public *Untitled-1989*, in which rows of carcasses hang in front of iron panels while being illuminated by the subdued flames of oil lamps. Loyal to his association with Arte Povera, a movement that questioned art as the private expression of the individual through the use of unconventional materials, Kounellis aimed at providing a more *immediately real* experience, which in turn proposed a fresher and less mediated connection to nature. The carcasses, relocated in the gallery space, traverse the history of the visual culture in which such fragmented bodies have been previously exposed: from Leonardo's anatomical drawings, to the grotesque paintings of Gericault, Goya, Picasso and Francis Bacon's distortions, passing through nineteenth-century mechanised slaughter.

13. Zhang Huan, *My New York* (2002).

Becoming Animal

During the second half of the 1940s, Francis Bacon found himself involved in a long-lasting fascination with the portrait of *Pope Innocent X*, a 1650 painting by Velasquez. Over a decade of incessant work resulted in an exploration of previously uncharted territories within the genre of portraiture. For Bacon, this manifested itself in the defining of a highly original and personal approach that equally shocked and charmed. At the core of this newly defined aesthetic lay an abrasive level of distortion and the use of vertical and diagonal brushstrokes arranged to define the rigid structure of a cage surrounding the seated screaming figure of the Pope.

As well as exploring the use of cages as constrictive structures through portraiture, Bacon simultaneously questioned the meaning of the anguished screaming mouth, originally inspired by a still from the film *Battleship Potemkin* (1925). In Bataille's vision the open

mouth is 'bestial', as it stands in diametrical opposition to the magisterial look of the face with a closed mouth.[10] It is indeed the tension between these two elements, the screaming mouth and the cage, that contribute to the remarkable innovative quality of the work. These elements are interlinked and indissoluble: the former a result of the presence of the latter; both sharply outlined, however materially impalpable.

The bars making Bacon's pope captive are alluded to, not physical, and as such these are painted with a relatively dry brush, which allows for what stands behind them in the pictorial plane to transpire. However, this does not diminish their weight, for the sense of claustrophobia they induce in the viewer stays strong. The bars allude to universal existentialist entrapments contingent on the phenomenology of the human condition, as well as to the limitations imposed by the public persona to which one subscribes, or to which one is relegated by society. It is worth remembering here that according to Bacon's Nietzschean atheism, the body itself is a cage.

The scream, haunting in its spectral pictorial silence, also acquires here a primordial and universal aura, especially if we take into consideration Bacon's view that we all come to life with a scream. In a variant of the theme from 1954, *Head Surrounded by Sides of Beef*, Bacon introduced hunks of raw meat to both sides of the Pope's head. Focusing on a close analysis of this subject in *The Body, the Meat, the Spirit: Becoming animal*, Deleuze and Guattari note that 'The scream, which issues from the Pope's mouth, [...] has meat as its object'[11] and continues, 'meat is not dead flesh, it retains all the sufferings and assumes all the colours of living flesh. It manifests such convulsive pain and vulnerability [...]. Meat is the common zone of man and beast, their zone of indiscernibility.'[12] These extreme levels of proximity leading to areas of indiscernibility are at the core of 'becoming animal', seemingly one of the most deceptive and subversive concepts defined through the philosophical plateaus of Deleuze and Guattari. Becoming animal is a movement from *major* to *minor*, a deterritorialisation in which a subject no longer occupies a realm of stability and identity but is instead folded imperceptibly into a movement; most importantly, becoming animal, according to these philosophers, is not imitation but a matter of intensities.[13]

As previously mentioned, the open mouth is to Bataille *beastly*, that is to say a place where the liberation of *inhuman* impulses takes place, where a closeness with the animal can more easily appear, where non-human intensities can be experienced. *Infinity Kisses* (1981–88), a photographic work by artist Carolee Schneemann presents a challenging scenario involving the kissing of her own cat. The images that compose the work are self-shot by the artist, and capture a daily morning ritual in which the cat would climb into bed with the artist and engage in deep-mouth kissing, his paw embracing her head, for up to 15 minutes.[14]

The work presents us with a singular combination of abjection and attraction, as some may view the photographs as extremely tender while others may find them utterly repulsive. Schneemann's inter-species relation dangerously leans towards the uneasy questioning of

'appropriate eroticism', zoophilia and hierarchical fracture between animal and human. However, looking at the series, a sense of intimacy that evades the sexual becomes apparent. In this case, it is the intensity of inter-species kissing, the leap involved in such exchange that generates a becoming of some description – a neutral place between animal and human that is neither man-made nor animal-made but a third entity altogether: a place where power relationships are temporarily suspended and human and animal are equalised. What is shared in this intimate consensual contact? What kind of reciprocity is defined, and on what grounds is this built? As a becoming, this encounter suggests new and challenging trajectories. In front of this work, the words of Deleuze and Guattari – 'We believe in the existence of very special becomings – animal traversing human beings and sweeping them away, affecting the animal no less than the human' – resound most vividly.[15]

The subject of becoming animal in art has been most notably addressed by Oleg Kulik, one of the most interesting and controversial Russian artists, who in his extensive body of work has assumed the role of *'artist-animal'*, or, more specifically, *'artist-dog'*. Through his thought-provoking practice, the artist asks questions about the essence of the human in a human, and what a reverting to the state of animal might mean. He too, like Schneemann, has explored the subject of animal proximity in a number of very extreme propositions that have regularly caused uproar in the Russian media.

Oleg Kulik: Becoming Dog

In 1994, Kulik staged *Meet My Boyfriend Charles*, a performance in fluxus style in which he kissed a goat, sitting naked on a single bed. This provocative work paved the way for further experimentations which eventually developed into the highly controversial *White Man, Black Dog* (1998). This performance saw Kulik, once again naked, in a completely dark gallery space complete with live audience, as he aimed at establishing a close bond with a dog. 'Do not imitate a dog,' said Deleuze and Guattari, 'but make your organism enter into composition with something else in such a way that the particles emitted from the aggregate thus composed will be canine as a function of the relation of movement and rest, or of molecular proximity, into which they enter.'[16] Split intermittently by camera flashes of two photographers documenting the action, the performance revealed a surprising effect amidst the darkness: temporal luminous imprints appeared on the retina of the spectators' eyes. Such ephemeral visions, in the opinion of the artist, were the only true, *absolutely real* art.

Becoming, 'the purest of the events', is an elusive participatory movement that may stake out a flight from the contingencies and restrictions of our human condition, in other words, a kind of 'un-humaning' of the human in favour of embracing new and unknown trajectories. As Kulik explains, the extremely dark conditions inside the gallery were key to the success of his performance. A huge packed crowd was made to sit in a large circle, and Kulik and the dog

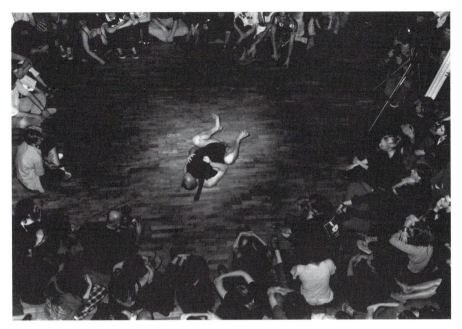

14. Oleg Kulik, *White Man, Black Dog* (1998).

performed in the middle of it. As the artist recalls, the weight of the audience was palpable in the darkness. Kulik believes that the dog too could sense it as 'he just wouldn't behave as we have arranged to behave with him. He felt that tremendous mass of people around us. I was even afraid that his behaviour would be inadequate, that he would bite and yelp'.[17] The darkness in which the performance was immersed made people helpless, as social structures momentarily dwindled and perception became heightened and distorted. In this state of unifying communal uncertainty, the temporal imprints left on retinas by camera flashes functioned as shared projections of the becoming induced by the close proximity between Kulik and the dog. The body of the dog and that of the artist, fleetingly portrayed in the same 'luminous imprint medium', molecularly merged together into one in the eye of the viewers.

The dog is a recurring participant in Kulik's work. According to curator Victor Misiano,

It is of principal importance that a dog emerged in his life as a teenage trauma: his parents made him sell the puppy he bought himself with the money he saved on breakfasts. So for Kulik, since his childhood, a dog signals the loss of linkage with the primordial nature, it signals the loss of the *Other* and the trauma of sociality.[18]

In April 1997, Kulik brought the performance *I Bite America and America Bites Me* to New York's Deitch Projects Space. Arriving from Moscow, not as a man but as a dog, Kulik spent

his two-week visit living in a heavily secured doghouse, purposely built within the gallery space. Visitors were invited to put on protective suits to enter the structure and interact with the artist. As in Kulik's previous performances in Europe, viewers were stunned by the degree of transformation he underwent to become dog.[19] The title of Kulik's performance stands as a parody, located somewhere between the clear reprise and the playful revision of Joseph Beuys's original work from 1974, *I Like America and America Likes Me*, which, as we have seen, saw the artist spending a week in the company of a coyote. Roberta Smith, reviewing the show for the *New York Times*, recalls that

> Pit bull is the breed brought to mind by the sound of Mr Kulik's ferocious growls and barks bouncing off the walls of his cage-like room; likewise, by the sight of his square, close-cropped head and muscular body as he roams about on all fours, craning at barred windows, growling at onlookers, pausing at water and food bowls and finally curling up on his pallet, all the while wearing nothing but a thick studded collar.[20]

As in Beuys's performance, where the artist was driven from the airport to the gallery in an ambulance, never touching American soil, Kulik, jumped straight in a van waiting at the airport, where he stripped off his clothes, put on a dog-coat, collar, leash and muzzle and began communicating only in a dog-like language. Once in the gallery space, Kulik's performance operated rather differently from Beuys's, this time mainly because of the exclusion of the real, live animal within the staging and because the performance involved the direct interaction of the viewers, who, one at a time, were allowed to enter the dog's house. Inside, Kulik became a dog; as the viewers, exposed to the dog-behaviour enacted by a human, were deterritorialised by the clash of significations, so that the layers of anthropocentrism that consistently define our relationships with dogs began to crumble.

The conflation of human and dog through the performance, a becoming of which Deleuze likely would have not approved, as based on behavioural mimicry, effectively posed questions regarding our emotional engagement with canines, an investment which at times seems to overshadow that reserved for other human beings. This certainly is problematic, as, especially in the case of Kulik, the performance subtly shifted between the comedic and the pathetic, the ferociously scary and the utterly vulnerable. Here 'dog-Kulik' could be symbolically read as a stand-in for Russia, its unpredictability, its now-tame, now-aggressive political presence, and its closeness and distance with the West. The title of the piece anchors our interpretation of the work within different parameters from those purely involved in the becoming animal. This piece is built over different channels individually functioning at different levels of intensity; the becoming animal happens to be one of them. Each channel, as in a multi-track layered sound-piece adds elements to the overall signification of the work. For instance, one channel of *I Bite America and America Bites Me* features echoes of Diogenes's Dog, a classical archetype of becoming animal. But a number

of other channels of Kulik's piece bear more contemporary socio-political, non-animal related rhythms.

In Winter 2008, to the question 'What does it mean to live a dog's life?' the artist responded,

> I submitted all the power of imagination, consciousness, my understanding of social topicality, my notions of the integrity of form and content, of everything that is usually ascribed to a decent artist, to one goal: to be a dog in my performance. And it worked. And it wasn't that easy. Try it when you have time to spare. I don't think I communicated really much. People entering my cage faced very simple questions, like whether I would bite or would not bite them, whether I'm clever or an idiot. But the main thing was that they interpreted me as some biological creature, which does not belong to any definite species and has no status at all. They examined this unprecedented becoming animal and even looked if it matched them.[21]

Kulik's becoming dog demands a leap of imagination capable of reaching beyond the comfortable, the rational and the known, while simultaneously excluding at once the possibility for the irrational, suggesting instead the effective plausibility of different systems of rationality. One may, however, ask, where does this lead? There is a reason why Deleuze

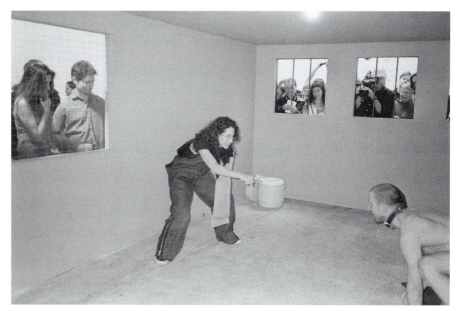

15. Oleg Kulik, *I Bite America and America Bites Me* (1997).

and Guattari claim that mimicking animal behaviour may not lead to real becoming, and this may lie in the fact that the mimicry in question would only be a stereotyped rendition of the animal as seen by humans. From this standpoint, the anthropocentric origin of the event would prevent it from achieving its full potential.

One could ask if becoming animal has in fact anything to do with understanding or experiencing non-humans in different ways; or if becoming animal, as enacted through the visual arts, is somewhat trapped in a Cartesian conception of the animal as lacking consciousness, justifying the assumption that an abandoning of our own human consciousness automatically translates into becoming animal. It indeed seems a recurring element in many stagings of a performative becoming animal that such human prerogatives as language are abandoned (in their human form), in order to be replaced by a pidgin language of some description – a language somewhere in between animal and human, but only symbolically so. Is becoming animal in contemporary art a matter that predominantly revolves around quantitative notions, through which the animal is still the one with less? Could we perhaps go as far as arguing that within the parameters of becoming animal, the animal is 'meat that feels' and the human is 'meat that thinks'?

Marcus Coates: The Shaman

On the pages of Deleuze's *Kafka: Toward a minor literature* and *A Thousand Plateaus*, becoming animal unfolds into a fascinating array of possibilities, each defining trait of the event revealing the inherent and powerful potentials involved in this transitional process. However, how well does the written text translate into visual-art practice? 'What does becoming animal look like?' asked Steve Baker in his challenging essay from 2002.[22] The question was pivotal at the time it was posed, and it can be argued that it is still of relevance today, as many artists have since engaged in the quest for an experimental state of identity-suspension involving the animal. Each artist, following personal and different routes leading to different animal becomings, has in the process expanded, reconsidered and contradicted the concept originally defined by Deleuze and Guattari.

Over numerous performances and video works, artist Marcus Coates has deconstructed and reinterpreted the philosophical work of Deleuze and Guattari from multiple perspectives, at times literally translating key concepts into challenging visual and participatory syntaxes, at others identifying new and original plateaus.

In *Journey to the Lower World* (2004) Coates directly borrowed the shamanic persona crafted by Beuys in *I Like America and America Likes Me* and conflated the human and the animal in an analogous way to that performed by Oleg Kulik in *I Bite America and America Bites Me*. Coates was inducted to the ancient techniques of shamanism on a weekend crash-course in London's Notting Hill (something the artist treats as a comical element of his

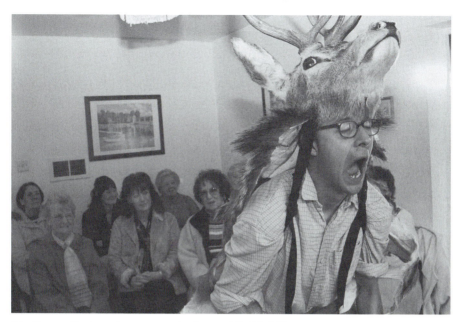

16. Marcus Coates, *Journey to the Lower World* (2004).

practice). The workshop trained participants to access a non-ordinary psychic dimension with the aid of chanting, ethnic drumming and dream-catchers.

Coates's shamanic performance involves the entering of a trance through which the spirits of animals he encounters and consults in his journey provide the answer to an original question posed on the spot by the audience. Unlike the previous performance pieces discussed in this chapter, *Journey to the Lower World* is a video work, and it captures a ritual held in a Liverpool tower block scheduled for demolition. In Kulik's performances, the space in which the action takes place is representative of metaphorical human entrapments. The tower block is featured in a long shot at the beginning and end of the film. With its bulky and blunt silhouette towering over the rest of the grey surrounding cityscape, we cannot help but read the building as a prison of a sort, a bastion of isolation from nature but also paradoxically from the rest of the urban context.

The ritual takes place in the living-room of one of the apartments in the block, where a small crowd of bemused residents have gathered to ask a pivotal question about the demolition of the site and the building of a new urban reality in which the residents will be re-housed. The question originating from the audience is, 'Do we have a protector for this site? What is it?' It isn't long before Coates, jerking about wearing a red deerskin on his head, begins his shamanic journey with a series of grunts, feral whistles and barks, one that will involve numerous encounters with animals. The animals will provide a final answer.

Even if seated and not physically joining in, it is apparent that Coates's audiences are led through a journey unfolding multiple discoveries and revelations about themselves as members of a community with their shared hopes, anxieties and dreams. This becoming is effectively triggered by the continuous shifting of certainty. In this performance the artist abandons human language to adopt a range of mock animal sounds suited to communication with the animal-spirits he encounters on his journey. Through this process, Coates's mouth is frequently seen wide open, an accented reminder of the bestial quality overtaking him through the trance. As the journey unwinds, the artist's body language also dramatically changes: at times he's silent and contemplative, at others he's loud and roaring; at times he looks oddly comical, at others worryingly unhinged. Is he taking us all through a 'journey to a lower world' or for a massive ride? How much about our own hopes and fears is revealed to us? However, and perhaps most disturbingly, Coates's final answer, in its poignancy, leads us seriously to suspect that something may have indeed happened through all the grunting, whistling and barking.

The Animal Voice

The ideas of community and identity have more recently been explored by Marcus Coates in *Dawn Chorus* (2007), an ambitious installation creatively exploiting the specificity of the medium of film and sound technology. In this work, the uplifting **birdsong** pervading the exhibiting space is offset by the absence of real birds, their place taken by 19 screens showing people of different social extraction and ethnic backgrounds. A closer look reveals that although looking ordinary, all individuals nervously fidget like birds as they deliver disconcertingly credible birdsong. Here, Coates addresses one of the archetypal markers of difference that have through Western history been instrumentally adopted to demarcate the clear distinction between the animal and the human realms: language.[23] For this project Coates spent two weeks camping with wildlife sound recordist Geoff Sample, living in a motorhome in Northumberland, getting up at 3a.m. to activate a 24-track digital recorder. As Coates recalls,

We recorded 3 or 4 hours each morning for a total of 60 hours over 2 weeks. Then we had to pick the best morning with the broadest range and level of communication between birds. We took the recording of birdsongs back to the studio and slowed them down about 20 times. Interestingly, a birdsong at normal speed could contain 4 or 5 notes but slowed down it could reveal up to 40 notes offering a different level of complexity to the listener. We then asked singers to sing along with it whilst we were filming and then sped up the film 20 times.[24]

The artist not only demonstrated the ability to devise rather ingenious representational strategies, but he also coupled his intellectual dexterity with a sophisticated and high-tech exploitation of the specificities offered by the kinetic plasticity of the sound constituency of film, for indeed it could be argued that each subject, captured in each screen, is in the words of Donna Haraway, 'a hybrid of machine and organism, a creature of social reality as well as a creature of fiction'.[25] Most of the individuals included in *Dawn Chorus* were amateur singers from Bristol, hand-picked at choir rehearsals. Piers Partridge, a musician who was filmed in his garden shed impersonated a blackbird, said of the experience,

> I found myself going deeper and deeper into the quality of the sound. The Blackbird had one or two favourite riffs, so I'd think, 'Ok, here it goes.' I imagined myself as a Blackbird on a spring morning, very early in a high place, having the freedom not to think but just to let the sound come out. With that came some interesting movements: I was cocking my head to look around. I felt really spaced out. When it finished I was miles away.[26]

As in Kulik's becoming dog, and *Journey to the Lower World*'s shamanic ritual, here the becoming animal is induced through behavioural mimicry, and mainly via the renouncing of human language in favour of a mock animal-sounding language. This could be taken as a critical point embedded in becoming animal in art, as the renouncing of human language may be simultaneously understood as the obliteration of human thinking, under the overall assumption that animals do not think. However, here too there are more tracks to the work. The main one surely owes its structural and elemental essence to Deleuze and Guattari's discussion of the '*minor literature*', as featured in their volume on Kafka's writings. According to the philosophers, a minor literature is an alternative language that relies on the deterritorialisation of language by intensifying features already inherent to it. The three characteristics of a minor literature are the deterritorialisation of language, the connection of the individual to a political immediacy, and the collective assemblage of enunciation.[27]

In *Dawn Chorus*, the literature produced is encoded in the form of animal language. Birds present very complex vocal communication patterns, which bear comparison to our own, even having varying geographical dialects within the same species. In order to allow his singers to reproduce a '*bird language*' convincingly, Coates deterritorialises the animal language by slowing its rhythms down, so that it can travel from a bird's beak to a human's mouth. As it is slowed down, the bird's language is phonetically transposed into the territory of human language. The speeding up of the film problematises this instance further by also deterritorialising the body language of the bird into the body of the human, and the becoming triggered by Coates here is largely generated by the conflation of the animal and human voice as well as the animal and human body languages.

Part of the appeal of *Dawn Chorus* lies in its melancholic atmosphere, generated by the fact that each subject is caught in isolation performing their song to an anonymous, potentially absent listener. Coates took great care in capturing his subjects within their own habitats – we see a doctor in his surgery, a secretary at her desk, a pensioner at home, and so on. In each screen, the backdrop is always an indoor scenario, a room, in many ways a cage, one that, like in Bacon's paintings, holds us together by capturing us in our human and social persona. 'We filmed each person in their own habitat, in their homes or workplace,' says Coates. 'We wanted them to preserve some humanness.'[28]

A characteristic of minor literatures, Deleuze and Guattari explain, is that the individual is inextricable from the socious, the subject linked to the political: 'its cramped space forces each individual intrigue to connect immediately to politics. The individual concern thus becomes all the more necessary, indispensable, magnified, because a whole other story is vibrating in it.'[29]

Coates's singers are politicised by the realist quality embedded in the backgrounds that contain them, and also by their multi-ethnic origins – a reference to the social reality of contemporary Britain. In the presence of the 19 screens forming the installation, the visual and the phonic take on a collective enunciative value that is encapsulated by the essence of the choir as an assemblage of equally relevant/irrelevant voices. This political nature, then, is inseparable from another characteristic of a minor literature, its collective value. Deleuze and Guattari explain the inextricability of the political and the collective: 'Indeed, precisely because talent isn't abundant in a minor literature, there are no possibilities for an individuated enunciation that would belong to this or that "master" and that could be separated from a collective enunciation.'[30] *Dawn Chorus* is to date one of the most original and experimental instances of becoming animal in contemporary art, as the direct involvement of technology allowed for a much needed departure from the realm of performance, which had become the predominant vehicle for the presenting of the becoming animal in art. The ultimate challenge presented by the work is that the becoming here involves an animal taxonomically very distant from humans. Through this distance, anthropocentric overlaying dissipates, creating a vacuum for other potentialities to manifest themselves.

Dawn Chorus also paradoxically reverses Descartes's reasoning trajectories on the subject of animals and language by metaphorically turning us into parrots and magpies, which, as the philosopher claimed, 'can pronounce words, and nevertheless cannot speak as we do, that is, in showing that they think what they are saying.'[31] From this perspective, the installation deterritorialises us within an unknown area, an area of animal competence, which automatically appears to be an area of human incompetence. The unfulfilled stereotypical connections that we, the viewers, would automatically like to establish between the sex, age, race and social status of the singers and their surroundings also play a key role. The conflation of human and animal (as in Kulik) facilitates a multi-layered dissolution of taxonomical certainties. What is consistently removed from the socio-cultural equation here

is the accent, fluency and overall control of language, challenging our presumptions of what a doctor should sound like and how a secretary might express herself, and obliterating, at least on screen, the boundaries of race, gender and social class.

Evolutional Proximity

Nicolas Primat's work focused heavily on primates (uncannily in French the artist's surname means just that). In a series of video works he explored the gap between animal and man and the possibility for effective inter-species communication. His work occupies a field rather different from Kulik's and Coates's, as his domain was less bound to the performative and more involved with the scientific field of ethology, requiring direct engagement with live animals. The artist effectively tried to unlock primate body language and relying on the close relatedness between humans and primates, used his own body to bridge the communicational abyss that separates us. This is something Primat learnt while working with a group of bonobos in a zoo in Holland. There, behind a glass partition, he enacted a sequence of signifying bonobo-signs that made him accepted by the group.

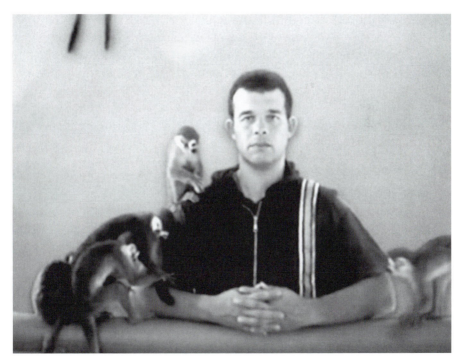

17. Nicolas Primat/Patrick Muck, *Portrait de Famille* (2004).

In 2004, Primat produced *Portrait de Famille* a video work filmed at CNRS (Centre National de la Recherche Scientifique) Marseille. In the video-loop we see the artist, from the waist up, standing in front of a flat blue-screen as spider monkeys freely explore and groom his body as if he were one of the group. The animals featured in the video are lab monkeys bred at the centre for the purpose of medical animal testing. While working with the animals over the course of the residence, Primat was able to establish a close bond with them in order to gain their trust and acceptance.[32] The framing and composition of *Portrait de Famille* suggest a reference to the famous and highly ambiguous painting *Portrait présumé de Gabrielle d'Estrées et de sa soeur la duchesse de Villars* (1594), in which two sisters are seen undressed from the waist up, as one graciously pinches the nipple of the other. The painting's elusive meaning has been interpreted in many different ways, but what remains indisputable is the sense of intimacy, closeness, trust and complicity that the two sisters share. In the case of *Portrait de Famille*, a similar level of closeness and complicity is re-proposed by the action of grooming, a kind of gentle pinching performed by the monkeys, while the title of the piece solidly frames the action within the evolutionist perspective that effectively sees us as part of one family with monkeys – and in a couple of moments, some monkeys do indeed gently toy with Primat's nipples too.

At a specific point, in the top left of the screen, two monkey-tails appear. These dangle close to each other uncannily suggesting the presence of a pair of legs. It is a completely accidental occurrence, for that matter surely not staged, but as this happens, for a few seconds only, the painting *A Bar at the Folies-Bergère* (1882) by Manet is vividly summoned. The two dangling tails echo the odd appearance of the trapeze's legs in the upper left corner of Manet's painting overlaying by default the artist's image onto that of the gloomy looking maid behind the bar, a place that from a formal perspective, Primat's silhouette echoes with striking precision. What is relevant about this new and unexpected overlay is the fact that the background in Manet's painting has been largely speculated to be a mirror rather than a wide view on the ballroom. Other artists, like Jeff Wall for instance have gone back to this idea and employed the deceitful use of reflections as an active signifier in the re-making of this iconic work (*Picture For Women*, 1979). In *A Bar at the Folies-Bergère*'s reflection, the gentleman seen talking to the girl stands in relation to the position occupied by the viewer of the painting, engaging the latter in a direct dialectic encounter aimed at breaching the safe division between the representative pictorial space and viewer's position in the real world. From this perspective the spider monkeys moving around Primat and in front of the blue screen become part of a reflection of which, us the viewers, are also part.

Technically, Primat's animal shares some similarities with that enacted by Beuys as he shared the gallery space with a coyote. It is the level of proximity with the animal that generates a becoming of some description in both occurrences. However, in Primat the relationship with the animal is not established through a shamanic intercession, it is not based on a transcendental plane, but it is instead grounded in scientific research and

supported by the determination to abandon, as far as possible, one's human ways in order to embrace those of the animal instead.

The behavioural repertoire performed by Primat is not derived from a vocabulary of stereotypical animal poses, but is part of a communicational code external to that of human communication. The acceptance by the spider-monkeys and bonobos with which Primat worked on a level functions as a reminder or re-validation of the closeness that effectively binds us to this group of animals in the specific.

The proximity we share with animals is something undeniable and the different examples discussed in this chapter, all illustrate in different ways, how our close human/animal relationships can be complex and multi-layered. Animal relations that are seemingly positioned at polar opposites such as those we establish with the pet and the farm animal may indeed function along the same economies of animal consumption. Blurring the boundaries further, we have seen how meat could be considered a questioning entity as the zone of indiscernibility between human and animal and in this suffocating proximity, the opportunity for the human to leap into the animal is proposed by the becoming animal through the obliteration of boundaries and the temporary suspension of identity. As we have seen the becoming animal, for as controversial as it may be, can simultaneously comment on our proximity to the animal while also allowing us to further reflect on human social relationships. While evolutionary proximity as explored by artists working with primates, more tangibly proposes a focus on the human/animal divide imposed by language and brings the human to use the body as a communicational bridge between species. The following chapter will continue to address practices insistently questioning the boundaries between human and animal through the scientific interface of bio-art.

Chapter 4

An Uncomfortable Closeness

Rachael: Do you like our owl?
Deckard: It's artificial?
Rachael: Of course it is.
Deckard: Must be expensive.
Rachael: Very.

(*Blade Runner*, 1982)[1]

So I ask, in my writing, what is real? Because unceasingly we are bombarded with pseudo-realities manufactured by very sophisticated people using very sophisticated electronic mechanisms. I do not distrust their motives; I distrust their power. They have a lot of it. And it is an astonishing power: that of creating whole universes, universes of the mind.

(Philip K. Dick, 1978)[2]

Some of the most intricate blurring of boundaries between animal and man ever staged have appeared in the work of artist Matthew Barney, who, over a period of eight years, has captivated international audiences with *The Cremaster Cycle* (1994–2002), an epic series of highly visionary and experimental cinematic mastery. In *Cremaster*, it is through the fragmentation and dissolution of linear narrative that Barney takes us through an alternative, ahistorical, mythological world in which the anxieties and desires of our contemporary lives are visualised. The title of the series finds its conceptual origin in the cremaster muscle, which the artist uses as a signifier for the initial genital indiscernibility in the embryo as presented up to the seventh week of development. To Barney, this period of uncertainty

is key, and represents a moment of pure potential. Interestingly, cremaster is not only a muscle of the human body, but also that part of a butterfly chrysalis that hooks the insect to the external surface onto which the metamorphic process takes place. Here too, the cremaster's signification is deeply related to ambiguity and potentiality, as associated to the metamorphic stage of insects. This ambitious cycle, consisting of five feature-length films, does not have the becoming animal as its main focus; however, a transformative force resulting in the alteration of the human body into animal-like forms is a constant underlying theme. And it is in the self-enclosed aesthetic syntax presented by the film that we also encounter the haunting presence of animal and human hybridity.

Hybridity and Nonlinearity

Hybrid, as represented in Western culture, stands for the symbolic coexisting plausibility of the rational and the irrational, the dychotomic relationship between reason and instinctual drives. Once transposed in a postmodern context, this combination may not be simply read as such, but should instead be understood as an ontological paradox functioning as a plateau, an opportunity for an alternative nature crossing the boundaries of species demarcation.

It is indeed through the heightened anti-naturalistic representation of the cinematic space that hybrid connections with the animal can be vividly formed. This is something that early-modern cinema appropriated from the fantastic representations of mythological painting. The minotaur, the medusa, the centaur, the siren, the sphinx and the satyr are just a few of the mythical chimeras that populated Greek mythology and Roman and Renaissance art, to resurface in fin-de-siècle paintings and then again through the visionary ambitions of cinematography. Unlike for literature and painting (the media through which the construction of the chimera originally took place), cinematic representation allows, through its complex indexical quality, for the generation of newer hybrid incarnations that intensely, with the addition of motion and sound, further blur the boundaries between the fictional and the real. The chimera is, in cinema, not a remote, static and two-dimensional creature — it is updated into a disturbing entity, alive in its diegetic dimensions.

It is in the cinematic postmodern context that the combination between animal and human entirely abandons the mythical remote locations in which chimeras reside, in order to pervade the spectrum of scientific plausibility, where it is recognised as a hybrid instead. The use of these terms largely varies in scientific and humanist contexts, and it would be therefore useful here to draw a distinction. For this purpose, we could broadly consider the hybrid to be a genetic combination between two species, and the chimera to consist instead of a body where the cohesion between two or more beings has not happened at a genetic level, but only through grafting. We could then argue that, at least in the representational

realm, the hybrid is the chimera's postmodern evolutional stage, and that it effectively takes the cohesion of animal and human to a whole different level.

The evolution from chimera to hybrid, as developed through the cinematic lens, is well captured in the 1958 film *The Fly* by Kurt Neumann and its 1986 remake by David Cronenberg. In the 1958 version, Canadian scientist Andre Delambre has been working on a matter-transporter device: the 'disintegrator–integrator', which allows for the teleportation of objects in space. Some early experiments with common objects proved successful, increasing Andre's eagerness to try teleportation on humans. He takes his wife down to his secret laboratory and excitedly introduces the invention to her. But unfortunately things do not quite go to plan, as a fly enters the disintegrator-chamber during Andre's attempt to teleport himself. Through the de-materialisation of his body, the scientist's bio-matter and that of the fly are mixed, generating a compound body (frequently referred to throughout the film as 'it') which predominantly retains human form while presenting the head and a limb of a fly. Simultaneously, the device generates a curious-looking fly with a tiny human head and one arm. Although the combination of animal and human body is here meant to happen on a genetic level, through molecular disintegration and re-integration, the final result aesthetically points, like Thomas Grünfeld's *Misfits*, to collage-like assemblages, less dramatic in their awkwardness than their Egyptian and Greek precursors but still confined to the classical repertoire of the compound chimerical body – one in which the animal and human anatomies are at odds with each other. This conflictuality, symbolising the uneasy juxtaposition of the rational and the irrational, is highlighted in the film through the growing antagonism between the human part of Andre's body and its fly component, which persistently tries to take over the human part.

In Cronenberg's remake from 1986, it is through the technological advancements of cinematic special effects and make-up that the body of Seth Brundle (Andre Delambre's postmodern incarnation) is turned not into a chimera but a hybrid. In Cronenberg's remake the human body enters a becoming which lasts through most of the story. Emerging from the aptly updated 'telepod', Brundle's body, at first, appears unchanged in its human form. However, dramatic mutations soon start to take place as his body begins morphing into that of a fly-like being (it is worth here noting that 'Brundle' is an anagram of 'blunder'). Through this becoming, Brundle initially acquires exceptional, gymnast-like agility, hyper-human speed and flexibility. He does not imitate a fly's behaviour, but instead enters levels of intensities capable of bringing the realm of the fly and the human to overlap. Unlike Delambre, Brundle does not lose his ability to speak, but begins to do so much faster than normal, entering a frenzied state which also renders him a better and longer-lasting lover. The intensity of this animal becoming is perfectly framed by Brundle's remark in an argument with his girlfriend: 'I've become free, I've been released!' he shouts. And indeed so it seems: the burden of being human is lifted, at least in the first stages of this becoming. However, as the teleporting machine confirms on its LED screen, a 'Fusion of Brundle and fly [has taken

place] at molecular-genetic level[3] The poetics of Kafka's *Metamorphosis* (1915) pervade the insect-transformations of both versions of the film, especially in that the sense of responsibility towards one's family, a loved one, or indeed the world, are in all three stories resolved through the death of the hybrid.

Popular culture, through the help of literary and cinematic representation, has found in the scientist an emblematic figure to idolatrise and simultaneously demonise. Saving humanity and destroying it at the same time, the scientist is superior to nature, as he can manipulate it as no common mortal can. However, the scientist can also err. And it is the shadow of this eventuality that plays a large part in the mistrust which popular culture places in genetic manipulation. The cautionary tales of *Jurassic Park* (1993), *Gojira/Godzilla* (1954), *The Island of Lost Souls* (1932) and *12 Monkeys* (1995) all point to the disconcerting visions of human cloning featured in *Gattaca* (1997) and *City of Lost Children* (1995).

What is most important to bear in mind here is that the hybrid, unlike the chimera, is not a mythical occurrence, but is instead human-manipulated, and as such raises a set of complex questions ranging from the philosophical to the religious and the ecological. As previously mentioned, the chimera was born in mythically remote locations, while the hybrid is born from the disturbing proximity, and behind the closed doors, of the scientific laboratory.

Hybridity and Selective Breeding

It is in the public domain that animals are extensively used in laboratories for a number of purposes, such as cosmetic testing or medical research. Mice have been used in human-disease research since 1909.[4] In 1988, OncoMouse™, a mouse engineered with human genes, to serve for cancer research, was the first lab animal to be patented. In 1996, the rather unsettling images of the Vacanti mouse, a hairless mouse with what looked like a human ear growing on its back, began to circulate. The media frenzy generated was phenomenal; however, the ear in question was not a real human one, but bovine cartilage that had been shaped to look like a human ear. The controversy among animal-rights groups, as well as anti-genetics groups around the world erupted.[5] Why does genetic manipulation trigger anxieties?

Genetic manipulation could indeed be seen as an extension of the old practice of selective breeding in animals and plants for domestication and agricultural purposes. The discovery that certain favourable traits could be brought forward in order to create more resistant, productive and beautiful beings is nothing new. In the first chapter of Darwin's *The Origin of Species* (1859), the foundation of his evolutional theory are laid on examples of selective breeding in domestic animals.[6] At the same time, Gregor Mendel, an Augustinian monk and scientist studying at the University of Vienna, carried out cross-pollination experiments on 29,000 pea plants in the attempt to understand how to control and effectively manage desirable traits by unveiling the laws that govern these processes.

Today, selective breeding of animals and plants is everywhere around us, in the species with which we have become familiar, in the supermarket as much as in the pet store and the farm. The practice is generally well accepted in many fields, most notably in the canine and feline worlds, where we would have no pure breeds without it, or in the botanical field, where selective breeding is considered a high form of craft, even an art form. Hybrid plants have also consistently been created since antiquity through the practice of grafting in order to enhance the quality of fruits and flowers, and it is impossible to deny that the cross-breeding of selected animals has played an intrinsic role in the history of our cultural and technological development. It is, however, when the mutation happens at the level of DNA, inside the laboratory, that the essential authorising power of nature seems to be completely obliterated – this is the point at which we find the emergence of the anxiety previously mentioned. Cross-breeding is still perceived as 'naturally plausible' and validated as 'natural' through the reproductive processes needed for its success to take place. The fact that nature somehow tolerates or allows these human interferences legitimises their status as 'acceptable' manipulations. As such, the event is not considered 'against nature'. Direct genetic modification is perceived instead as bypassing this essential, validating stage and as such it is deemed 'unnatural'.

Belgian artist Koen Vanmechelen's ambitious work titled *The Cosmopolitan Chicken Project* (2000–ongoing) brings the effective functioning of cross-breeding to the fore in the utopian attempt to create a new international species. This new breed, the result of crossing species from all over the world, will be a universal chicken, or as the artist calls it a 'Superbastard'. Vanmechelen's personal exhibition, held in 2001, was titled *Between Natural Breeding and Genetic Engineering*, and intrinsically operated a reprise of Darwin's own experiments with chickens by questioning a range of contemporary cultural issues, such as genetic manipulation, cloning, globalisation and multiculturalism.[7] Through the multiple readings lending themselves to anthropomorphic interpretation, the installation also allowed audiences to question more closely the practice of cross-breeding, its methods, moral and ethical-related grounds, paradoxes and contradictions by relocating the animals into the remit of the gallery space.

Selective breeding first came under questioning with the surfacing of eugenics in early-modern times. The term was coined in 1883, and defined a philosophy aiming to improve humanity by encouraging the ablest and healthiest people to dominate procreation. Its positivist, utopian core was soon overshadowed by the interest that Nazi Germany developed in it and the strong responses it generated in the United States. Eugenics then became synonymous with racial hygiene, and was progressively abandoned after the war.

Say It with Flowers

The first ever exhibition of genetic art to take place was staged at the Museum of Modern Art in New York in 1936. It was the work of artist Edward Steichen, who exhibited a collection of gigantic delphiniums he had bred over 26 years through a combination of traditional methods of selective breeding and the use of a chemical that altered the plants' genetic make-up.[8] This was effectively the dawn of what is called bio-art, a strand of artistic practice using the procedures of biotechnology and shifting the working environment of the artist from the studio to the scientific laboratory: today, a multitude of artists engage with tissue culture and transgenic engineering. However, it took some time, until 1988 in fact, for genetic art's next noticeable evolutionary step to surface in the gallery space. Again, it was an experiment with plants, a selection of irises presented by artist George Gessert (*Iris Project*) that had audiences pondering the potential impact of selective breeding and genetic engineering on humans. As the artist commented,

> All works of genetic art, whatever their political slant, validate public discussion about biotechnology and genetics. This has important political implications. Business, science, agriculture, and government control not only biotechnology, but also most discourse about it. Almost everyone else, including artists, have stayed out – or been held out – of public discourse about genetics. Until very recently the few who spoke up in even small ways were often ridiculed, marginalised or attacked. This was, in part presumably because eugenics was lurking in the wings, ready to pounce if people as allegedly emotional and irresponsible as artists got involved.[9]

The *Iris Project* was indeed received with some controversy. Exhibiting these plants in the artistic context, rather than in the more obvious flower shop, brought eugenics to the surface as subtext. We would hardly draw such considerations in a shop when purchasing a bunch of flowers for a loved one. However, most of the flowers surrounding us in such a shop would effectively be the result of extensive manipulation, just like Gessert's.

It is important to note that the early art projects involving genetic art made use of plants rather than live animals as a medium, possibly due to the limited technological facilities available to artists in the past, but also to avoid too much undesired attention. Plants are living beings too, of course; however, within this context, anthropomorphic readings of the subject still retain a safe metaphorical distance from human life.

Alba: A New Dawn for Art?

It was only later, in 2000, that the heated controversy over a work of genetic art would explode on the grounds that it involved a live animal. However, in this case the work in question belonged to a new and more problematic genre, that of 'transgenic art' – a sub-category of genetic art involving the manipulation of DNA.

Alba was created in February 2000, an albino rabbit whose genetic material was combined with that of a jellyfish, making it glow fluorescent green when exposed to ultraviolet light. In biological terms, the word 'alba' signifies 'white matter', in this case referring to the natural colour of the rabbit, but also to the whiteness of the canvas as an artistic originating point, while in Italian and Spanish the word alba signifies *dawn*, in this case alluding to the revolutionary originality of the project and its value as a starting point for a new age of art. *GFP Bunny* (where 'GFP' stands for 'green, fluorescent protein') was unveiled by Eduardo Kac in May 2000, and described as a three-part undertaking: the first phase involved the birth of Alba, which took place in Jouy-en-Josas, France; the second consisted of the debate fomented by a media storm; the third, would have concretised in the bunny arriving home in Chicago and becoming part of Kac's family as a pet.[10]

The third stage of the project never took place, as the controversy generated led the French laboratory to claim her as its property and never to release her. *GFP Bunny* painfully exposed the intensity of the anxieties revolving around genetic manipulation, and revealed current public opinion on the subject. We can easily appreciate the ability transgenic art has to trigger heated public discussion – surely a strength of this art form – although we may ask how innovative it is really from an artistic perspective.

As with the birth of photography and cinema, genetic art technically involves the birth of a new medium for the arts, one that presents new paradigmatic sets through which meaning is created. In Kac's vision, artists should appropriate the tools of genetic science in order to expand the remit of art practice to territories thus far unexplored, to create a multidisciplinary dialogue on the subject. In other words, he is proposing an artistic practice that has its roots grounded in conceptual art, through which the artwork itself is less important than the discussion generated by it.

First, the main subversive step taken by transgenic art, as Kac claims, is that of proposing a different relational mode within the artistic paradigmatic set where audience and work of art are brought together in a relational of two subjects, rather than subject and object. The livingness of the art object replaces the traditional fixitude and finitude of the art object's formal and contextual elements, as these can be continuously revised by the living art subject itself. Once relocated in Chicago, Alba would have functioned within new signifying parameters, proposing complexities of a different nature from those involved in being displayed in a museum or a gallery space. As a live animal, she would have also eventually given birth, become ill, or died. All these stages of her life as a member of the Kac family would have been most likely part of the artistic project as a whole, and possibly exposed to international audiences via a blog or podcasts. Of course we can, however, question the nature of Alba's subjectivity through the consideration that she was always so strictly bound to the experimental whim of an owner/creator that commissioned her engineering. There is here great suspicion that Alba, aside from being alive, did not differ too much from Duchamp's urinal, which he titled *Fountain* (1917). Ironically,

just like the original *Fountain,* Alba disappeared, so that all we have left of both is a few photographs.

It may be productive now to follow this similitude further, and argue that most genetic art owes a large part of its provocative and irreverent qualities to the early-twentieth-century readymade, as well as to the performative practice of artists working with animals in the gallery space, such as Beuys and Kounellis. Of the readymade, genetic art borrows the technical distancing between the artist and the work of art, the obliteration of traditional artistic skills (the object is not originally crafted by the artist directly), as well as the taste for assemblages of different objects with the aim of creating a third original art object, usually one of an uncanny nature. This is a typical tendency of the Surrealist readymades, like *Cadeau* (1921), in which Man Ray created neither of the two original constituting objects involved (iron and nails), and limited his intervention to the gluing of the nails to the plate of iron, creating something of a chimerical object. Similarly, Kac combines rabbit genes to those of a jellyfish, but goes as far as delegating a laboratory to carry out this creative process, in keeping with the artistic tradition of delegation endorsed by artists like Kippenberger and Warhol, among many. In 1917, Duchamp made a statement that became of great importance to the future development of art in general and conceptual art more specifically. In order to generate heated discussion around his readymade *Fountain,* he stated that 'Whether Mr Mutt [the pseudonym signature he used for this work] with his own hands made the fountain or not has no importance. He CHOSE it. He took an ordinary article of life, placed it so that its useful significance disappeared under the new title and point of view – created a new thought for that object'.[11] Similarly, we can argue that Alba too was some 'article of life': a bunny in the laboratory, one among many other anonymous animals that are routinely and systematically produced in order to study the development of cancerous cells. It was only when Kac claimed her as a work of art, when he *chose* her for *GFP Bunny,* that she became art.

Back in early 1900, through its multipliable nature, the readymade posed a threat to the secular systemic values of art. It was through its ubiquitous existence that the originality of the unique work of art was entirely shattered in the early-modern period, and it is through the same multipliable quality that genetic art threatens, in the minds of many, not only art, but this time the whole world.

Like for the readymade, the question of authorship is particularly relevant in the context of genetic art. In many genetic art projects, the artist has very little, or no, involvement in the actual production of the *art subject.* Therefore, in compliance with the paradigmatic sets of conceptual art, genetic art does not capitalise on the skillful execution of an art object but functions instead in the ideas and discourses generated around the emergence and recontextualisation of the object/subject. In this case, and this is a large part of the problem, the artist can be seen as not only authoring an artwork, but indirectly 'authoring nature' itself, something that some may argue should not pertain to the remit of art. Or

could the opposite be argued? After all, wasn't art's secular task that of recreating nature in the best possible way through the process of mimesis, and in the attempt of achieving this didn't art constantly perfect nature through the selection of colours, lines and volumes? From this perspective, genetic art can be understood as the next developmental step of such classical artistic discourse. How innovative is then transgenic art, considering that it seems to re-enact so many already-seen aesthetical and conceptual tropes?

The Dynamics of Genetic Art

When Eduardo Kac announced *GFP Bunny*, he described the project as three-part. Genetic art is ultimately designed to provoke heated discussion, and as such it requires a performative stage to fulfil its main purpose. The performative in genetic art is key in both stages, that of the creation of the *art subject* and that of the controversy which follows this creation.

The first stage, or *creation stage*, usually takes place in the laboratory, and it predominantly goes unseen by the audience until, usually a few images testifying to the existence of the work as well as revealing its genetically manipulated origin are released. Although unseen by the public eye, this stage is most charged, as it automatically conjures a multiplicity of anxiety-ridden narratives from previous genetic interventions on farm animals such as Dolly (1996–2003) the cloned sheep, the Vacanti mouse (1996), the first cloned dogs (2005) or Allerca's hypoallergenic cats (2006). The shadow of the early-modern ambiguity of eugenics

18. Eduardo Kac, *GFP Bunny* (2000).

and Nazi camp experimentation looms long. Rotwang, the evil inventor who tried to bring the city in Fritz Lang's *Metropolis* (1927) to its knees, contributed to this overall disconcerting picture, as have the primary antagonists in Mary Shelley's *Frankenstein* (1818), H.G. Wells's *The Island of Dr Moreau* (1896) and the already mentioned *The Fly* (1958/1986).

The myth of Frankenstein, along with its successors, taps into the idea that scientists, and in this case also artists, are human beings whose egos may drive them to either irresponsibly manage their creations or, worse, to align themselves with the wrong party in search of fame and success (a concept that would lead us back to eugenics).

Behind the closed doors of the laboratory, as the boundaries between man and animal are genetically blurred, is where the set of ethical and moral questions revolving around the creation of the artwork are generated. Is it at all within our remit to manipulate animal and plant life? Moreover, should artists be at all involved in processes that traditionally belong to scientific territory? The idea of the artist in the lab using science for creative purposes conjures images of artistic shamans, witchdoctors and astrologists, appropriating modern science as a tool for the generation of social narratives. But what are the consequences when an artist's genetic experiment goes wrong? If the work is not carried out in the name of science (therefore, 'advancement') but rather for creativity's sake, then would those consequences be justifiable? What are the ethical responsibilities of artists and curators in creating, presenting and contextualising such works for audiences? Clearly, previous conceptual art did not carry such a problematic aura. We may therefore identify this aspect, presented by genetic art, as being an original artistic trait of its genre.

The second performative stage of genetic art relies on media attention and audience response. It is in the *debate stage*, when the work comes into the public domain and takes on multiple meanings functioning as a trigger for discussion. Usually, a limited number of images of a genetic art piece are made to circulate through the media. Kac produced a number of posters to be hung in public places in order to trigger discussion. However, it is only once the images are posted on blogs and websites that these artworks effectively enter an artistic dimension, in the sense that the dialogue between audiences becomes truly unpredictable, aggressive, compassionate, intolerant, however creative and global. The Internet in particular accelerates this dialogue exponentially. Here, images of genetic art, like images of other genres, become part of a specific economy of visual consumption that sees them beamed around the world, often misrepresented and tagged with inaccurate captions. The images enter an 'electronic mythical realm' where nothing is real but where simultaneously anything can be. The suspicion that everything may be a hoax constantly looms on the cybernetic horizon, posing further questions on the effective authenticity of anything we see or learn in hyperreality. It is through this stage that our anxieties are tested, and that our moral and ethical stances are displayed for everyone to read, copy and paste into a multitude of other websites for potentially endless commentary.

The third, or *integration stage*, through which genetic art frequently operates is forged from debate about the future of the created 'art organism'. The Pandora's box has been opened through the creation of the living being. Once the manipulated living being exists, what is its future? As a living entity, this mutated animal/plant could contaminate the rest of the planet if set free. It could mate with a compatible 'natural' form of life and multiply, further upsetting the already tampered-with natural world that surrounds us. Kac was disappointed that Alba was never allowed to join his family in Chicago. There is here indeed an open-endedness to the work which is integral to the value of the project itself. The fact that Alba was not allowed to leave France highlighted the intensity of the anxiety related to contamination. What else, aside from coloration, might the addition of fluorescent genes have caused in the animal? In this respect, Kac deliberately decided to be provocative, stating, 'There is no transgenic art without a firm commitment to and responsibility for the new life form thus created.'[12] Would we, however, be able to consider the adoption of Alba as a pet within the context of responsible actions? This could surely be interpreted as an act of care. But at that, it does not extend to broader consideration of environmental issues. Indeed, other statements by Kac reveal that his set of ethical responsibilities may slightly differ from the norm, as he also claims that 'With at least one endangered species becoming extinct every day, I suggest that artists can contribute to increase global biodiversity by inventing new life forms.'[13] This statement is as imaginative as it is disturbing. How seriously are we to take it, considering that it is delivered within the realm of performativity which envelopes genetic art? Which commitments and responsibility is Kac referring to here? Does he artistically exist in a Baudrillardian postmodern apocalypse where the signs of the real are substituted for the real itself?[14] What would the consequences of such an approach be, however, when live matter is involved?

The online world is full of mythical creatures that have 'allegedly escaped the scientific laboratory'. Creatures of cryptozoology, like the contemporary mythical Chupacabra (goat-sucker) 'populates' South America and is largely believed to be a CIA laboratory experiment gone wrong.[15] The Montauk Monster, another figure of contemporary mythology, was washed ashore dead in New York during the summer of 2008. At the time, the general public assumption was that the animal was a laboratory experiment escaped from a nearby research area called Plum Island.[16] Or even the Mean Mouth Bass, an extremely violent fish commonly believed also to be a laboratory experiment gone astray.[17]

Aside from the will to provoke heated debate, there is a genuinely interesting aspect to genetic/transgenic art that mostly goes unnoticed. The creation of transgenic organisms brings to the surface more distinctively the flux of bio-material that all living things belong to, and that surprisingly allows for the mixing and functioning of these third entities. This demonstration of the continuity of life — the inter-species genetic communication that supports the validity of evolutionary theories – is surely a remarkable underlying theme of genetic art.

In his essay *Cell Fusion* (1970), Professor of Medicine Henry Harris observes,

Any cell – man, animal, fish, fowl, or insect – given the chance and under the right conditions, brought into contact with any other cell, however foreign, will fuse with it. Cytoplasm will flow easily from one to the other, the nuclei will combine, and it will become, for a time anyway, a single cell with two complete, alien genomes, ready to dance, ready to multiply. It is a Chimera, a Griffon, a Sphinx, a Ganesha, a Peruvian God, a Ch'i-lin, an omen of good fortune, a wish for the world.[18]

Harris's enthusiastic statement captures the glaring evidence of bio-continuity between animal and animal and us and the animal world. Most recently, the emergence of 'post-natural history', taking selective breeding as its starting point, aims to contextualise and validate the legitimate value of transgenic interventions through culture, nature and biotechnology. However, for as interesting and exciting as this may seem, it is the use we may make of this knowledge that can become highly problematic.

Bio-art for Art's Sake?

General popular responses to transgenic art remain sceptical of the true motivations driving the artists' involvement in this field. In the original *The Fly*, Andre's wife is shocked to hear that their cat disappeared in an early unsuccessful teleportation experiment: 'No more experiments on animals. It's like playing God!' she exclaims.[19]

In 2000, Marta de Menezes worked on a project titled *Nature?*, which was also received with controversy. In *Nature?* the artist took advantage of new methodologies in developmental biology, and with the help of a laboratory at the University of Leiden (Netherlands), proceeded to modify, for artistic purposes, the wing patterns of butterflies. The artist interfered with the pupal stages of Bicyclus anynana and Heliconius melpomene, two African butterflies displaying distinct eyes and colour patches on their wings. Through microcautery, involving the use of a heated needle, the artist erased spots and created new designs on one of the insect's wings. In the process, she claims that no harm was done to the butterflies. However, doubts about this statement brought me to consult Dr Dick Vane-Wright at London's Natural History Museum, a world authority on butterflies, to ask if this would indeed be the case. Dr Vane-Wright confirmed my suspicion that pupae are indeed sentient beings, and that they are sensitive to light, heat and most clearly touch. Dr Vane-Wright also confirmed that pupae have a central nervous system that is carried over from the larval stage and that 'butterfly wings have blood flow in their veins, which also carry tracheae (breathing tubes) and nerves — supposedly one trachea and one nerve per long vein. There are sensory mechanoreceptors on the wings, and these are largely concentrated

on the surface along the course of the veins.'[20] Is it relevant that pain has been inflicted on animals in the process of art-making? Indeed it is, especially if the same artistic statement could have been drawn without pursuing such a path.

Visually, the result of Menezes's modification is not particularly dramatic. An eye-spot is missing here and there, a patch of colour is erased. What does this project say about butterflies, our relation with them, or art? Menezes claims that 'on seeing the change of pattern, one also looks more closely at the non-manipulated side, and thus the natural design is emphasised.'[21] This statement is concerning, as it suggests the possibility that in today's image-saturated world, some of us may have lost the ability to engage with natural forms simply for what they are. Do we need an artist to tamper with the wings of a butterfly in order to appreciate the beauty of its original design? A sense of sadness pervades. What does this project really tell us, aside from demonstrating how far we can go in manipulating the world around us through new technology and for our own aggrandisement?

The Western Australia-based artist group the Tissue Culture and Art Project (founded 1996) has instead over the past years created a body of work titled *Victimless Utopia* (2000 onwards), involving genetic engineering that through a multidisciplinary setup addresses a range of issues directly related to our exploitative relationship with animals while providing us with solutions 'sitting on the edge of the plausible' which may one day contribute to a full revisiting of this difficult relationship. In *Victimless Leather* (2004) the artists produced cultured cell lines that formed a living layer of tissue supported by a biodegradable polymer matrix in the form of a miniature stitchless coat-like shape.[22] As the title of the work suggests, the piece aims at removing the animal from the creation of clothing in order ultimately to avoid deaths in the name of fashion. The prototype coat created is not a new consumer product but acts as a questioning entity suggesting a deconstruction of the cultural function of leather as a second skin.

Likewise, for the project *Disembodied Cuisine* (2003) by the same artist-collective, a steak was created in the laboratory by growing frog skeletal muscle over biopolymer. The installation culminated in a 'feast' where the steak was eaten in front of an audience in a gallery space.[23] Both projects illustrate the possibility, in some future, of growing tissue for consumption directly in the form of disembodied meat or tissue. If this were a viable avenue for future development, animal farming, along with the slaughtering industry, would become redundant; all related ecological and economical issues could forever vanish. Would we, however, choose to take this opportunity? Our complex relationship with food for instance is tangled in a web of tastes, textures, colours and smells that an in-vitro steak might find hard to supply. How would the idea of freshness apply to surrogate meat? Who would be responsible for setting a standard for quality? Would such production-technology be affordable and clean for the environment? Would this semi-living meat also at some point demand the granting of rights?

Hybridity and Robotics

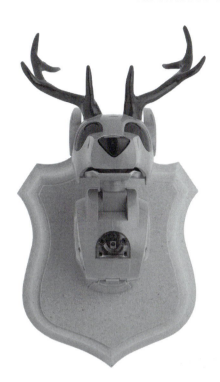

The work of artist France Cadet, an artist we encountered earlier in this book, raises questions directly related to various aspects of genetic engineering, and it does so using a combination of humour and technology to test the boundaries between humans, animals and machines. In her *Dog[LAB]01* (2004) project she created seven 'transgenic' robotic dogs in order to make a critical social statement about the excesses and dangers of cloning and other experiments using animals. Her adoption of the mechanical form directly references the late-eighteenth-century appearance of robotic animals. A link between animals and machines was outlined by René Descartes, who in 1641 theorised a mechanised vision of the universe in which animals are nothing more than automata without a soul.[24] This vision has greatly influenced our relationship with animals ever since. In 1739, the creation of the Canard Digérateur by Jacques de Vaucanson seemed to support Descartes's claim, suggesting that humans could indeed create machines that *functioned* similarly to animals. This mechanical duck was claimed to be able to feed on grains, metabolise and defecate. Of course the process of digestion, exclusive to the world of the living, was simulated. However, this peculiar robotic duck paved the way for the world of robotics to embrace directly the animal world as a first step towards the possibility of one day creating human-like robots. The seductiveness of such a proposition was later outlined in Hans Christian Anderson's tale *The Nightingale* (1843), in which the Emperor of China imprisons a live nightingale but then receives a mechanical copy – he loses interest in the live bird, favouring the bejewelled replicant over the animal.

19. France Cadet, *Cervus Elaphus Barbarus - Cerf d'Afrique du Nord* (2008).

Cadet's work directly pointed to Eduardo Kac's *GFP Bunny* through the creation of an albino fluorescent mechanical dog (Alba was originally meant to be a dog). In fact many of the creatures on show explicitly referred to the real creations of genetic manipulations that had so captured people's imagination in previous years. The conflation of dog, robot, toy and farm animal tangled the viewer in a contradictory web of significations. By preserving

20. Patricia Piccinini, *Superevolution* (2000-1).

the generic morphology of the dog, each creature claimed a bond of closeness and trust with the viewer who, in turn, was unsettled by the alien qualities displayed by the robot. These mechanical animals are monstrous and cute at the same time. As each animal is underlined by a canine essence, *Dog[LAB]01* also simultaneously comments on the previously discussed commodification of pets, questioning the legitimacy of genetic manipulation in this animal category. Through the form of robotic toys, the creatures of *Dog[LAB]01* suggest that our relationship to nature essentially isn't dissimilar to that we have with toys: something entirely created to entertain and amuse. And should we want to take this reading further, it is unavoidable to note that the robotic toys Cadet designs have young boys as a main target. This of course works as a rather painful strike at patriarchal society, its essence and the impact of its ways on our relationships with animals.

Artist Patricia Piccinini has also consistently questioned through her practice the effects of technological advance on human and animal life. Through the lifelike appearance of her

computerised silicone sculptures, Piccinini also aims at triggering discussion on the possible uses of genetic engineering. Her audiences are challenged by a captivating combination of hyperrealism and a rather disturbing oscillation between the inherent cuteness and the disturbing aura that her creations present.

In *Superevolution* (2000–1), Piccinini placed two animatronic animals into an enclosure with real wombats at Melbourne Zoo. Similarly to the work of Tessa Farmer, discussed in Chapter 2, here the resulting combination of bio-matter and hyperreal artist-made matter blurs the boundaries between what is synthetic and what isn't. The synthetic organisms were referred to by the artist as 'siren mole', in reference to their body shape, terminating in an elongated protuberant tale-like appendix, and also in light of the polyform essence of their bodies. These bare and furless bodies also allude to other marsupials, without specifically matching the morphological characteristics of any one single species.

Piccinini's work conjures many of the anxieties already discussed in this chapter. As strange as the siren mole may look, its lifelike animal visage makes the possibility of a reproductive union with the real wombats in the enclosure seem not so remote. However, unlike in Kac's radical approach to art, Piccinini's work successfully addresses a very similar range of issues without resorting to the use of genetic manipulation on live animals in order to make her point. It could be argued, of course, that Kac's ethical position as an artist is very different from that of Piccinini, for Kac is effectively supportive of genetic art while Piccinini's practice instead questions it in a rather subtle but direct way through the use of technological advancements and the blurring of boundaries between the natural and the artificial. Piccinini's works are open texts carefully balanced to encourage a sympathetic bond with her hybrid creatures – after all, they are not wholly monstrous. Piccinini's philosophy is underlined by a sense of responsibility for life that differs greatly from Kac's. 'Ultimately my main interest,' says the artist, 'is the relationships between the creations, their creators and the world. I believe that with creation – be it parenthood, genetic engineering or invention – comes an obligation to care for the result. If we choose to customise life then we must be prepared to embrace the outcomes.'[25]

The fact that one day we may be able to build not only convincing autonomous robotic animals, but also self-moving robotic humans that may become more and more indiscernible from us poses a number of questions. The blurring of boundaries, the anxiety and the increasing unpredictability that such a scenario could lead to have already been perfectly captured in *Blade Runner* (1982). In depicting hyper-futuristic monumental urban reality, the film directly references the dystopic essence of Fritz Lang's *Metropolis* (1927). As for *Metropolis, Blade Runner* plays out against the backdrop of a hypertrophic futuristic urbanisation sustained by corporate power, where the question of what is human and what is robot, is crucial. In both narratives, the replicants need to be eliminated, but the seamless continuity with which they emulate human form makes the task extremely difficult. Both films, it could be argued, take the viewer through an examination of humanity and towards a definition of

what its essence may be. In *Blade Runner,* replicants are morphologically, dynamically and substantially human in every way, they are stronger than humans, but preserve the emotional void typical of the machine. However, there is a belief that their closeness to humans may lead to the development of emotional responses, which would then result in the creation of a superior species of human that could wipe out the original one.

Emblematically, it is through the 'eye-analysis' of the Voight-Kampff test that the difference between replicant and human can be identified. The questions of the test focus on empathy towards animals. In *Blade Runner,* animals have become largely extinct, presumably through the atomic annihilation that preceded the events recounted in the film. The animals of 2019 (the year in which the story takes place) are *animoids,* biomechanical replicants that are sold and bought as pets at the market and function as a status symbol. Their commodified nature has unequivocally replaced any other kind of nature.

The fact that the questions in the Voight-Kampff test use animals as an indexical tool to identify compassion is also key. A large part of the emphasised valuing of animal life presented in the film is caused by the rarity of animals. In the film, empathy is represented as a trait that separates humans from replicants. Therefore, treating animals fairly and with empathy shows the ability to *feel* for a life form. Ironically, as Deckard administers these tests, he seemingly feels nothing for the replicants he hunts — he is actually as emotionless as they presumably are, but over the course of the film his views change as he transforms into an empathic figure. Ultimately, *Blade Runner* suggests that a sense of stability attached to the understanding of what is natural and therefore original underlies our existence. The implicit suggestion is that when this referential system fails, then there is no certainty, not even about one's own nature and identity. The impending possibility that Deckard may too be a replicant is in fact a dilemma to which there is no answer in the film. Have the boundaries been irrevocably dissolved?

Mechanical Animals in the Zoo

Robotarium X (opened 2007), the work of artist Leonel Moura, looks at robotics as a new kind of legitimate species born from a post-nature context. Moura created a zoo space through which he exhibits and taxonomically arranges these newly created life forms. The majority of *Robotarium X* inhabitants belong to the BEAM family (biology, electronics, aesthetics and mechanics) meaning a minimum of electronic components, a simple sensor/actuator system and solar power.[26] Moura gathered 14 species of robots, for this piece, giving them Latin names, following the tradition of natural history. The classifying process here largely relies on recurrent morphological traits as well as internal components and locomotion patterns.[27] In creating his robots, Moura follows the selective lines of evolutionary trajectories of the living. So in this instance we find the artist creating and also classifying the newly created specimens.

21. Leonel Moura, *Bucinaderm*, from *Robotarium X* (2007).

These new species were presented in an enclosure of glass and steel, where their autonomous behaviour functioned as spectacle for the viewer. Moura truly believes in the possibility that in the near future robots will be able to acquire their own free will and enter evolutionary stages of their own, not engineered by us. 'I don't fear that moment,' the artist says. 'On the contrary, the emergence of a new kind of life form, as much or more intelligent than us, will boost humanity's own evolutionary process. [...] The process of generating a new kind of nature is thus unstoppable.'[28] There is an echo of Kac's enthusiasm for transgenic art and the creation of new manipulated animal life, in the words of Moura. However, in this case the sets of ethical considerations triggered by *Robotarium X* are very different. No longer are we here concerned with the impendent possibility of creating new species which may infiltrate natural ones – not yet at least – but instead with contemplating the possible creation of altogether new, alternative kinds of nature. Moura does not fully clarify whether, in his view, this will replace nature itself or coexist in harmony with it.

'*Robotarium X* is an artistic vision of the future,'[29] says Moura, yet in this prognostication we find something rather disturbing, given that these newly created species are confined in a zoo setting. Moura explains that 'wildlife does no longer exist, as it is crammed with electronic collars, assisted reproduction, protectionism, selectivity and genetic manipulation, and that it is in zoos that wildlife is reproduced.'[30] Consequently, a robotarium would function as the equivalent of a zoo for robots, but for all that Moura's vision is challenging, the

adoption of the zoo setting betrays an underlying conservative approach, harking back to the politics of the human–animal relationship that shaped the very expansion of zoos in late-eighteenth-century Europe.

In the zoo, as in the menagerie, animals were originally caged for human amusement, and functioned as symbols of the status and power of the owner. As part of a spectacle of curiosity which the zoo stages so well, the animal becomes an object to be looked at, admired for its beauty, strangeness, strength and colours. The relationship with animals experienced at the zoo is a complex one that presents visitors and those who work there with a series of pressing ethical and moral questions.

Moura claims that the zoo has today mainly become a place for education and for preserving animal life. But it could, however, be argued that it has also become a place that has been widely read as the monument to our difficult relationship with animals too. If, as Moura claims, *Robotarium X* is a vision of the future, are we then facing the fact that the technological and philosophical advances that should have taken us far from Victorian times have done nothing to alter our Christian–Cartesian relationship with the other? Will the robots of *Robotarium X* become curiosities for audiences to throw nuts (or rechargeable batteries) at? Or are there different and more productive relational modalities we could explore? After all, in *Blade Runner*, our relationship with the replicants ultimately reveals itself as one based on objectification and exploitation, resulting in conflict.

A New Cyborg Manifesto?

The proliferation of works of art involving states of becoming, genetic manipulation and robotic technology can be, broadly speaking, understood as a visual materialisation of posthumanism. Posthumanism, in opposition to humanism and its anthropocentric certitude, re-thinks the human as part of an extended disembodied technological network that perpetually expands its consciousness. It stems directly from the critical fields of enquiry on the subject of *otherness* that developed in the 1970s, like feminist theory, race and queer culture, and capitalises on the technological advances that still today dramatically continue to increase the speed and reach of our daily lives. Posthumanism decentralises the finitude of humanness while demanding a reinvention of the human through the convergence of science and art. Essentially, human centrism is replaced by a system of plural equalities where technology simultaneously contributes to dissonant synchronous visions of euphoria and deep anxiety.

In 1985, Donna Haraway's *A Cyborg Manifesto* outlined the main posthumanist traits within the elusive and compound fractured identities of the cyborg. The term 'cyborg', short for cybernetic organism, was first used in 1960 in an article by Manfred Clynes and Nathan Cline, two engineers working for NASA, on the advantages of using autonomous human-machine

systems.[31] In Haraway's appropriation of the term, a cyborg is reconfigured as 'a hybrid of machine and organism, a creature of social reality as well as a creature of fiction.'[32] Among her many other assessments, the author claims that the cyborg is 'theorised and fabricated',[33] and that it emerged in the late twentieth century from unique technological advances, the impact of which are shaping our world even today. From an ontological perspective, the cyborg exists as a physical coupling of bio-organism and machine, for instance through the implementation of machinic extensions to the body (computerised prosthetic limbs, heart valves, etc.) and also, and perhaps most importantly, as a network where the human organism is expanded through technology (Internet, media and computer communication, telephony, etc.). As Haraway explains, it was when machines became self-moving, acquiring a level of autonomy through the implementation of electronics and programming, that they could achieve man's technological dream. It is this autonomous agency that so well blurs the boundaries between natural and artificial, machine and animal. And this is indeed a key aspect of both Moura's *Robotarium X* and Piccinini's *Superevolution*.[34]

Robert Pepperell, author of *The Posthuman Condition* (2003), argues that, 'Humans have imagined for a long time that the ability to develop and control technology was one of the defining characteristics of our condition, something that assured us of our superiority over other animals and our unique status in the world.'[35] It is therefore through the inexorable technological advances of the past forty years that this certainty comes to fade, that the human has inadvertently decentralised itself. Through this shift, individuals are no longer identity-driven entities but elements of networks bound together by a newly found intimacy between human and technology. Where do we end, and where do the machines that make our lives what they are begin? We are an integral part of a world of connections that could be further explained through the rhizomatic model envisioned by Deleuze and Guattari in *A Thousand Plateaus* (1987). In their vision, the rhizome is a heterogeneous, non-hierarchical self-regenerative and self-mapping connection of multiplicities which stands in opposition to the Western structural model based on the binary logic of dichotomy represented by the root-tree, which instead plots a point and fixes an always-predictable order through its genealogical development. Likewise, the cyborg, operating through a disintegration of the physical boundaries of identity, aims at establishing a continuous becoming of organism and machine through which our cognitive functions as well as our biological ones are enhanced and diverted from Christian–Cartesian conceptualisations of hierarchical dualities in search of new and alternative departures. It is through the disintegration of unitary forms that the cyborg emerges.

Through the filmic representations of the past thirty years, the genetic combination of animal and human has found the incarnation that is most uncomfortably close to reality. Genetic manipulation in general has highly problematic aspects, and we have seen how the emergence of the field of transgenic art seems to polarise responses to this practice. Better accepted when experiments are on plants rather than animals, transgenic modification and bio-art in general pose ethical questions that simultaneously reverberate in the philosophical,

scientific, artistic and ecological spheres. Some artists discussed in this chapter have swapped the art studio for the scientific laboratory; others have attempted to critique genetic engineering through the creation of highly suggestive mechanical bodies that allow them to disentangle their practice from the contingent issues involved. The cyborg, a hybrid of machine and organism, further contributes to the blurring of boundaries of identity in a consistent shift from anthropocentrism that proposes the opening of new and exciting relational modes. Having extensively discussed the 'uncomfortable closeness' that humans and animals can find themselves involved in, the following chapter will take us in the opposite direction, to where the distance between the human and the non-human seems irreducible.

Chapter 5

The Animal that Therefore I am Not

...the institution of speciesism [is] fundamental to the formation of Western subjectivity and sociality as such, an institution that relies on the tacit agreement that the full transcendence of the human requires the sacrifice of the animal and the animalistic, which in turn makes possible a symbolic economy in which we can engage in what Derrida will call a 'noncriminal putting to death' of other humans as well by marking them as animal.

(Cary Wolfe, *Animal Rites*, 2003)[1]

In the film *Avatar*,[2] neural connections among different beings are formed via interlacing membranes that literally plug one body into the other. These connections are capable of supporting everlasting inter-species relationships, effectively trespassing on the boundaries of identity through the creation of expanded sensory awareness. The most interesting aspect of this interconnectedness of living networks is that this bond transgresses evolutionary bio-proximity, connecting members of substantially different species through a communicational connection that leaps beyond anything we have thus far experienced in organic life.

What is offered by *Avatar* is the challenging vision of an inter-species communication that surpasses the creation of a shared language – like for instance the use of American Sign Language for the deaf in experiments with primates – and reaches to establish such communicational ties through a permeability with more remote living beings, like reptiles and even plants. In order to formulate this visionary posthumanist thesis, *Avatar* incorporates a dychotomic opposition between Western and Eastern cultures. The skin-colour of Pandora's inhabitants is a rather direct reference to the iconography of Vishnu, the Hindu God who through his incarnation in ten different avatars is able to transcend his god-status to interact

with human life. Vishnu is the pervading essence of all beings, and is essentially at one with creation. His skin is blue, like the sea, the sky and clouds filled with rain, symbolising his all-encompassing infinite essence.

East, West and the Cosmos

Turning to Eastern cultures and philosophical approaches has become more and more a feature in the questioning of our Western ways, based on the logocentric emphasis on culture which thus far has prevented a consistent shift from an 'I-centredness' humanist position. The work of Kinji Imanishi, a Japanese ecologist and anthropologist, founder of Kyoto University's Primate Research Institute, suggested a different relational model with nature as early as 1941. In his book, *A Japanese View of Nature*, Imanishi re-thinks our understanding of animals, environment and humans by outlining a holistic cosmos where animals are an integral part of environmental systems, and environments are seen as extensions of living beings. The work of Imanishi is of particular interest, as it operates across the fields of biology and philosophy, and pioneers views that today have come to the fore in ecological concern. In the chapter 'Similarity and Difference', Imanishi explains that 'The category of living things includes both, animals and plants, advanced and primitive things, and many in between; each inhabits its own world and leads a particular life so that each living thing should be studied in its own proper perspective.'[3] Through Imanishi's writings, the importance of considering humans as part of a holistic system – not just from an ecological, but also a philosophical perspective – becomes very evident.

In the middle of the 1980s, the development of 'deep ecology', an alternative, holistic understanding of the cosmos emerged to challenge 'shallow ecology', the archaic anthropocentric approach that understands nature as a resource to exploit. In deep ecology, also a central theme in *Avatar*, a sense of connectedness and belonging to the cosmos is imbued with a spiritual quality. This element heavily features in the film as a variant form of pantheism. In pantheism, nature and God are indissolubly one, defining a spiritual bond that replaces the worshipping of a supernatural external God. Pantheistic ideas are pre-Christian, dating back to Heraclitus and the philosophy of the Stoics, therefore bearing relatively solid connections to paganism. In 2006, the book *The God Delusion* by Richard Dawkins attracted much criticism because of its boldly presented views, openly doubting the existence of one God. Dawkins felt compelled to write the book in response to the rapid spread of 'creationism' in the United States, which reached its climax in the 2007 opening of the Creation Museum in Kentucky. The event was received by a media frenzy that led public opinion to believe this to be the first institution of its kind. However, it soon emerged that 12 others had already opened around the United States over the previous few years.[4] What at first seemed an

extravagant, isolated case suddenly revealed itself to be 'the tip of the iceberg', an iceberg that had been growing in size for over two hundred years.

In 1802, William Paley (1743–1805), an Anglican archdeacon, developed the idea of natural theology. He claimed that a person who found a watch on a heath could not deny the existence of a superior intelligence that had designed, made and lost the object. God was no other than the watchmaker of the world, and human beings discovered the results of his work in the treasures of nature.[5] It is evident that Paley's ideas, if not directly informed by Descartes's understanding of animals as automatons, were in any way cast in a similar mould, positioning the understanding of nature as a mechanical object primarily created for man's use. It is not therefore much of a surprise that the reviews *Avatar* received from *L'Osservatore Romano*, the official Vatican newspaper, directly pointed to the pantheistic content of the film. Gaetano Vallini writes,

> the subtle environmentalism gets bogged down in a spiritualism linked to nature-worship which hints at one of so many fashions of our time. Making nature-destroyers of the invaders, and environmentalists of the indigenous, seems to be an over-simplification which lessens the scope of the plot.[6]

The Vatican Doesn't Like Plants

The Vatican's criticism of *Avatar* was rather fierce. A remark especially made in a review broadcast by Radio Vaticana (the official Vatican station) expressed more directly reservations with the pantheistic subtext of the film:

> But the enchantment has less enchanting motives, too: Pandora is a planet which cleverly winks at all the pseudo-doctrines which have made ecology the religion of the millennium. Nature is no longer a creation to be defended, but a divinity to be adored, while transcendence is emptied by incarnating itself in a plant and in its white vines which nourish spirits, branching off into real pantheism. *Avatar* seems harmless, and certainly is not the first to propagate the eco-spiritualist tendencies shown through the beauty of the planet Pandora; tendencies born in the Age of Aquarius and seemingly confirmed only in 2154, the year in which the story takes place.[7]

Statements such as these capture the underlying insecurity that pervades the current Christian approach to global culture. The use of carefully selected reductionist labels like 'pseudo-doctrines' or 'fashions of our time' in reference to the pantheistic features of *Avatar* clearly denote a lack of understanding of the current ecological paradigm and the urgency to engage audiences, in one way or another, in the ecological debate. Unfortunately, it seems that on holy grounds at least, a revisitation of the Christian-Cartesian relational

mode with nature seems not only impossible, but condemned *a priori* as a direct threat to God.

Of all the questionable statements delivered in the Vatican reviews, one specific remark, that 'transcendence is emptied by incarnating itself in a plant', is of particular interest. It is clear that to Pellegrini the idea that a plant could be envisioned as a transcendent entity is utterly implausible and incorrect. Let's not forget that Christianity and anthropocentrism are indissolubly bound; after all it is in Genesis that God says, 'Be fruitful and multiply and fill the earth and subdue it and have dominion over the fish of the sea and over the birds of the heavens and over every living thing that moves on the earth.'[8]

Animal/Human/Machine/Plant?

Through the disintegration of the dichotomic opposition of nature and culture proposed by Donna Haraway, her vision of boundary-breakdown between animals, humans and machines bears a conspicuous omission: plants. Why have plants been ignored in the outlining of the cyborgian reconfiguration? To this point, plants have been silent witnesses to the animal revolution in the humanities and the arts. Frequently studied for their medical properties and consistently exploited for their aesthetic, edible and malleable qualities, plants have played a defining role in the historical and cultural development of humankind. Just as this role comes increasingly into focus, the botanical world is seriously threatened by the same agents that affect animals. Forests are razed at an alarming rate as large seed banks scramble to preserve genetic material of the world's flora before it is lost. Why are plants, then, not yet part of the current humanities discourse? Why would the current revisionist wave responsible for the reconsidering of our relationship with animals draw a line at the botanical? As posthumanism addresses the humanist foundations that still support our daily lives, the acts of decentralising, questioning, fragmenting and reconfiguring have largely taken place away from the botanical world. This leads one to ask how much of the humanist approach to the hierarchical is retained by posthumanism. Is there a safe organisational structure in place which posthumanism implicitly adheres to and that prevents its rhizomatic network from imploding? Are plants merely a backdrop in front of which the posthumanist reconfiguration takes place? Would there be an interest in exploring different relational opportunities? Would it even be possible to think about plants as companion species?

In *Avatar*, the Tree of Souls (Vitraya ramunong) is a bio-luminescent weeping-willow-like tree guiding force and deity of Pandora, which also establishes a network between al Na'vi that allows them to communicate through an expanded sensory awareness. The Tree of Voices functions instead as a historical collective memory that allows the natives to hear the voices of their ancestors. Most visible of all in the film is, however, the giant Home-Tree, standing

roughly 460 metres tall: this is where the leading clan lives. On Pandora, it could be argued that plants have overtaken animals in the forming of vital relational modes. Following this visionary example how would a different consideration of plants contribute to the shifting of human–animal relationships, and moreover to our relations with the ecosystems we live in?

Plant and Animal Cognition

The International Laboratory of Plant Neurobiology was founded in 2005 in Florence, and ever since has greatly contributed to the scientific debate on plants' cognitive and sentient qualities. A few years earlier, in 2003, the provocative essay by Professor Anthony Trewavas (University of Edinburgh) titled 'Aspects of plant intelligence'[9] ignited the debate.

The essay bravely addressed the concept of intelligence in plants, and went on to argue not only that plants are intelligent beings but that they are also capable of learning through memory. Defining intelligence in living beings is a particularly difficult task – the misconception that humans are more intelligent than other animals, for instance, is still perpetrated, even in Trewavas's text. We are gradually coming to realise that there may be no such thing as one objectively quantifiable type of intelligence (aside from that portrayed through the questionable processes involved in IQ tests), but that there are different intelligences for different inclinations and niches. If we can recognise intelligence in animals, on what grounds would we deny this to plants?

Recent advances in plant molecular biology, cellular biology, electrophysiology and ecology have unmasked plants as sensory and communicative organisms, characterised by active, problem-solving behaviour.[10] Plants are not the passive, 'ultimate automata' which many conveniently like to think. There is a lot more to them. But of course a new understanding of plants would come with a set of new and challenging ethical issues to address, some of which may hit hard at the foundations of veganism and vegetarianism's quasi-certainties.

Speed, Intelligence and Memory

One of the main issues related to the understanding of non-mammals and plants in general revolves around the fact that these beings operate on different timescales from ours. In animals, behavioural responses are identified and measured through the materialisation of rapid movement. The main difference between animals and plants here is that movement in plants appears to be intrinsically bound to growth, and as growth is something humans and animals do not consciously have control over, then plants' ability to move is automatically discounted, perceived as a result of involuntary drives, the equivalent in us of hair and nail growth. However, this is not entirely the case, as it has been shown that plants have

control over their growth and that growth in plants is the result of carefully gathered and processed information.

In 2007, *Growth Rendering Device*, an installation by robotic artist David Bowen, brought to the gallery space the seemingly imperceptible process of plant-growth and movement. Traditionally, representational tropes of the botanical world have largely been developed through the static nature of illustration and painting. In opposition to the fixity of the innumerable paintings of plants which have made the history of the still-life genre, and in contrast to the tradition that mainly, in that context, understood them as a *memento mori,* in this kinetic installation a robotic armature held a vase with a pea plant, whose daily movements were captured and documented over the length of the exhibition. A rasterised inkjet drawing of the plant's profile was created every 24 hours.

In doing so, the movements of the plant – which belong to a quality that we only generally appreciate as growth rather than motivated movement – were made visible. These diagrams clearly showed how leaves shifted in time to capture the required amount of light, and by doing so allow us to appreciate how the whole structure is continuously balancing its own weight and mass in relation to external stimuli.

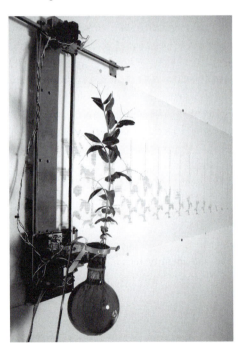

22. David Bowen, *Growth Rendering Device* (2007).

A few plants are capable of movement fast enough to be perceived by us, thus insistently prodding the boundary that separates them from animals. Shy plant (Mimosa pudica) and the famous venus flytrap (Dionaea muscipula) are among these. Mimosa pudica is a small plant with compound leaves capable of folding shut when touched. The movement is smooth and immediate, and the leaves part again when the plant is not disturbed for a few minutes.[11] This behavioural trait may have been developed to discourage grazing animals or even to shake off parasites. This is the result of an evolutionary adaptation that tells us one very important thing: that the plant is able to feel being touched – the plant is sentient. How far we could take this statement is entirely up to how willing we are to embracing a reconsidering of the boundaries that conveniently

separate us from animals and plants. Venus flytrap has developed apparatuses capable of closing extremely rapidly to imprison and then digest small insects. This plant, native of the Carolinas in the United States, has evolved in order to supplement nutrients scarce in the soil in which it grows. In this case too the plant is sentient and has developed, through evolutionary processes, an original and far-from-passive approach to feeding as it captures insects in its multiple ciliate mouths.

Movement and speed are not, however, just problematic elements in the observation of plant life, but also become challenging quantities in the understanding of non-mammals that operate at considerably different speeds from ours. For instance, most insects are just too fast for our perception, and their behaviour therefore appears to us non-calculated, mechanistic and unmediated by reason. In 1974, in *The Evolution of Intelligence*, David Stenhouse defined the expression of intelligence in animals as that delay needed for response to a signal. This delay is erroneously understood as the presumed act of cognition required to appropriately assess external circumstances, resulting in pertinent, calculated behaviour.[12] This is what Imanishi draws our attention to when he says that each being should be studied in its own perspective. Which perspectives could be adopted and how might we depart from our own established cognitive sets in order to find these perspectives is the key challenge ahead.

One of the most pressing questions we could now pose is where in the plant does cognition take place? In humans and animals the brain is the site of cognitive functions, but in plants? There seems to be unanimity that the plant is a 'whole thinking body' in which decisions are taken at multiple points, at organ level. However, new evidence has recently emerged to further this theses. Most interestingly, scientific research looked back at the original experiments that Charles and Francis Darwin conducted on plants between 1850 and 1882. In *The Power of Movements in Plants*, the Darwins presented a discovery that was then discredited, and has only recently been reconsidered as valid. Leading botanists of the time, including Julius Sachs, strongly disagreed with the Darwins, leading to a general abandoning of this path. However, the ideas were reconsidered by Stefano Mancuso, currently director of the International Laboratory of Plant Neurobiology in Florence. Through his research (2008) it has been revealed that

> Plants recognise self from non-self; and roots even secrete signaling exudates which mediate kin recognition. Finally, plants are also capable of a type of plant specific cognition, suggesting that communicative and identity recognition systems are used, as they are in animal and human societies, to improve the fitness of plants and so further their evolution. Both animals and plants are non-automatic, decision-based organisms.[13]

These new developments suggest that the humanities in general, and in particular the field of human–animal studies, has some catching up to do, in order to reassess the role played by plants in the posthumanist rhizosphere. However, before this can take place in a

productive way there is a secular complication that urgently needs addressing: language. Although Trewavas's attempt to re-think plants in an admittedly provocative way is extremely valuable, clearly in order to understand and therefore articulate the distant and radically different behavioural modes presented by plants, concepts such as 'memory', 'learning' and 'intelligence', used by Trewavas, may need to be revisited in their essential meanings when applied to the botanical world, in order not to become anthropomorphically entangled. In other words, we could go as far as suggesting that new words might be coined to capture the complexity of something that animals and plants do/are, but that stands for something different from what we experience.

The Abyss

The emblematic moment in which Jacques Derrida, emerging from the shower, found himself being looked at by his cat has predominantly shaped the methodological approaches to most recent philosophical speculation on animals.[14] The main questions posed by this encounter highlighted the presence of an unbridgeable abyss between man and animal, one Derrida more accurately identifies as 'the abyssal limit of the human'.[15] From this point onward, the concept of the return of 'animal gaze' has extensively contributed to the re-thinking of the animal from object to subject, and more recently to becoming in the contemporary animal-studies discourse. The concept of gaze acquired popularity in continental philosophy during the 1960s through the discussion of the 'medial gaze' by Michel Foucault and the expansion of Lacan's analysis of the role played by the gaze in the theorisation of the *mirror stage* as part of the development of the *concept of identity, subjectivity* through to *imaginary order*. However, it was in the early 1970s with the work of John Berger (*Ways of Seeing*, 1972) and through the essay 'Visual pleasure and narrative cinema' that the concept was fully discussed in the gender-driven discourse of professor of film Laura Mulvey. In art history, the most prominent example of powerful gaze is that offered by Manet's *Olympia* (1863), the high-class Parisian prostitute portrayed proudly lying naked, looking her viewer straight in the eyes. Similarly, the return of the animal gaze came to represent a challenging moment in the power relationship between human and animal. As noted by Theodor Adorno in *Aesthetic Theory*, there 'is nothing so expressive as the eyes of animals – especially apes, which seem objectively to mourn that they are not human'.[16] In Hegel, we find that the 'soul' makes itself apparent through the eye.[17] Therefore the centrality of this organ within the spiritual context is paramount to the essence of the human in opposition to the animal, to which Descartes denies a rational soul altogether, saying that 'the souls of animals are nothing but their blood'.[18] Therefore, when it comes to the animal, and of course the plant, the eye becomes a very complex entity.

In the light of these intricate complexities, discussing the return of the gaze in relation to a primate or other mammal is one thing, but attempting to apply the same concept to the

compound vision of insects, or even to the seemingly blind world of plants, reveals the limitations of this approach. Among insects, the praying mantis is able to return the gaze; and what a brave confrontation it is. That beautifully alien insect body, so distant from our human anatomical structures, seems to imbue the stare with incredible weight. The insect clearly acknowledges our presence and, unlike others, its first instinct is not necessarily flight. The mantis turns its head, and looks at you straight in the eyes, or so it seems. Its large compound eyes, capable of a superhuman 360-degree view, present dark, round areas that strongly evoke the presence of pupils. However, these 'pupils' are illusory, not what they seem.

Is the abyss discussed by Derrida too wide and too deep when the gaze returning ours is that of an insect? Are there productive opportunities, exchanges and relationships involved in this kind of encounter too, and if so, why have these been thus far overlooked in favour of a focus on mammals? This is of course a complex and multifaceted argument, and most likely one of the main reasons why mammals have been consistently the focus of our relations with animals lies in our inherently anthropomorphic approach, one that works well with other mammals, but one not so well with insects or plants.

Anthropomorphism and the Animal Face

Anthropomorphism is an innate way of establishing an engagement with the animal. In modern times, and especially in popular culture, the attribution of distinctively human attributes to animals not only serves as a commercial strategy that facilitates the selling of animal bodies as cultural objects, but is seemingly an inescapable behavioural reflex that we all fall into at some point or another.

The photographic project *The Inheritors* (2001) by Nicky Coutts captures the ambiguities of anthropomorphism through the creation of unsettling imagery in which animal faces have been altered. Coutts's work directly challenges Levinas's assertion of the impossibility of the *animal face* as distinguished from the ethical significance of the 'human face' ('The paradox of morality').[19] In Levinas's phenomenological discussion, *otherness* occupies a kind of primacy which in the realm of the encounter is always unknowable. The face becomes the threshold through which ethical obligation is established among beings and the unknowability of the *other* is the one element which continuously calls for a furthering of the relational. Interestingly, Levinas considers the reduction of something irreducible to something essential as 'violence'.[20] This 'totalisation' occurs when limits are placed on the 'other', and particularly surfaces when the other is, so to speak, pre-emptied of its 'unknowability', representing a denial of difference and autonomy. From this perspective, we may ask if anthropomorphism could indeed be understood as a form of relational violence to the animal through the repression of animality as replaced by a simplified set of human connotative agencies. Levinas's consideration of the animal as other becomes further complicated as he makes a

distinction between mammals and non-mammals through *the* apparent biological condition in which 'lower' animals are segregated. In *The Provocation of Levinas: Rethinking the Other* (1988), Levinas was asked to elucidate his position on the non-human through questions which directly challenged the applicability of his 'ethics of alterity' to animals. Levinas stated that the animal face is merely 'biological', and that it does not invite, or command, a direct ethical response, as the face of the other-human does:

> I cannot say at what moment you have the right to be called *face*. The human face is completely different and only afterwards do we discover the face of an animal. I don't know if a snake has a face … I do not know at what moment the human appears, but what I want to emphasise is that the human breaks with pure being, which is always a persistence in being […].[21]

Through this distinction between human and animal face, Levinas fails to recognise the 'unknowability of the snake', as the animal responses are not based on reciprocity but on what simply seem biological responses.

In the ten black and white photographs that form the series *The Inheritors*, Coutts replaced, through image manipulation, the eyes of animals with those of humans. At a glance, something does not quite meet our expectations, and it is soon after that the gaze of the human eye piercingly emerges. Is this face wholly animal? The return of the gaze from these animals makes for an unsettling and uncanny encounter – the text is open. The images could be intended as the caricatured result of indiscriminate genetic manipulation involving animal and human genes or the opposite, as the suggestion of the inherent closeness

23. Nicky Coutts, *The Inheritors (*7)* (1998).

between animals and humans that should define the ethical remit of our companionship. The superimposed human eye brings the animal closer to a level of equality with the viewer, demanding the chance of a different relational mode, through the allusion of the presence of an emotional world similar to ours. Do these animal faces unsettle, in that they suddenly claim an ethical responsibility that is otherwise denied? In her book *Insectile* (2001),[22] the artist even attempts to give human faces to trees, with rather interesting results.

Anthropomorphism and the Pest

Raid, the insecticide brand which developed a reputation based on the slogan 'Raid kills bugs dead', produced countless TV commercials in which anthropomorphised insects like mosquitoes, cockroaches and flies are recklessly killed. In these adverts the insects are given human-like faces and talk. In the first ever black and white commercial for the brand (1956), numerous analogies between the killing of insects and the use of chemical weapons in war could be drawn, through both the visual imagery and the voiceover. The Raid spray-can is also anthropomorphised, conjuring the muscular body of a white American soldier. The military innuendo is defining to the advert. Mosquitoes flying in a 'V' formation reminiscent of warplanes, are 'swept from the air'. We are told the spray 'hunts them down like radar' as a crowd of insects trying to escape a poisonous cloud is 'attacked'; once the cloud dissolves, a few rows of tombstones are revealed.

Those presented in these adverts are *humanised insects*. Is there an ethical demand made by these faces? If anything, the anthropomorphic representation here suggests the conflation of insects, pests with 'the enemy': an enemy with a face. What is at stake here is effectively control over a territory. The pest becomes such as it invades our home space uninvited. Pests are undesirable animals, those that transgress our safe boundaries and that carry with them the anxiety of multiple contaminations. Their killing is not only frequently encouraged but institutionalised. And though Levinas grants that it might be possible for a dog to have some kind of face, a mosquito having one seems out of the question. The underlying openness which characterises his relational face-to-face mode is intrinsically *totalised* in the pest. Welcoming the other places one's freedom at risk, and simultaneously evokes the command 'Thou shalt not kill', as expressed through the recognition of the face.[23] However, as Levinas acknowledges, war rescinds the unconditional imperative connected with the other and suspends morality[24] – and at war with some animals we constantly seem to be.

A photographic project by the artist Catherine Chalmers, *American Cockroach* (2003–4) attracts controversy every time it is exhibited. This series of photographs records the imaginary and highly anthropomorphised life of cockroaches. The project is structured in three different sections: *Executions, Impostors* and *Infestations*. The *Executions* series sees roaches being killed in an electric chair, being hanged and burnt (seemingly alive). In *Impostors*, the insects

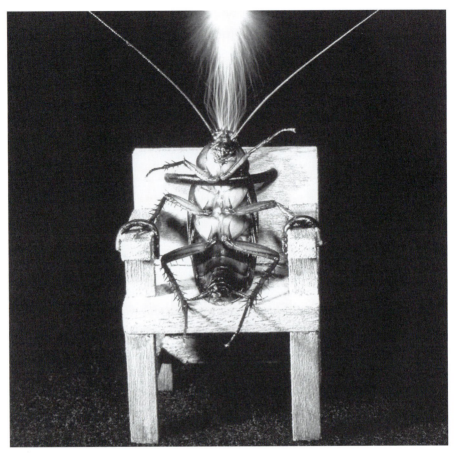

24. Catherine Chalmers, *Electric Chair* (2003).

are given makeovers and look like some form of elegant-looking hybrid. In *Infestations* we find roaches dealing with their day-to-day activities in doll's houses; their presence harshly clashes with the ornate and kitsch décor. Chalmers's photographic work resonates in different ways, with each series focusing on a particular relational dynamic between us and the insect. As viewers, we are at times almost surprised to find beauty in these insects, but we are also quickly reminded of the unpleasant quality which roaches' presence evokes as we see them larger than life, mating on our beds or drinking from a bath tub. It is, however, the *Executions* series which usually attracts most controversy, as the insects have been effectively killed for the creation of the shots. As with other insects which fall into the category of pests, like mosquitoes and flies, killing is the automatic response. However, we will hardly find people complaining at a store that sells insecticides and other insect-killing devices, so why do

viewers react to Chalmers's images? In *Execution* it is the chosen iconography that further complicates not only our relationship with these images but that also comments on the history of executions as a defining trait of Western, and especially American, culture since early modernity. Among other things, this series pushes us to focus on the relevance of size in our relationship with animals. As the artist claims,

> Size is significant in nature. If an animal is large enough to eat you, you tend to give it more credence. If it's small enough to step on, one usually does with impunity. The usual predator prey relationship can easily reverse itself depending on which animal is larger.[25]

Anthropomorphism and Popular Culture

In visual representation, anthropomorphism can be channelled through different mutational paths. The most visible is a morphological alteration of the animal body in order to incorporate some human-like qualities: human-like eyes, upright walking position, or the addition of clothing. In the most pronounced anthropomorphic cases, animals acquire human language. All the 'animal-lackings' instrumentally used by continental philosophy in order to assess the difference between animality and humanness are through anthropomorphism filled with hybrid human–animal supplements.

These newly formed human–animal hybrids are omnipresent in children's entertainment. Hanna-Barbera have since the 1940s created a multitude of much-loved, hybrid animal characters: Tom and Jerry (1940–1958), Top Cat (1961–62) and Yogi Bear (1961), to name a few. *Looney Tunes*, the Warner Brothers animated cartoon series, also produced some memorable characters, like Bugs Bunny (1942), Wile E. Coyote and Road Runner (1948), and Sylvester and Tweety (1945). Why have all these characters been so successful? A large part of the characterisation of these animals depends on the balance between the animal's stereotypical representation of species idiosyncrasies and the careful overlaying of human behavioural traits. For instance, Yogi the bear loves picnic baskets, but is capable of saying 'Hello Mr Ranger, Sir'.[26] As Erica Fudge argues in her book *Animal* (2002), anthropomorphism plays a key role in the production of children's stories, and as such it may be fulfilling one of the key desires of our lives, to comprehend and communicate with animals.[27]

In the light of the fact that anthropomorphism shapes our relational approaches to animals from an early age, we may then assume that as such it plays a defining role in our adult encounters with animals too. Does anthropomorphism then represent an obstacle to a posthumanist understanding of animals? Does it essentially perpetrate a romanticised, distortive and emotionally driven one-directional mode? In a parallel with zoos, anthropomorphism presents a vision of animals that no longer corresponds to their original free-selves. And it can indeed function as a form of control over the animal, as animality is attenuated through

an imposed similarity with humans. In this representational mode, we are the central entity, the one animals emulate. Animals become therefore mirrors for humans, flattened reflective surfaces onto which we project our impulses, vices and virtues. Similarly to the role of zoos, anthropomorphism provides something of an opportunity for contact with the animal, albeit a very mediated opportunity. Is this better than nothing? When we try to understand animal behaviour, the abyss of incommunicability and experientialism can be easily filled by anthropomorphic approaches. How much these approaches contribute towards an enhanced understanding of the animal is up for discussion. In the light of these complexities, it may still be language that constitutes the main obstacle. As Fudge points out, 'If I cannot say that a dog is sad, what can I say that it is? In a sense, without anthropomorphism we are unable to comprehend and represent the presence of an animal.'[28]

In his series *Animatus*, Korean artist Lee Hyungkoo focuses exactly on the paradigmatic set in which an anthropomorphic representation of animals merges, in the tradition of animation, through the realistic anatomical representation of natural-history-museum specimens. In *Leiothrix Lutea Animatus* (*Tweety & Felis Animatus*, 2009) the cartoon characters' essential two-dimensionality is challenged through the evidence provided by the anatomic plausibility of the skeletal structures created by the artist. The three-dimensionality of the these skeletons – captured in a classic narrative moment, as in the tradition of natural-history display – through a hiatus of hyperrealism infiltrates these characters into the order of natural history, posing the taxonomical question of how evolutionarily close to us these anthropomorphic animals may actually be.

In the media, anthropomorphism can effectively facilitate the empathic relationship between characters and audiences; the bond, in diegetic terms, is created on grounds that do not necessarily owe anything to real-life dynamics. One of the main agencies of anthropomorphism in fiction is of allowing for complex and at times troubling issues to surface at a safe distance. The dramatic stories of *Dumbo* (1941) and *Bambi* (1942) could well be used as examples of children's stories addressing deeply traumatic events. In both narratives, the animal functions as a vehicle through which difficult stories about human relationships can be told in a cautious yet direct way.

Anthropomorphism and Speciesism

Detractors of animal anthropomorphism, like physiologist Ivan Pavlov and entomologist John Kennedy, condemn it as an anti-scientific approach that prevents the accessing of 'true knowledge of animal-life.'[29] In summer 2000, British philosopher Roger Scruton extended this idea and fiercely criticised animal-rights activists for their anthropomorphic views, and labelled their approach as 'anti-scientific mechanism'.[30] It is entirely true that anthropomorphism permeates our relationships with animals in a number of ways, and where to draw a line in

the relativist approach is not an easy task. As Erica Fudge argues, anthropomorphism in its inherent distorting quality may indeed also serve an ethical function: 'If we don't believe that in some way we can communicate with and understand animals, what is to make us stop and think as we experiment on them, eat them, put them into cages?'[31]

It is in the field of animal-rights advocacy that we encounter one of the most complex issues related to anthropomorphism: the problem of 'speciesism'. Since the term was coined by Richard Ryder in 1973, and subsequently further contextualised by Peter Singer through the publication of his 1975 book *Animal Liberation*, the multifaceted and self-propagating discussions generated by the seemingly endless applications of this concept have consistently defined our attitudes towards animals in a multitude of fields.

A speciesistic approach involves assigning different values or rights to beings on the basis of the species to which they belong. In principle, the concept claims that animals should not be treated as objects or property in the light of their sentient qualities. However, those opposed to the recognition of human-like rights for animals, like Scruton, claim that anthropomorphism, through its distorting lens, plays a defining role in the idea that animals and humans should be considered equal, and that no distinction should be made between species.

From animal-rights activism to environmental campaigning, from defining animal welfare in farming to the regulation of animal experimentation in pharmaceutical laboratories, speciesism has effectively marked a line, or more accurately a series of blurred lines between the ethically justifiable, the excusable and the unacceptable in our relationship with animals. While the achievements of speciesism go undisputed in the field of animal liberation, it may be worth focusing on the blind-spots involved in the concept, as these, like its arguments, have also in turn highly influenced our attitudes and approaches to animals, and appear to constitute a great part of the foundations on which the contemporary academic scrutiny of human–animal studies develops.

In Mark Dion's installation from 1990, *Wheelbarrows of Progress*, the leading wheelbarrow was loaded with stuffed animal toys that through a typical iconic cuteness proposed a sharp critique of the environmentalists' tendency to focus on charismatic animals. *Survival of the Cutest (Who Gets on the Ark?)*, the title of the first wheelbarrow, presented an obvious selection of megafauna. The message is clearly and sharply captured by juxtaposition of the soft stuffed toys and rough utilitarian surfaces of the wheelbarrow. Here, the toys directly comment on the objectification of animals and the inescapable drowning of these in the capitalist system that simultaneously kills them and sells off their bodies. The elephant, the panda, the polar bear, the zebra, they all belong to the cliché of the 'animals to save'; the animals containing an anthropomorphic other, or in the understanding of Deleuze and Guattari, the 'Oedipal' animals, 'those which invite us to regress, draw us into a narcissistic contemplation and [...] are the only kind of animals psychoanalysis understands'.[32] Simultaneously, the presence of the wheelbarrows addresses our relationship with nature as a resource to exploit and commodify.

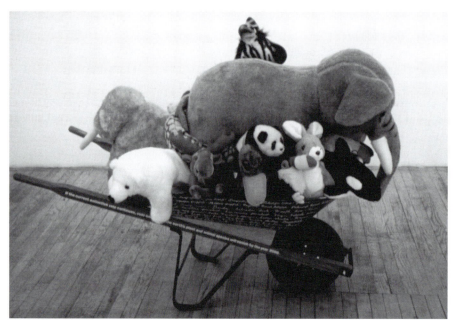

25. Mark Dion, *Survival of the Cutest (Who Gets on the Ark?)* (1990).

In deconstructing speciesism, we find that through arguments in which the generic term 'animal' is persistently used, this stands simultaneously for a plurality of beings at once: a chimerical, compound body that might remind us of those created by Thomas Grünfeld. Further observation would reveal that this chimera is one in which all the body parts seem to belong to different mammals, at times to birds, but never those of insects, arachnids, reptiles or amphibians. The 'all-encompassing animal', extensively used by the principal philosophers of the continental tradition, fails in signification if used to articulate the complexities presented by the postmodern animal. Most evidently, Derrida coined the neologism 'animot' in order to challenge this singularity and homogeneity of the generic term 'animal'. Derrida's preoccupation in the creation of this word was of a linguistic kind, where 'animot' alluded to an *otherness* capable of pervading the word, language and discourse.[33]

Paradoxically, it seems that through the *speciesistic* discourse some animals are represented as being more animal than others. So, in the attempt to bring mammals and humans closer, speciesism may have also inadvertently distanced non-mammals from us and other animals. It seems that the more animals are perceived to be taxonomically close to us, the easier it is to anthropomorphise them, and the more we are inclined to acknowledge human-like rights to them. But what happens when we stretch further afield in the taxonomic order? What are the challenges involved in the encounter with a non-mammal from this

perspective? Moreover, what are the potential productivities that may lie at the core of such encounters, which we are currently overlooking?

The concept of 'pain' has historically functioned as one of the main discriminatory tools employed by speciesism through its articulation of difference and similitude between animals and humans. According to the utilitarian vein that runs through the concept, pain is a negative quantity, and the amount of pain felt or inflicted makes a difference between the ethically acceptable and unacceptable. Here is where the largest problematic areas involved with speciesism can be encountered. What effectively is pain? How do we measure other beings' pain? How do we know if other animals feel pain, and whether their pain is comparable to our own?

In 'The animal that therefore I am', Derrida asks 'Can they suffer?' and, reaching for a plausible answer, he explains, 'No one can deny the suffering, fear or panic, the terror or fright that can seize certain animals and that we humans can witness.'[34] It seems clear here that the 'certain animals' Derrida refers to are mammals, perhaps birds at a stretch. Are all the others forever destined to a world of passive cultural existence?

The scientific debate revolving around the subject of animals and their sentient/non-sentient qualities is constantly subject to revision. However, in our daily lives, our recognition of pain is entirely limited to what we perceive as indexes of it: screaming, twitching, bleeding, crying and so on. When these indexes are transposed to taxonomically more remote animals or even plants, a majority, or all, fail in signification. However, recent research consistently tells us that fish, crustaceans and insects can indeed feel pain.[35]

Pain intrinsically calls for empathy. We clearly establish a sympathetic link with the animal based on formal analogies and assumptions. Beyond sensory perception, our quantification of pain is also strictly bound to our scientific knowledge of biological responses: these are by no means to be understood (as we seem to think) as universally correct or exhaustive. Historically, due to technological advances as well as cultural shifts, our understanding and acknowledgment of a number of phenomena has changed dramatically, bringing us to re-evaluate many quasi-dogmatic life-certainties. Could it be that one day soon, new technologies will enable us to understand better the sentient qualities of invertebrates and plants? After all, we are always bound to the 'scientific extensions' of our senses, and as a consequence we only measure the world with a humanly limited set of tools. As Kant argued, 'we only perceive what the senses present to us, but have no knowledge of the way things beyond the impressions they give us really are.'[36]

When it comes to animals and plants especially, it seems particularly evident that we are confined to *the world of appearance*, and that, as Kant argued, this is of necessity not the real world, since it is heavily informed and shaped by consciousness. Could it be that establishing different connections between us and cold-blooded animals truly requires a great conceptual leap, one for which we are not yet ready? And is that leap too demanding, such that the work required outweighs the rewards?

Beyond Anthropomorphism?

Jakob von Uexküll offered an opportunity for a change in attitudes towards animals in general, and in particular towards those taxonomically distant beings, through the formulation of the concept of *Umwelt* while studying ticks in the early twentieth century. His interest in the infinite variety of perceptual worlds of inexplicable animals drove him to develop the concept in order to avoid being trapped in the false knowledge imposed by human judgement, anthropomorphism and the superimposition of human values. Agamben interestingly describes *Umwelt* as follows:

> Where classical science saw a single world that comprised within it all living species hierarchically ordered from the most elementary forms up to the higher organisms, Uexküll instead supposes an infinite variety of perceptual worlds that, though they are uncommunicating and reciprocally exclusive, are all equally perfect and linked together as if in a gigantic musical score.[37]

Umwelt has recently resurfaced in academic interest, but can it cross the boundaries of philosophy and science in order to inform larger audiences, and so to guide our perception and understanding of these animals towards new trajectories? Some contemporary artists are attempting to apply this concept to their work. Over the past ten years a Colombian artist, Maria Fernanda Cardoso, has developed an international reputation for her body of work focusing on insects. She has very little doubt about her collaborators: 'Of course all living things are sentient beings. How could you eat if you did not feel hungry? How could you avoid danger if you couldn't perceive it or couldn't fear it? How can you live if you don't know what's good for you and what's to be avoided?'

Her best-known work is perhaps *Flea Circus*, where the stunts of real flea wire-walkers, trapeze artists, cannonballs are magnified and beamed onto screens for the amazement of the audience. Aside from the spectacle involved (an element also worthy of scrutiny) it is remarkable that Cardoso effectively establishes a close relationship with one of the smallest and most undesirable insects in the world. As she explains, the fleas are directly rewarded by feeding on her blood, but as it is, she lives off them as well. In this work she effectively tries to figure out the *Umwelt* of the fleas in order to identify relevant 'carriers of significance', elements that trigger the insect's interest. How does she obtain cooperation from the fleas? 'I try to imagine how the fleas perceive me and the world around them, and try to re-create or use aspects of it to my advantage. I try to use those key elements so I can induce certain behaviours.'[38]

Uexküll's *Umwelt* constitutes an original form of engagement with animals, especially with those which do not return the gaze, through the way that the animal's world is determined by the limits of the animal's perceptions and its range of actions in response to it. Portuguese designer Susana Soares uses bees' and mosquitoes' exceptional odour perception as part of

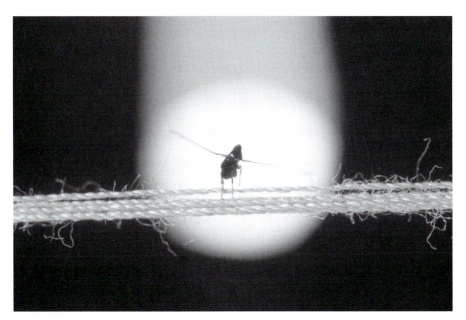

26. Maria Fernanda Cardoso, *At the Tightrope with a Balancing Pole*, from *Flea Circus* (1996).

a beautiful and strange medical-sensing device establishing a human–nature collaboration that takes advantage of untapped naturally occurring phenomena. The artist explains:

> The idea behind *Why Me* is that people will find out, in a playful way, if their body odour is attractive or unattractive to mosquitoes. It works in a rather simple way: two people place their hands on the opposite sides of the object and in an average of 90 seconds the insects will invariably fly towards the most attractive scent. [...] Unattractive chemicals might be a sign that the person they are about to feed on is unsuitable due to stress caused by illness or disease. This also generates shifts in the way we perceive mosquitoes as in this case it would be a positive thing that the mosquito chooses you as it could be signifying good health.[39]

Soares claims that new advances in areas such as genetics, biotechnology and nanotechnology are changing our very nature, not in a way that we can perceive, not as an act of natural selection or evolution, but due to technology. In the near future, people could be equipped with machinery that would enhance their perceptions, allowing them, among other things, to have brushy nails that will scrape genetic information while touching. In which situations would we use them? Who's going to use them, and what for? We find that both Cardoso and Soares develop a very intimate knowledge of the biological and behavioural peculiarities of generically undesired insects and present this new knowledge to audiences

in challenging and engaging ways, reversing the pre-established stereotypical expectations involved in the encounter.

The Technological Bridge Over the Abyss

The influence of technological advance in the creation of new and different relational modes between humans and animals has become a key aspect of Ken Rinaldo's work. Rinaldo is an artist and academic who creates multimedia installations that blur the boundaries of art and biology through the use of highly sophisticated technological interfaces. One of his most innovative projects, *Augmented Fish Reality* (2004), is an interactive installation consisting of five rolling robotic fish-bowl sculptures designed to explore inter-species communication. Siamese fighting fish control these sculptures using intelligent hardware and software. Fighting fish are very territorial, have excellent eyes that allow them to see outside the water; they have colour vision, and seem to like yellow.[40] Small lipstick video cameras mounted under two of the bowls capture images of the interior of the fish bowls as well as humans in the gallery environment. These images are projected onto to the walls of the gallery space to give human participants a sense of the interior of the tanks and a feeling of immersion in them. These are robots under fish control, as the fish may choose to approach and/or move away from the human participants and other fish.

Research by Culum Brown at the University of Edinburgh argues that fish intelligence is much greater than originally believed.[41] Fish are now regarded as steeped in social intelligence while also displaying cultural traditions and cooperating to observe predators and obtain food. Some fish have demonstrated impressive long-term memory and the ability to map their environments mentally in finding food, creating relationships with each other and avoiding predators. *Augmented Fish Reality* again suggests that the development of micro-machines, biotechnology and computer systems will further collapse the gap between the organic and inorganic world as these machines expand the spectrum of senses available to humans and other animals. Intelligent systems, coupled with sense-extension lenses, are getting progressively more transparent and embedded in deeper levels of our sensorium. Thus the perceptual alterations that may occur with these lenses are less and less overt.

The next question, the artist explains,

is what kind of implants are possible that will allow us to augment and extend normal ranges of hearing, for instance? Perhaps to the subsonic or ultrasonic levels so we can hear the ultrasonic chirps of bats or sub audible rumblings of killer whales, without cumbersome electronics. This will certainly increase the possibilities for inter-species communication. What new knowledge and ways of seeing might we have access to with new extended senses? What other senses, like vision, touch, or

27. Ken Rinaldo, *3D Visualisations of Augmented Fish Reality* (2004).

smell could be augmented? Might we create a sixth sense that would allow us to directly sense pheromones? What more can we understand about animals signalling, if we could really use computers, sensors and statistical analysis of body languages in relation to certain situational and environmental cues, that would allow us to really understand how animals intercommunicate?[42]

In 1974, 'What is it like to be a bat', a controversial essay by American philosopher Thomas Nagel, argued that phenomenal subjective experience is not expressible through objective terminology. A bat is a mammal of the most peculiar kind. For instance, it is capable of flying, and also has an extrasensory capacity called echolocation which humans lack. At once the bat is radically different from us while maintaining a bond of closeness to the human which is perhaps more direct than that between humans and birds and insects. Nagel claimed that 'no matter how the form may vary, the fact that an organism has conscious experience *at all* means, basically, that there is something it is like to *be* that organism.'[43] This condition 'is not analyzable in terms of any explanatory system of functional states, or intentional states, since these could be ascribed to robots or automata that behaved like people though they experienced nothing.'[44] However, this does not mean that we should not acknowledge its existence. Nagel recognises that bats have experience and

that 'We must consider whether any method will permit us to extrapolate to the inner life of the bat from our own case, and if not, what alternative methods there may be for understanding the notion.'[45]

Artist Antony Hall has used his scientific knowledge to enable humans to establish a communicative link with electric black ghost-fish. In *ENKI Technology* (2008), the fish are kept in a tank as the human participant wears headphones and light frames (used to expose the eyes to controlled bursts of light), to become immersed for 15–30 minutes in controlled light and sound. The electrical signal from the fish is being transmitted to the human body, and it creates an electrical image for the fish to use. Through this communicational network, which capitalises on electrical impulses – the main means of communication for the fish – we may experience as closely as possible what it may be like to be a ghost-fish, if only by proxy.[46] Could the opportunity of inter-species communication with animals invite us to also establish a more respectful reciprocity?

The current state of affairs in popular culture suggests that the animal-rights messages against animal cruelty have worked relatively well for mammals; however, invertebrates and other cold-blooded animals have not been granted any rights at all, and are therefore killed in front of TV cameras for the purpose of entertainment. The popular TV programme *I'm a Celebrity… Get Me Out of Here!* offers a good example. Since its first series was aired in 2002, the programme has routinely included the unnecessary and relentless killing of invertebrates of all kinds, as well as the mistreatment of a range of cold-blooded animals. These killings went largely unquestioned until, on the 6 December 2009, the BBC reported, '*I'm a Celebrity… Get Me Out of Here!* winner Gino D'Acampo and Stuart Manning face charges of animal cruelty after cooking and eating a rat in the show.'[47]

The RSPCA stated, 'The killing of a rat for a performance is not acceptable. The concern is this was done purely for the cameras.'[48] The following day, *The Guardian* newspaper reported that 'ITV has apologised over the killing of a rat on *I'm a Celebrity… Get Me Out of Here!* and will change the show's guidelines to ensure it does not happen again.'[49] Subsequently, ITV was fined 3000 Australian dollars. Interestingly, newspapers around the world widely reported the news, but missed the opportunity to question what the real difference between killing rats and insects is. Is this in any way a question relevant to audiences? To find a hint of such daring thinking, one has to look at the online comments posted by readers in response to the article. One reader of *The Independent* newspaper interestingly points out,

The RSPCA have obviously taken their eyes off the ball here. Whilst Gino and Stuart were busy getting stuck in to a nice bit of rat, their fellow contestants spent the whole of the series eating live grubs, insects and arachnids all in the name of entertainment. Did the RSPCA miss all of that? Maybe I'm naive in assuming that insects are animals? Or are they just not cute enough to bother about?[50]

Why did the RSPCA react so strongly towards the killing of one rat while the systematic killing of cold-blooded animals programmed in the day-to-day running of the show received no objections? Why did none of the reports mention the paradoxical double standards which clearly drove the RSPCA's reaction?

The turn of events poses a number of questions about our attitudes towards animals and the ethical issues involved in the killing of this and the other, the pest, the pet, the sentient and the allegedly non-sentient. As the TV programme is truly internationally popular, one may ask what impact on viewers and their understanding of animals it may have. We could even go as far as asking why it is even possible to produce and air a TV show that capitalises on the killing of invertebrates and cold-blooded beings? Which part of the animal-rights message has not worked to prevent this? Had people been eating invertebrates as part of a gallery exhibit, would the outrage have been immediate?

In 1995, in a defining revision of *Animal Liberation*, Peter Singer drew some considerations on the sentient qualities of taxonomically more distant animals, and surprisingly took a U-turn on his initial standpoint establishing that, ultimately, taxonomically more remote y Abeings should be treated as we would treat mammals. However, this part of the argument does not seem to have had the same impact as the original one in favour of mammals.

Returning to the discussion of anthropomorphism and its influence on our understanding of animals from an early age, one may be left wondering if the disparity in approach towards mammals and non-mammals effectively starts there, through the anthropomorphic projections and the sense of connectedness with the world that it instils in a child. Animals enter the world of children as colourful anthropomorphised entertaining entities, and for many only transform into boring realities after the infantile stage. As a result of this reflexive process all the animals that do not lend themselves to anthropomorphic relational modes are excluded, at least for many, becoming invisible and merging with the leafy backdrop. At times, when these creatures are encountered, a sense of disgust, indifference and apathy prevails, so that no relational mode different from that of pure objectification becomes possible. Butterflies are of course an exception, but only because of their essential connotation as beautiful natural objects. The words of Kinji Imanishi come again to mind: 'so that each living thing should be studied in its own proper perspective'.[51] Could it be that from an early age children could be educated to relate to animals in different ways, so as to be guided in the understanding that certain animals will be able to offer a relational mode that others simply will not, but that for this reason they should not be looked at as inferior and worthless, but only as different? And might this avoidance of simplification also bring children to develop into more tolerant and understanding beings towards other humans too? And finally, can the involvement of animals in the works of artists discussed in this chapter play a role in promoting this type of awareness?

Overcoming the boundaries of inter-species communication, or indeed finding alternative ways to engage with non-mammals and even the botanical world, as we have seen, has

been the preoccupation of some recent artistic output. Popular culture has consistently relied on anthropomorphism as a means of achieving a form of empathy with the animal, but the challenges presented by it lead us to consider that the creation of different kinds of knowledge could lead us to different understandings of animals, especially those more taxonomically remote from us. Not only that, but this self-centred empathy often results in stereotypes that can lead to anti-species approaches, as seen in the Raid commercials, or species indifference, as in the discussion of some forms of TV entertainment. However, as scientific knowledge expands, our deeper awareness of the complexity of animal sentience at all levels blurs the boundaries between species – indeed, between plants and animals as well – and raises ethical questions. The same technology that science uses to learn about animal intelligence is being leveraged by artists to express and dramatise this blurring of boundaries, through provocative contemporary works that lead us to question the source of self-recognition (or lack thereof) we find mirrored in the animal gaze. Is this reflection of our own making? That of the animal? Or is it a combination of both? Until science and technology can allow for *Avatar*-inspired shared experience with the *other,* it is in the gallery space that the inter-species experiences have already begun to overlap.

Chapter 6

The Death of the Animal

The killing of animals is a structural feature of all human–animal relations. It reflects human power over animals at its most extreme and yet also at its most commonplace.

(The Animal Studies Group, *Killing Animals*, 2006)[1]

We shouldn't have done it. We did not learn enough from the mission to justify the death of the dog.

(Oleg Gazenko)[2]

Since animals have come to inhabit physically, and not just symbolically, the gallery space, the problematic of dealing with a living being within a structure not specifically designed for its wellbeing has raised substantial questions. As seen in Chapter 1, the white cube does not normally account for the physiological needs of animals; as a result, the deterritorialisation of the animal within the gallery space can indeed be fatal, or at least traumatic.

A question surfaces upon encountering the live animal in the gallery space: is it acceptable to inflict pain, or even kill animals, for the purpose of artistic expression? Circuses claim that no suffering is involved in the performative work the animals undertake. We are regularly told that they enjoy performing as a form of exercise and physical and mental activity. Doubts have been cast on this anthropomorphic interpretation of induced animal behaviour: jumping through a hoop or dancing on a ball can, by human standards, correspond to an idea of fun, but may not necessarily be a source of enjoyment to animals.

The type of spectacle the animal is required to enact in the gallery space tends to differ substantially from that seen under the circus tent. In the white cube, the live animal is generally not trained to perform tricks — it is simply *meant to be*. In compliance with the

paradigmatic set typical of postmodern art, the animal in the gallery space must be the *real thing*, not a mediated referent, and as such, it should display its *thingness*, the one shocking element that even the vivid representation of Stubbs's *Whistlejacket* could not fully evoke.

Kounellis's *Untitled (12 Horses)* (1969), also discussed in Chapter 1, challenged its viewers through the physical presence of live horses within the exhibiting space. A sense of wonder and surprise triggered by the encounter with the live horse, in contrast to the paradoxical distancing caused by centuries of beautified and polished representations of horses, proved challenging.

Until the 1960s, the presence of the animal in the gallery space mainly stood as a metaphorical oxymoron: the encounter with an unpredictable being within a highly rationalised space. As previously discussed, Joseph Beuys's 1974 *I Like America and America Likes Me* pushed the boundaries of the performative encounter between animal and human to claustrophobic levels of physical and metaphorical endurance. It surely paved the way for many artists who engaged with the question of the animal thereafter. But, as exciting as this encounter initially seemed, the novelty wore off relatively quickly, generating a need to surpass and augment such experience. Consequently, artists began to work in two different ways: on the one hand, some undertook further research in the realm of representation by identifying new ways of capturing animals through new and old media but with the aid of embracing and simultaneously challenging philosophical thought, while on the other hand some tried to explore further the dynamics of the encounter through the thrill of death.

The Cycle of Life

The spectacle of killing animals has been used to powerful effect in early-modern times. In 1903, Thomas Edison famously filmed the electrocution of Topsy the elephant. The aim of the one-minute film titled *Electrocuting an Elephant* was to create evidence against the AC electric current in order to promote Edison's own 'safer' DC system. The shock-factor involved in killing the elephant, in this case signifying ultimate strength and resistance, played a pivotal role in the fascination that the footage held for audiences. Based on similar ideas of spectacle, recent contemporary art practice has seen a number of contributions capitalising on this exact fascination.

The trend of killing animals in art was set in 1971, when American artist Newton Harrison planned to electrocute catfish, oysters and shrimps as part of his *Portable Fish Farm* installation at the Hayward Gallery in London. Harrison filled tanks with 135 catfish, 96 oysters, 11 lobsters, 2 crayfish and innumerable tiny brine shrimps to demonstrate how we may live in a polluted environment by harvesting fish. On the opening night, 35 of the catfish were scheduled for electrocution, to be served up to specially invited guests along with hushpuppies and salad. Harrison explained that his 'piece is about the cycle of life'.[3] Interesting as this may sound, we will find, discussing a series of more contemporary works

of art, that this use of 'animal death' as a representational metaphor for 'the cycle of life' and the laws that govern it is indeed a recurring one. The exhibit was extensively covered by the media, not only because of its unusual content, but because it angered comedian Spike Milligan to such a degree that he took a hammer to the Hayward Gallery and smashed one of its windows in protest. The RSPCA eventually stepped in, demanding that the catfish be killed in private, rather than within the spectacle arena set up at the Hayward. The fact that the RSPCA identified the public staging of the killing, rather than the killing per se, as the really unacceptable feature is a matter of great relevance. The animals in Harrison's tanks belong to what we culturally understand as edible species, and as such the killing of these, which happens on a mass scale every day, is morally acceptable. The banquet, taking place in the gallery following the killing also served to reassure audiences that the killing wasn't simply happening in the name of art, but also adhered to the norm of animal killing for consumption. It is, however, the entertainment value linked to the killing, which echoes a morbid fascination for the spectacle of animal-hunts and executions dating back to the performances staged in the Roman Colosseum, that is problematic. Contemporary Spanish corridas can be used here as a controversial example of a still-practised formula of entertainment involving the public suffering and killing of an animal.

One of the most interesting aspects of the killing that takes place in the gallery space is that it functions as disproportionate catalyst for reactions. For instance, millions of bovines are killed every year for human consumption, but the one animal killed in the performative space, creates a strong public response, as if mass animal killing was not an everyday occurrence. The reason for this is to be found in the secular separation of art and the functional world, and the idea that killing an animal in the name of art is not necessary, as it is for eating. Killing in the gallery space is therefore understood as gratuitous and unnecessary – spectacle instead of food. It is, however, worth noting that the issue may be more complex than this. In Harrison's exhibit, the dinner is instrumental to this problematic, but even its staging was not enough to overshadow the inappropriateness of the *spectacle of killing* presented to viewers. Seeing the animal being killed in front of one's own eyes triggers in some a primordial sense of excitement, one that we find particularly difficult to justify, but also one that continuously operates as an overwhelming attractor. The position of the viewers, when confronted with this reality, is much more entangled than that of someone sitting in front of a steak at a dinner table.

Looking and Killing

Why does an artist stage an animal killing? Why are we tempted to look at it? And if we decide to look, what are we looking for? A further breaking down of these questions would demand that we ask if the death of the animal is indeed necessary to the exploration of such

human fascination with supremacy, power and death, or whether such impulses could be explored via other artistic avenues that do not require killing.

In 1990, Damien Hirst brought the killing of insects within the walls of the gallery space with his installation *A Thousand Years*. According to Hirst, and as previously seen in Harrison, the work functions as a self-contained life-cycle. In a large two-parted glass case, maggots hatch from a white minimalist box, metamorphise into adult flies, and feed on a severed cow's head. Hanging from the upper part of the glass cabinet, an insect electrocutor serves as the end for the majority of the insects housed in the piece.

The work stirred a media frenzy in the UK, propelling *A Thousand Years* to the traditionally art-repellent pages of the tabloids. In Hirst's conception, flies symbolise people, and the closed system mirrors our world, with its mechanistic functioning exposed to the bone. Quite simply, we come to life, feed, become sexually mature, mate and eventually die from natural causes or by accident. At this point, we need to draw a specific conclusion. Hirst stages the death of an animal whose culturally common significance is confined to the 'pest' – a disease-propagator that needs to be killed. It was noted that over its first installation period, at least sixty generations of flies had come and gone.[4] As previously discussed in Chapter 5 the pest poses an intricate set of moral or ethical questions. Some controversy was created by the initial use of a real cow's head, and it was soon replaced by a taxidermied head created by artist Emily Mayer. No objection was raised about killing flies, the main feature of the piece. As we have seen, killing insects is acceptable and justifiable in a way that killing fish or mammals is not, and as previously seen this attitude applies well beyond the killing taking place in the name of art. In this case, it has to be recognised that the killing is not mediated, but staged in front of the eyes of the audience, and that it is highlighted by the buzzy noise of the electrocutor. However, why would one be surprised at the silence accompanying the killing of the flies? Wouldn't it be hypocritical to point the finger at Hirst for killing the insects when this is exactly what everyone, at some point, does, without thinking much of it? At the end of Hitchcock's *Psycho*, Norman Bates, ventriloquised by his mother, says, 'They'll say, "why she wouldn't even harm a fly."'[5] In this case, the harming of a fly is used to indicate the easiest and most commonplace sign of violence one could commit, at once irrelevant and normalised by cultural habits. It is indeed the fact that Bates would not even swat that fly that confirms that his departure from the *common norm* has already largely taken place.

In June 2009, as American president Barack Obama gave an interview on CNBC, he smacked a fly that landed on his forearm and killed it instantly. He pointed to the floor and instructed an obliging cameraman to get a close-up of the corpse. In this case, the uncannily precise killing of the fly worked as a cunning signifier of the swift thinking and lethal precision of a man in control. News reports emphasised the event but did not question the killing of the fly. Animal-rights organisations around the world must have felt stuck between the need to say something and the fear of appearing ridiculous, as flies are routinely

killed by everyone. On this occasion, Bruce Friedrich, PETA's spokesman, cautiously said, 'We believe that people, where they can be compassionate, should be, for all animals.'[6] This seems a reasonable proposition, but also one that to be applied in practice would require a complete revision of our relationship with animals.

Simulated and Live Killing

In 1991, Hirst's first solo exhibition in London, *In and Out of Love*, continued his experimentations with insects, including the presence of live tropical butterflies. The show was installed on two floors of a vacant shop. The upstairs room contained flowers, bowls of sugar-water and white canvases with pupae attached, from which exotic butterflies hatched, mated, laid eggs and died in a cyclical rehearsal of biological functions. Downstairs the canvases presented dead butterflies embedded into monochromatic fields of viscous household gloss-paint, fulfilling a static aesthetic role. *In and Out of Love* brought living creatures in physical contact with the traditional representational plane onto which they were once only depicted: the canvas. From this angle the work mainly appears to comment on the postmodernist dislike for representation in art, reassessing, in a rather dramatic way, its privileging of the real. Unlike in *A Thousand Years*, the killing does not happen in the gallery space, but is implied by the simultaneous presence of live fluttering butterflies and those stuck to the canvasses. The encounter with these butterflies, one of the most culturally celebrated insects, is different from the traditional pinned encounter provided by the entomology cabinet. These circumstances remind us that this killing is also institutionalised, but that it is so in an opposite way to that of flies. The killing of butterflies aims at preserving the body in its perfect beauty, while the killing of flies aims at disintegrating the body as source of disgust.

Of the work, Hirst said, 'It is like a butterfly has flown around and died horribly in the paint. The death of an insect that still has this really optimistic beauty of a wonderful thing.'[7] Of course the artist would have never been allowed to create such paintings using mammals, as then the whole idea would have seemed extremely reprehensible. We could go as far as to argue that we implicitly subscribe to a 'hierarchy of animal killing' that has its grounds in the previously discussed speciesistic approaches, in which cold-blooded animals stand somewhere in between the two extremes, as our biological distance from some groups allows us to disengage with their behaviour, the value of their lives, and consequently their pain.

From this perspective, Hirst's works are rather 'soft', especially when compared to those by Huang Yong Ping, a French artist of Chinese origins whose projects often cause controversy. As the founder of the Xiamen Dada group in the early 1980s, Yong Ping's installations are designed to shock and challenge audiences' expectations on art and the experiences it provides. In April 2007, as his retrospective exhibition, *The House of Oracles*,

reached Vancouver, the artist was forced to remove all animals included in one exhibit due to strong public protest led by the Humane Society and the British Columbia Society for the Prevention of Cruelty to Animals. The piece in question was *Theatre of the World* (1993), which consisted of a turtle-shaped cabinet with a transparent top through which reptiles, amphibians and insects could be seen roaming, occasionally attacking and eating each other, and frequently fighting. In viewing tarantulas, cockroaches, millipedes, scorpions, lizards, snakes and toads sharing an enclosure, the visitor is caught in a multiplicity of dissonant reactions. Some may find all these animals repulsive, and therefore care very little for their fate. Others may secretly, or not so secretly, hope to witness some action, others are simply disgusted at the bad taste they feel the work represents.

According to the artist, *Theatre of the World*, similarly to the works previously discussed, should function as a metaphor of the human condition, aiming at capturing the essence of the struggle for power experienced in our daily lives. Different animals of various species then metaphorically represent different human races and social classes coming together, providing a representation of the tensions that shape contemporary human societies. For this purpose, the installation is inspired by the traditional preparation of 'gu', a magical potion said to be made in South China by putting five venomous creatures in a pot for a year.[8] 'There's a lot of discussion around the ideas that this work offers. Around how we engage as individuals, how races get along together, how humans have an impact on the natural world', said Daina Augaitis, curator of the Vancouver Art Gallery.[9] Part of the beauty of art is intrinsic to that ability, specific to art, of capturing complex relational systems in multi-layered, creative and original ways. Using animals in the way Yong Ping did in *Theatre of the World* undoubtedly demonstrates very little respect for the lives of the animals involved, but also points to a relative poverty of ideas in the communication of complex concepts, for which the artist could have simply found more sophisticated and imaginative, alternatives. It is also here worth mentioning that Yong Ping's concern for the wellbeing of the animals was never paramount, and when controversy erupted, he countered that it was the animal-rights activists who 'violently interfere[d] with the rights of an art work to be freely exhibited'.[10]

Of course, it could be argued that one of the most relevant purposes of art is that of making us aware of our own hidden drives, and that through surprise at the unexpected in the gallery space we can be taken through journeys of self-discovery that might otherwise never take place. However – and this is where the ethical considerations concerning the use of animals in the gallery space need to be clarified – how far should we be entitled to go in order to fulfil this curiosity? How far can our self-centredness take us in order to justify the killing of animals for the value attributed to self-discovery?

Theatre of the World is presented by Yong Ping as a metaphor of society, and as such it is meant to be a work about culture and history, or so at least it is in the eyes of the artist. However, we can argue that the installation is essentially not much more than a miniature killing arena for cold-blooded creatures, and that as such it effectively attracts the viewer by

trading on gore and violence. To draw a parallel, the nudity of Renaissance Venuses were for centuries admired (and indeed erotically so) under the pretence that the male gaze observing the body did so in appreciation of the mythical and moral values embedded in it, rather than for its erotic charge. This supported the hypocritical pretence on which the objectification of the naked female body would develop, almost unquestioned, through early modernity. It was Manet's *Olympia* (1863) that subverted these dynamics, revealing the real interest in looking. Likewise, the socio-historical contextualisation provided by Yong Ping only disguises the real currency in which the piece trades.

Live Killing and Cinematic Killing

In homage to *Theatre of the World*, artist Adel Abdessemed created a seemingly redundant video version of what Yong Ping's work presented in the flesh. One minute and twenty-seven seconds in length, the footage, called *Usine* (2009), presented scorpions, lizards, tarantulas and snakes, but upstaged Yong Ping's work to include pit bull terriers and fighting cocks, grouped together in a concrete pen for the express purpose of fighting and killing each other. The work lends itself to multiple interpretations. It could be seen as a representation of an aspect of Mexican culture in which animal fighting is still practised (the film was shot in Mexico), while the title *Usine*, meaning factory in French, shifts again the context towards the competitive cruelty embedded in the capitalistic world we live in. In artistic terms, there is of course a substantial difference in presenting live animal killings and filmic renditions of such events. The physical killing taking place in the gallery space preserves the sharpness typical of unmediatedness, along with the uniqueness of the killing scene, which further triggers the urgency to see, or the opposite, in some, not to see at all.

In March 2008, the San Francisco Art Institute was forced to cancel an exhibition by Abdessemed because of the inclusion of a film titled *Don't Trust Me*. In this case, as with Topsy the elephant, the killing of animals was mediated by film. *Don't Trust Me* portrays six animals — a sheep, a horse, an ox, a pig, a goat and a deer — being struck and killed by a hammer. The animal is in the screen-frame, but the hand that kills is not visible: a hammer suddenly knocks the animal to the ground; then we move to another animal, and so on. Each killing occurs so quickly that it is difficult clearly to determine what happens on screen. The museum presented the show proposing the following questions: 'Do these incidents represent slaughter or sacrifice? What are their social, cultural, moral, and political implications? Or are such questions now verging on irrelevance, as if something else altogether were taking place, something wholly other, unforeseen, and unexpected?'[11] Interestingly, all the questions posed by the institution appear to be oblivious to the value of the animal killing involved.

Professor of Critical Studies Akira Mizuta Lippit argues,

> There is no proper death of the animal and no death as such in cinema. [...] The death of animals on film is an impossible spectacle – speculative and spectral, linked to cinema through the magical process of animation. Against the impossibility of animal death, cinema provides artificial life, anima, animation, and the possibility of reanimation. Film, the emblematic technology of the late nineteenth century, keeps animals from ever truly dying by reproducing each individual animal death in a fantastic crypt. It multiplies and repeats each unique death until its singular has been erased, its beginning and end fused into a spectral loop.[12]

Lippit's perspective is deeply fascinating, but the philosophical visions that pervade the text do not necessarily suffice to justify the physical death of the one real animal needed to begin the loop. However, what Lippit's conception of cinematic space brings to the surface is that the death of the animal, once filmed, is multiplied and endlessly repeated, its shock value delivered to a new audience with each replay. In the economy of animal killing for the purpose of spectacle, *Usine* is much more effective than *Theatre of the World*. The scenes of animal killing in *Usine*, through repetition, depart from the materiality of killing and dissolve into a representative realm that, through seriality, effectively denies the veracity of each killing. Yet, it is the physical killing of the real animal used for the filming that is problematic, although the multiplication of it through film could be seen as a 'cost-effective' by-product of a brutal act.

Underneath its extremely violent surface, we are told by the press release for the exhibition that the work references the seemingly out-of-control expansion of China's development and the violence to which the population that propels such development is subjected. The hidden reference to this system surfaces as we realise that the choice of animals presented in the film is not random, but those of the traditional calendar of China. From this perspective, the hammer which kills the animals symbolises the Communist regime. The significance of the work, with its current-affairs-grounded focus, still makes one wonder if contemporary art practice has completely abandoned the quest for sophisticated ways of conveying meaning. Again, the killing of animals is here used to capture the essence of entirely non-animal-related issues, with the aim of representing socio-historical paradigmatic sets.

A detail of interest that is an essential part of both *Usine* and *Theatre of the World* is that the killing of the animals in question is not effectively operated by the hands of the artist. In this case, the artist becomes a mediator who only happens to have facilitated the circumstances in which the animals will then kill each other or be killed. In *Don't Trust Me*, the animals are killed by a human entity, implied by the hammer. The killing hand stays anonymous, is disembodied, the implication being that the hand of the artist is busy operating the camera. But does this staged disassociation with the killing on the artist's part attenuate the ethical considerations implicit in their relation to the stagings?

In a performance from 1972, *Untitled (Death of a Chicken)* artist Ana Mendieta decapitated a chicken and held it by its legs as it slowly died. The animal's blood covered Mendieta's naked body in a contemporary re-enacting of the ritualistic power of ancient cultures, where the animal killing functions as a symbolic body. Here, the violence of the killing referred to the world in which the artist lived.

In *Don't Trust Me*, the hand that kills is invisible but implied, while in Ana Mendieta's film it is her own hand that kills the bird. A number of ethical considerations are raised by the differences between killing an animal oneself, allowing animals to kill each other, allowing this to happen in the gallery space, or mediating the violence through cinematic representation.

A Matter of Delegation

Marco Evaristti, an artist who has made controversy his main artistic skill, produced in 2000 *Helena*, a work that allows us to investigate these issues further. The installation stirred animal-rights campaigners and public like nothing previously; it also got Evaristti charged with multiple accounts of animal cruelty, in multiple countries. *Helena* was inspired by the famous Milgram experiment from 1963, where the willingness of participants to obey an authority figure resulted in them performing acts that conflicted with their personal ethical stands.

According to Evaristti, the installation, comprising ten Moulinex Optiblend 2000 liquidisers, each containing water and a goldfish, essentially constitutes a social experiment. Its title references the Trojan War, with the goldfish representing the beautiful Helena and the mixer standing in for the killer machine of war. Unlike some of the works previously discussed, *Helena* does not automatically prescribe the killing of the animal on display. The opportunity to kill the animal is instead offered to a member of the audience, but it is not necessary for this event to take place in order fully to comprehend the social commentary made by the work. The death of the animal is here constantly imminent, but also potentially absent. What gives the work its charge, is the tension between an attractive/repulsive moral set of preoccupations and the tension it instantly creates in the gallery viewer. Suddenly, in front of *Helena*, by implication, we simultaneously become a passive voyeur, a potential killer or an unbending moralist; which of the three we already are, or are about to become while exposed to the work, is sometimes unpredictable.

Evaristti contends that 'Here one sees evil, sadism, our animal instinct, because we know that if we push the button, there is a chance that it could work.' In her essay 'Marco Evaristti and the open work', Anna Karina Hofbauer argues that 'The participatory element in this otherwise sculptural work leads to a modification of reality, in which it is not Evaristti who comes over as irresponsible, but where he passes on the ethical and moral issues to the observer.'[13] Can we, however, subscribe to Hofbauer's argument? Is

the artist truly free of moral responsibility just because his apparent role is limited to that of providing the opportunity for killing? Inevitably the button was pushed, and it was pushed more than once. In 2003, a court in Denmark ruled that the fish were not treated cruelly, as they had not faced prolonged suffering. The fish were killed 'instantly' and 'humanely', said Judge Preben Bagger. The court had earlier heard from an expert witness from the blenders' maker Moulinex that the fish had probably died within one second of the blender being switched on. A vet also told the court that the fish would have died painlessly.[14] The verdict reinforced the commonplace notion that, so long as killing happens without pain, it can be tolerated and excused. This is entirely arguable, as at the core of killing lies the ending of a life. Pain is simply a state which may or may not feature in the process of dying. Whether dying happens in painful ways or not, it is still the taking of life which is to be considered paramount, along with the shortening of its emotional, biological and ecological ties to the cosmos. It has to be mentioned that the case went to court only because Peter Meyer of the Trapholt Art Museum in Kolding, where *Helena* was first exhibited in 2000, refused to pay the 2000 kronor (£180) fine originally imposed by Danish police. He argued that 'It's a question of principle. An artist has the right to create works which defy our concept of what is right and what is wrong.'[15] It has been extensively argued that exhibits like *Helena* can be justified on the grounds that they provide the viewer with an experience that challenges understanding of social norms and structures; yet this may not constitute an umbrella under which anything can be presented to an audience as art.

Never Burn Live Rats on Stage

In 1976, performance artist Kim Jones produced *Rat Piece*, a half-hour-long performance in which he set fire to three live male rats in a cage. In the performance was Jones's alter ego Mudman, a shaman-like figure caked in mud, who committed the killings. Jones's past as a marine serving for the US in Vietnam re-emerged in his practice, which usually involved war, healing and destruction as main themes. In this case the burning of the rats was proposed as a memory of real routine procedures witnessed during the war. As reported by Martin Harries,

> The rats' deaths were gradual: Jones periodically fed the fire with more fluid. The panicked rats scampered up the edges of the cage, ran in circles, and screamed as they neared death. Jones briefly screamed, too. After the rats were dead, Jones slowly covered their remains with soil and stones from a few bags.[16]

As the following statement proves, the artist was initially unaware of what impact his action would have on the audience:

When I did it, I didn't realise how upset people would be by it. I knew they would be upset. When I did it people just went nuts. I ended up going to court. People still get upset about it. I can understand that because I tortured the animals to death, but it was important for me to have that experience as an art piece. Instead of just talking about killing something, or burning something, to actually have the audience that went to see this experience the smell of death and to actually have control in a certain way. They could have stopped me.[17]

This statement further complicates the performance and the animal killing featured, as the artist points the finger at the audience. Similarly to Evaristti's approach, where the audience is to be empowered, Jones's statement suggests that the artist can pass on ethical responsibilities to the audience, and that unless actions are prevented by external entities, then all those involved are accomplices. The artist effectively discharged his responsibility on three counts: the first is that he was just reproducing something he saw and used to do in the war in Vietnam. As such he is presenting the American audience with another aspect (one that lends itself to symbolic interpretation) of the war that America did not want to see. Consequently, America has the duty to see and hear what happened in Vietnam, especially when this is delivered directly by a soldier. Jones's preference for presenting the audience with the real thing, 'experiencing the smell of death', is in keeping with postmodernist sensitivities, loyal to the unmediatedness of the representational, where the real thing provides viewers with a freer and more personal opportunity to make sense of reality directly.

Jones's claim that the audience could have prevented him from killing the rats is of particular interest. In the presence of an animal killing within the artistic arena, we are all guilty, and we are so by implication unless we act to prevent the death from happening. So why did the audience not intervene? As Harries points out, 'Audiences do not intervene, or when they do intervene, the members of this group become something other than an audience.'[18] Being part of an audience implies a lot more than just looking at what happens on stage, and the implicit conventions involved in such a role are pressing to a degree that the interference with the performance is traditionally forbidden unless the format invites the audience to do so (for example pantomime). Otherwise, being part of the audience means to have a reduced range of expressive channels at one's disposal. It may be argued here that the shock this specific audience must have experienced in seeing the live rats burning on stage contrasted with the notion that rats are a pest, and that therefore their death is not too serious a matter, and that may have in some way contributed to the audience's passive response. We can safely say that things would likely have been very different had the cage contained kitties.

Can Contemporary Art Productively Address the Killing of Animals?

In *Killing Animals* (2006), the influential book discussing the complexity of the ultimate expression of human power over animals, art historian Steve Baker poses the question 'can contemporary art productively address the killing of animals?'[19] Baker's question seems to imply the need for a resolute approach: if contemporary art is not able productively to address the killing of animals, then such killing is hollow and unnecessary. From this perspective, contemporary art would not only be missing the opportunity to engage with the current, critically informed discussion on animals, but would also fail animals once again in *using them*, instead of trying to understand them from new and different perspectives.

Here Steve Baker's original question can be further expanded by juxtaposing it to another question, one Roland Barthes poses at the beginning of his seminal essay 'The death of the author' (1977): 'Who is speaking thus?' Barthes brings to the surface the problematics related to the traditional critical approach to creative work: how can we detect precisely what the author − in this case, the artist − intended?[20] Similarly, this question could be extended to: is it the artist who speaks through the work of art involving the killing of an animal? Or is it the animal itself? It has been extensively argued that the *use* of animals in classical and modern art was characterised by a 'metaphorical ventriloquism', where, in other words, the animal was contextualised in order to speak of a broad range of human affairs rather than animality itself. Does the killing of animals in the white cube contribute in any way to the breaking down of this or other paradigmatic sets? As we have seen in the works previously discussed, the answer to this question is probably no. When an animal is killed in the gallery space, it most often becomes a stand-in for a human, compensating for the impossibility of killing other humans in that context. From this perspective, the livingness of the animal and that of the human symbolically overlap. Alternatively, are we left to suspect that the killed animal simply, once again, ventriloquises human concerns and the artist's own set of preoccupations and anxieties? It is worth remembering that the headline-grabbing power that these works command may be at the very heart of why some artists present works in which animals are killed in the first place.

An example of this attitude may be provided by the work of artists Katarzyna Kozyra and Nathalia Edenmont. As an art student in 1992, Kozyra decided to explore the subject of death and the food chain through her graduate project. While her professor suggested she create a sculpture, Kozyra chose instead to stuff a horse, a dog, a cat and a rooster, each with red coat or plumage, matching her own hair. Of this project the artist said that the starting point was the Grimm fairy tale. This sheds light on the final pyramid composition, in which one animal stands on top of the other, a seeming reference to *The Bremen Town Musicians*. 'What was intriguing about this sculpture,' Kozyra says, 'was that it could be made using ready-made materials, i.e. animals.' For visual appeal, she too wanted the animals to appear

undamaged, so she could not use roadkill. To the artist, the pressing concern was killing the animals herself. Kozyra continues,

> I was balancing on the edge of accepted ethical norms, while at the same time I was touching that difficult thing called the 'death of a living creature'. All of these animals were basically destined to die, however, using them for the sculpture generated ethical problems. And yet animals are murdered every day and used for everyday purposes, or for consumption. My personal participation in the act of death and using their carcasses to realise an idea changes the point of view, it has evoked and continues to evoke various reactions.[21]

For unspecified reasons, Kozyra decided also to film the killing of the horse and have it shown on a TV screen next to the sculptural piece, so that the act would be an integral part of the exhibition. As she says, this was the most shocking and provoking feature of the project, the one that audiences found unacceptable. Here, once again, the artist presents the killing of the animal through a video installation, in this case illustrating her first-hand involvement as the footage shows the horse entering the stable, being killed and then being skinned. What does the work say about animals, or death in general? However, a caption on the home page of her website reassures us that 'Kozyra's notoriety and controversial status in Poland is legendary and her works, never sensational for the sake of publicity, continue to elicit extreme responses and heated public discussions.'[22]

In 2004, the photographic work of Nathalia Edenmont became controversial. The animals in her images posses a freshness that makes them look alive, as she takes care to photograph them not later than fifteen minutes after she has killed them. In *Star* (2002), five little white mice have been hollowed out to become finger puppets. The killing of these animals is not shown to the audience, but our knowledge that the artist has carried out the killing herself, as she claims, plays a key role in our understanding of the images. Here too we are presented with a socio-historical contextualisation that aims to justify in some ways the killing of the animals involved. Edenmont explains that the five mice on the fingers of a human hand represent the five stars of the former Soviet Union, where her mother was murdered. As we are informed of this, the work ceases to be about the animal, and acquires the typical features of the traditional treatment reserved to animals in the history of art, where they only function as representational symbolic vessels. It is perhaps, then, not a coincidence that a large number of Edenmont's works directly reference the tradition of seventeenth-century painting and the freshly killed animals used in the work of Dutch masters. This stylistic similitude proposes to consider the treatment of the subject in question in relation to the specificity of the media of painting and photography. Aside from also having acquired a historic aura, seventeenth-century still-life paintings present us with a very similar theme to that of Edenmont's images: dead animals captured in their most vivid freshness. However,

still-life paintings are far from being considered controversial, and are very much appreciated around the world as prized possessions of many art museums. Are painted animal deaths less problematic than photographic ones, only because photography's indexical quality more directly reconnects the killing with the signifier? Are we assuming that artists painted their animals entirely from imagination?

The presence of dead animals in Edenmont's images has been justified by the gallery representing the artist: 'due to the fact that they have been freshly killed, Edenmont's animals are caught in a moment frozen in time that suspends the borders between life and death.'[23] On Internet forums, Edenmont's images have been widely labelled hoaxes. The freshness of the animal bodies she uses has raised suspicion that the photographs are the result of digital manipulation. Should this be the case, Edenmont's images would instantly lose much impact and would have circulated (perhaps in a very limited way) for what they effectively really are: odd curiosities with elusive depth. Is this a stunt designed to promote the work of an otherwise rather unoriginal photographer?

The Cyber Killing

Guillermo Vargas's *Exposición No 1*, staged at the Galería Códice on 16 August 2007, is the only work to date to generate more controversy than *Helena*, and in this case the killing of a dog was involved. The exhibit featured a captured starving street-dog tied to one corner of the gallery, a burning large censer filled with 175 rocks of crack cocaine and marijuana, a stereo playing an anthem in reverse, and a few photographs on a wall. The artist, a native of Costa Rica, allegedly asked two local children to capture a stray dog. The animal was then tied in the gallery space where a wall, within view of the starving animal read 'Eres lo che lees' ('You are what you read'). An indisputable level of cruelty becomes apparent when the viewer realises that the words are written with dry dog food. The permanence of the dog in the gallery space is only documented by a number of images published on Internet blogs. In these, we can see the animal confined to a corner of the gallery and tied with a one-metre-long rope that only allows it to face in one direction. As visitors were instructed not to feed or give water to the dog, it is believed that the animal died.

Juanita Bermúdez, director of Galería Códice, stated that the animal was fed regularly and was only tied up for three hours on one day, before it escaped.[24] Vargas refused to comment on the fate of the dog, but remarked on the fact that no one had tried to free it, feed it, call the police, or do anything for the animal. It is worth remembering that the artist has been most elusive and contradictory in his words about the piece. A statement by Vargas, from October 2007, stated,

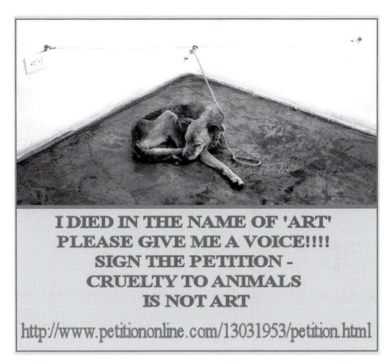

I DIED IN THE NAME OF 'ART'
PLEASE GIVE ME A VOICE!!!!
SIGN THE PETITION -
CRUELTY TO ANIMALS
IS NOT ART

http://www.petitiononline.com/13031953/petition.html

28. Unknown Author, Internet advert against Guillermo Vargas's *Exposición No 1* (2007).

The purpose of the work was not to cause any type of infliction on the poor, innocent creature, but rather to illustrate a point. In my home city of San José, Costa Rica, tens of thousands of stray dogs starve and die of illness each year in the streets and no one pays them a second thought. Now, if you publicly display one of these starving creatures, such as the case with Natividad [the name of the dog, meaning 'Nativity' in English], it creates a backlash that brings out a bit of hypocrisy in all of us. Natividad was a very sick creature and would have died in the streets anyway.[25]

More than 2.6 million signatures were collected worldwide to prevent Vargas from representing his country at the Bienal Centroamericana Honduras 2008, to which he was invited on the merits of *Exposición No 1*.[26] However, not unlike the images by Nathalia Edenmont, the work is shrouded in doubt as to the authenticity of certain details. *Exposición No 1* is very poorly documented, and even so, only on the Internet, where the piece has featured in a number of blogs, each claiming different and discordant facts. The majority of these assert that the dog died, although there is no evidence of this and no statement linked to witnesses who attended the event (and who are visible in some of the images taken of the exhibition) has ever surfaced.

The only evidence of the installation is indeed a handful of uncredited photographs, fewer than ten, all of which focus solely on the dog at the expense of the larger piece. Taken together, they provide only a fragmentary and inconclusive account. Who took these images, and how did they end up on the Internet? Would the photographer know if the dog really died? Or can we assume that *Exposición No 1* was a hoax designed to pluck Guillermo Vargas from obscurity? Are the photographs entirely staged for the purpose of generating free publicity? Or are we meant to understand the photographs to be the real work of art, instead of the event they claim to immortalise? But does this matter? As far as 2.6 million people around the world are concerned, in cyberspace, Natividad died, even if there is no clear evidence to prove it.

It is plausible here to argue that the work exists more in the virtual space provided by blogs than it ever did in the Galería Códice, where the event allegedly took place. From this perspective, *Exposición No 1* functions as a contemporary mythology, tailor-made for the Internet generation, shrouded in hearsay and speculation, morphing through repeated and mistranslated contrasting narratives. This kind of example suddenly makes Baudrillard's view that the world has been launched into hyperspace in a kind of postmodern apocalypse very believable. 'The airless atmosphere has asphyxiated the referent, leaving us satellites in aimless orbit around an empty center. We breathe an ether of floating images that no longer bear a relation to any reality whatsoever.'[27]

In a way, Vargas's installation confuses the lines of ethical and moral concern to a degree that it makes it impossible to discuss the work within artistic parameters without finding the task hollow and cynical. The most evident difference between the animal killing involved in this installation and those that took place in other works discussed here lies in the fact that the animal in question is a dog. In *Animal* (2002) Erica Fudge argues,

> A pet, simply put, is an animal that enters our (human) domestic space. It is different from other non-tame or wild-animals, because it lives with us in our homes. On this basis, it is possible to see pets as making up a different class of creatures. They are both human and animal; they live with us, but are not us, they have names like us, but cannot call us by our names.[28]

It is plausible to speculate that, despite publicity, the career of an artist might be forever ruined by a piece like *Exposición No 1*. However, the case of artist Tom Otterness goes to show that the opposite can be true. Otterness is today a very wealthy and accomplished public sculptor with a presence on many streets of New York and collections in Washington. At the age of 25, before becoming established, Otterness filmed himself shooting a dog he had adopted in order to make a short film. In 2008, the killing came back to haunt him because of a prestigious commission for a sculpture to be installed in a public space in New York. The controversy prompted Otterness to release a statement asking for forgiveness,

which in turn triggered another Internet storm. As published in the *Brooklyn Daily Eagle* in April 2008, the apology read,

> Thirty years ago, when I was 25 years old, I made a film in which I shot a dog. It was an indefensible act that I am deeply sorry for. Many of us have experienced profound emotional turmoil and despair. Few have made the mistake I made. I hope people can find it in their hearts to forgive me.[29]

The killing of pets, and specifically dogs, the closest pet of all, proves the most difficult to accept and forgive, at least in Western culture. It is possible that by 'killing' a dog in a gallery space, Vargas crossed a very specific line, one that could only be surpassed by the killing of, say, a primate. This at least would dilute any future killing of any other animal occupying a lower rank in the 'hierarchy of animal killing', making it entirely redundant. Should this be true, the killing of animals in contemporary art could be a self-exhausting parable, a phenomenon which has already reached its apex and that is destined soon to disappear. In the light of all the examples discussed here, can contemporary art then productively address the killing of animals?

No Killing Required

An installation by Joana Vasconcelos, titled *Passerelle (Catwalk, 2005)* uses ornamental ceramic dogs in order to address multiple concerns about our relationship with pets. The ceramic dogs in question belong to the family of kitsch objects that in Europe can be purchased in garden centres as well as at shops in petrol stations. Upon entering the gallery space, these dogs become symbols of our relationship with pure-breed canines, referencing the manufacturing of perfect forms, and directly pointing at the asymmetric relationship of power we establish with the animal. To complicate this interesting premise further, the dogs hang from a mechanical overhead conveyor, summoning the chilling echo of slaughterhouse processes. Suddenly the evoked images of cow carcasses and the hanging ceramic dogs overlap, providing a reading of generalised animal exploitation and commodification. Dogs, like cows, are mass-produced animals shaped and packaged by consumerism. The conveyor lies still until a viewer pushes a foot pedal connected to the structure; as the machine is activated, the ceramic bodies begin to move, swing and hit each other. Noise of crashing ceramic invades the space; some bodies shatter, creating a field of dead animal shards on the floor underneath.

The viewer can't help but stand bemused in front of the result, puzzled by the divergence of the emotional responses which the vision provokes. As in Evaristti's *Helena*, the visitor is given the power to initiate the process. What brings us to push the pedal in this case? As the

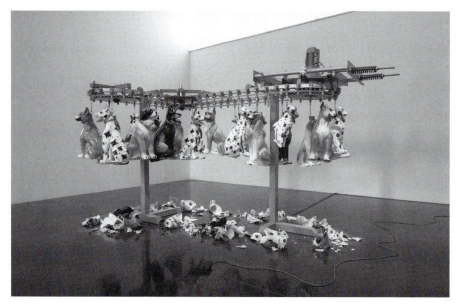

29. Joana Vasconcelos, *Passerelle* (2005).

carousel stops, would we want to see more and push it again? A level of sadism similar to that involved in *Helena* may indeed bring us to follow this urge in order to see how far the destruction can go. Upon seeing the animals crashing to the floor, the disconcerting artificiality of what we understand as our relationship with nature is also metaphorically unveiled. The machine here symbolises subjugation, the contribution of technology to such processes and our overriding controlling participation to this process. The animal is turned into a hollow ornamental object, something we consume on a surface level, and it is metaphorically killed through the breaking of the ceramic shell; our emotional responses are tested; a rich and suggestive commentary on our relationship to animals is effectively delivered. The point is sharply made – no real animal killing needed. However, it has to be recognised that for as interesting as her body of work is, Joana Vasconcelos's name has not yet hit the headlines, despite the fact that she is indeed a very successful artist in her own right.

Another artist whose work addresses the killing of animals in productive ways, similarly employing the use of sculpted animal bodies, is John Isaacs. Isaacs's work gives us the opportunity to focus on the function of hyperrealism within this context, making us aware that this representational mode can effectively evoke the presence of livingness as substitute for a live animal. Hyperrealism enhances the impact of the created imagery as well as its communicative potential, without introducing the multifaceted ethical considerations imposed by the involvement of a living being. Along with his animal bodies, Isaacs's installations bring to physical existence the sometimes volatile nature of modern anxieties.

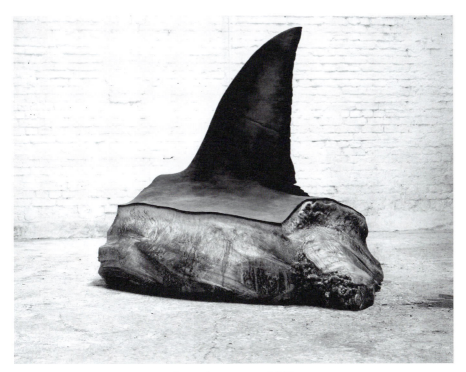

30. John Isaacs, *Everyone's Talking About Jesus* (2005).

Often, this materialisation takes place through the creation of violent imagery involving dying, already dead, and disturbingly disfigured animals. Encountering Isaacs's animals in the gallery space makes for a surreal experience, a sensory assault triggering ethical considerations on mass-killings that relentlessly take place in the real world. Overcoming the initial sense of uneasiness, perhaps led by the very primordial instinct that guides us to take a second look at something upsetting, we may also identify Isaacs's concern with animal rights and environmental deterioration.

At times, his animal bodies are broken up, or crudely chopped up into desolated freshly bleeding parts; at unison, these animal body parts display the devastation that has already happened, while referencing a developed organism with skin, muscles and organs, an operating system with innumerable complex interactions, themselves the result of millions of years of evolution. The overall destabilising effect involved in the encounter with these works is deep, making it clear that the objective of deconditioning is to view things without a predetermined frame of mind, leading to a predictable response. This effect becomes even more unsettling when the viewer realises that the disfigurement and fragmentation inflicted on the animal body bears the unmistaken signature of human action.

For instance, his controversial piece *Everyone's Talking About Jesus* (2005) consists of the fin section of a shark's body sitting, in its overwhelming fleshy hyperrealism, on the gallery floor. Made of wax, polystyrene and epoxy resin, the sight of this animal-chunk is just as unsettling as the view of its counterpart made of flesh and bones would be. One may argue that the smell of the rotting real animal flesh would add potency to the vision, but would it be needed in order to make the point the artist is intending? Not really. Through the display of dead animal flesh, Isaacs addresses the unsettling practice of 'finning' sharks, which involves the removal of the fin and the throwing back of the rest of the fish to bleed to death. This practice has been condemned by animal-rights activists for its cruelty, and there is a worldwide campaign to outlaw it. *Everyone's Talking About Jesus* not only raises awareness of a serious problem, but also brings the viewer to confront it through the raw abrasiveness of hyperrealism. Here too, no animals are harmed or killed in the making of Isaacs's work, and the use of violence, which, the artist claims, 'bring[s] the viewer away from looking at art, to remove that preconception and penetrate straight into the mind', is calibrated and aimed at making statements that may bring gallery visitors to support a worthy cause.[30]

Steve Baker has also more recently, as a practitioner, explored the possibilities for contemporary art forms which may propose a 'yes' as answer to the question he originally posed: 'can contemporary art productively address the killing of animals?' In 2009, Baker began producing visual imagery that challenged our response to one of the most commonplace animal deaths of our time: roadkill. In *Norfolk Roadkill, Mainly,* Baker presents images captured as he cycled in his local area. The images of dead-animal bodies are juxtaposed with seemingly unrelated scenes from nearby realities: architectural features, paintings, discarded objects, vegetation and street signs are just a few elements presented in these diptychs. The juxtaposition of the images echoes the photographic work of American conceptual artist John Baldessari, where two disjointed realities are brought together to create an open text triggering associations and suggesting implications. In Baldessari, the final result is usually humorous or uncanny: the images question orders of events while proposing a paradox. However, in Baker's work the juxtaposition also poses multiple questions of a different nature.

Roadkill is a particular and under-explored issue in itself. Some one million animals are killed on UK roads each year, and this does not take into account all the cold-blooded creatures that encounter the same fate.[31] This mass-killing is non-systematic but accidental, and as such is considered part of the reality of driving in the countryside.

The sight of roadkill is ambivalent, in that it is of course an unnecessary instance of animal death, but it also renders the animal visible and therefore makes us aware of its existence in a specific geographical area. Sightings of roadkill are indeed used to estimate population numbers in specific areas and assess decline or increase in some species. In Baker's work, picturing the animal body conjures the impossibility for animals of dealing with human technological advancements. From this perspective, roadkill could be understood as a

Spixworth Road, Hainford, 20/9/09

31. Steve Baker, *Untitled* (2009).

by-product of industrialisation, where the speed of machines is something animals have not had time to adapt to. The hedgehog will be 'forever' too slow and too shortsighted to avoid cars. The supremacy of modernity over nature is once again expressed through the flattening of the animal body embedded in the asphalt, at times reduced to a stain, bits of fur and feathers – erased.

Each diptych by Baker is grounded in an overall sense of accidentality. In opposition to the *fast leaving behind* imposed by the car, Baker's encounter with roadkill is slow, as on the bike he stops to allow observation and thought. Baker therefore witnesses the roadkill along with its randomness and seeming irrelevance, and juxtaposes it to an image of a different place. At times, parts of his bike's frame or its shadow are included in the photographs. The bike's presence contextualises Baker's role as witness, one that brings the intricacies of roadkill to the fore by posing questions concerning the complexities in which these flattened bodies are tangled.

Interestingly, ownership of roadkill is notoriously a grey area in the UK. The rule of thumb is that the killer of the animal may not make a meal of it, but the person behind can. From this perspective, Baker would indeed be entitled to take possession – something he does in photographic terms – of the dead body. However, he does not present the images within a moral context, and this is surely one of the most interesting aspects of this work. The diptychs do not make any demand for compassion, and the relational opportunities between the two juxtaposed images never cooperate in a bid for romantic readings. These animal deaths are not glamorised in any way, as there is nothing heroic or spectacular about roadkill. There is

instead something too commonplace, and therefore utterly discardable, about these deaths, as they are endlessly serialised in their anonymity. If anything, roadkill is the exact opposite of the sublime animal.

Norfolk Roadkill, Mainly is silent in the aftermath of the mechanical noise which flattened the animal body, as well as silent in the spatio-temporal leap which links the juxtaposed photographs together. The silence featured in these pictures is also that of Baker's pedalling, an action through which these animal bodies are encountered, looked at, collected and brought to an audience. However, this silence is juxtaposed with the multitude of pressing questions that these images simultaneously bring to the fore in the making of ethical statements through the relentless exposure of evidence. Who is ultimately responsible for these deaths? Do we have to accept these animal deaths as a contingent inescapable element of capitalism?

The ambivalence of roadkill and its seemingly suspended underlying ethical entanglements have allowed beer brand Brewdog to create a limited edition of their 'extreme beer' called *The End of History* with a 55 per cent alcohol content offered in bottles that are encased inside a taxidermied animal, the bottle-top sticking out of the animal mouth. Stuffed roadkill stoats and grey squirrels were made available through their website, and were sold out in no time, despite prices ranging from £500 to £700 a bottle. Ironically, these animals have been 'invested' by capitalism twice: first killed by one of its most prominent symbols, the car, a mechanical animal on wheels, and then turned into packaging for an exclusive super-alcoholic beer sold online, eternally objectified as the least essential novelty part of an otherwise disposable object, a beer bottle.

The work of Sue Coe, an English artist and illustrator who has been living in New York since 1972, largely revolves around the idea of witnessing and using drawing as an intimate way of making sense and reporting traumatic instances involving animals. Coe's work is directly political, and her illustrations clearly point at the unfair and cruel relationship between humans and animals, aiming at generating awareness and sensitising opinions. In her career she has touched subjects related to social class, gender and racial differences in contemporary society, and subsequently focused, in the late 1980s, on animals.

At heart, Sue Coe has been an animal activist since a very early age. She grew up a block away from a slaughterhouse, and could see directly how animals were being treated there. *Porkopolis: Animals and Industry* (1989), was an exhibition describing factory farming, its methods and the impact this technology has on animals and environment alike. Those illustrations, and the ones that followed, were not fantastic visions but the result of the artist's careful in-field research of her subject. This is what makes Coe's illustrations so breathtakingly sharp in their technical and contextual balance.

The artist believes that

Technique is the test of sincerity, so for art to become a weapon, it first has to be art. Slaughter has been normalised by being concealed, and we need the light of day to

spotlight these places. When I draw, there is also time that is spent with the subject, there is an intimacy in drawing. The meat packers could see what I was drawing, it was being drawn on the kill floor, and was the truth, it was not my 'taking' a photo, and 'taking' it away from them ... if they wanted the drawing they could have it.[32]

The idea of drawing as illustration of the real, and the understanding of drawing as a time-consuming process through which thinking on a subject can take place, is surely not a common path to contemporary art. Stylistically, the artist's approach is informed by the work of artists such as Goya and Rembrandt, both painters of distinguished talent in the representation of the unusual, the grotesque and the horrific, painters of intensities, one may claim, more than anything else. Coe says, 'I'm a medievalist,'[33] a trait particularly visible in the fragmented and at times flattened perspectival approach which allows the artist to capture with extreme clarity the most dramatic and chaotic events. One of the most recognisable characteristics of medieval painting exhibited in Coe's work lies in the formal simplification of her scenes, the lack of detail, the demarked closeness of form (seldom defined by black outlines) the calculated use of light, and the overall flatness of the image, which largely contributes to the overall bold impact the images possess. Formal elements, as in medieval painting, are here subordinated to the effectiveness of narrative. In the middle ages this was

32. Sue Coe, *Modern Man Followed by the Ghosts of His Meat* (1990).

indeed the primary role of sacred images, to recount a story that should be made accessible to the illiterate. From this perspective, Coe's work is a visual learning opportunity for those who have not considered animals from new and different perspectives yet. Her animals are never anthropomorphised, they retain the essential traits that connote them as live animals. However, they are interpreted, they are stylised and simplified for immediacy of communication, and seldom stare back at the viewer as if asking something or inviting a reciprocity, one that inevitably results in discomfort. Coe's illustrations, whether exhibited as stand-alone prints in a gallery or as part of illustrated books with accompanying text, are extremely poignant, and capture the sincere tragic quality of the events depicted without any sensationalism or gratuitous use of graphic elements. These are images that effectively try to re-establish the connection between us and animals which the slaughterhouse, with its 'operating behind close doors', obliterates. The animal comes in on four legs at one end and comes out packaged meat, ready for consumption, as if never alive. Coe shows us what happens in between, in a way that removes any possibility for the resurgence of the slaughterhouse tours discussed earlier. Coe's illustrative style at times borders on the caricaturistic and satirical, defining gruesome scenarios in which humans are rendered grotesque and animals' presence borders on the surreal.

Modern Man Followed by the Ghosts of His Meat (1990) could, for instance, be used as an example of the uneasy balance that Coe so effectively strikes in her work. Walking home after stopping for a McDonald's in the middle of the night, a man is surprised by the vision of animal-ghosts following him. The whole image is in black and white, in order to enhance the ghostly atmosphere, but the McDonald's food bag the man clutches in his hands is painted in colour, becoming the chromatic punctum of the work. In the darkened sky, the moon is obscured by the bright electric light of the lamppost, seemingly a reference to the early-modern period and futurist paintings, bringing us back to a time where our relationship to animals changed most dramatically. The subject and its treatment border on the humorous, making the whole image resounding more intensely with the sinister plausibility of this absurd proposition. The window of a butcher's shop is visible in the background, but there is no attractive charge here in the dismembering of the animal body, there is no attractor at work. The images ask for empathy and compassion, demand ethical responsibility, and ask us to think about our actions while portraying animal deaths. Coe's work is routinely published and exhibited internationally, and her prints and paintings are auctioned as fundraisers for animal-rights organisations.

So it could be concluded that contemporary art can indeed productively address the killing of animals, but only when artists refrain from using animals as metaphorical figures, and instead hold the animal at the core of their concern. Of course it is not in those works involving the actual killing of animals that we encounter productive opportunities, but it is also interesting to note that it is when relatively more traditional media are at play that at least *the death of the animal* can be more productively explored. This is not to say that more

traditional art forms are by default better equipped for such a task, but that perhaps the death of the animal produces a representational crisis of a contemporary kind, one that goes beyond the animal subject to shortcut the effective philosophical value of art itself. The art which desperately seeks to capture attention, despite the hollow quality of its intent, fails to provide new knowledge.

Chapter 7

Conclusion
In Conversation with Mark Dion - The Culture of Nature

Of the many artists who have over the past twenty years engaged with the subject of nature and the animal, Mark Dion surely occupies a prominent place for his persistence in producing original, challenging, political and critically informed work. His practice has, in his own words, 'never been "about nature", but rather has been concerned with ideas about nature'.[1] It is therefore no coincidence that Dion's reputation has been built through a series of challenging works exhibited in both natural-history museums and contemporary-art galleries alike. From taxidermy to spectacular cabinets of curiosities, trees covered in tar, stuffed toys and giant moles, the artist's practice is driven by a genuine interest in nature which Dion has nurtured from a very young age and which often focuses on issues of classification, conservation and ecology, in an attempt to challenge our views on animals and ecology. Key to his work is the idea, derived from the writings of contemporary evolutionary theorist Stephen Jay Gould that all taxonomic systems are the result of social structures and the understanding of knowledge that these allow to form. The job of the artist, he says, is to go against the grain of dominant culture, to challenge perception and convention.

Dion's critical and political approaches to art-making have provided many contemporary artists with a framework for creating new and challenging works about nature. Scientific field research is a recurring feature in the artist's work, and usually involves the gathering of natural and non-natural objects or collating of data that are then creatively displayed in the aim of subverting certainties in the production of new knowledge in both the artistic and scientific fields. In order to facilitate this, Dion has on a number of occasions performatively adopted the role of the archaeologist, who gains first-hand knowledge of the world by discovering, identifying, categorising and collecting objects.

In 2000, as discussed in Chapter 1, Dion created one of his most political pieces, *Some Notes Towards a Manifesto for Artists Working With or About the Living World*. This highly

influential work, reproduced next, has by many been considered a seminal moment in the development of a critically and ethically aware approach to contemporary art practice and has informed and inspired a large part of the art discussed in this book. It seemed therefore appropriate that ten years after the appearance of the work, we met with the artist to discuss how and if things have changed.

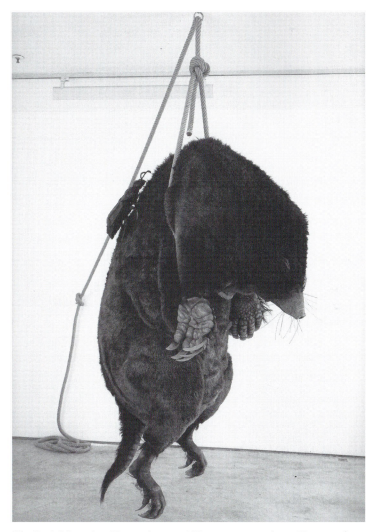

33. Mark Dion, *Les Necrophores - L'Enterrement (from Homage à Jean-Henri Fabre)* (1997).

Some Notes Towards a Manifesto for Artists Working With or About the Living World

1. We are not living in a simple age and as artists of the time our work reveals complex contradictions between science and art, between empiricism and the ideal, between nature and technology and between aesthetic conventions and novel forms of visualisation. Our goals vary. While some may wish to dissolve the contradictions in our social relations to the natural world, others may be interested in analysing or highlighting them.

2. A: Humans do not stand outside of nature: we, too, are animals, a part of the very thing we have tried to control, whether for exploitation or protection.

 B: Just as humanity cannot be separated from nature, so our conception of nature cannot be said to stand outside of culture and society. We construct and are constructed by nature.

3. Our work, rather than being 'about nature', can be better characterised as being focused on ideas about nature.

4. Artists working with living organisms must know what they are doing. They must take responsibility for the plants' or animals' welfare. If an organism dies during an exhibition, the viewer should assume the death to be the intention of the artist.

5. Artists do not break international wildlife protection laws (unless those laws are irrational).

6. The relationship we have to living organisms is a passionate one. Our subject rules our lives. We live, breathe, and eat our field of investigation. This passion is essential for the production of compelling artwork.

7. Artists who produce work about biology or who collaborate with fungi, plants or animals are not bound by form or materials. One can produce an argument in many different languages; no form of expression is more perfectly suited to ecological issues. Painting, architecture, landscape design, photography, performance, virtual technology, sculpture, installation, video, horticulture, and agit-prop have all been deployed to great success.

8. Understanding the past's traditions of nature, in folk culture, science, aesthetics, philosophy and religion, is a source of illumination for the present and also the future. The beliefs of the past form the foundations for contemporary institutions and more often than not, still persist in their own operation.

9. Artists must resist nostalgia. We never do 'golden age' history. When we reference the past it is not to evoke 'the good old days'. Our relation to the past is historical, not mythical.

10. Nature does not always know what is best.

11. We reject the notion of the environment as a perpetually stable and self-regulating system, existing in a constant state of balance. The natural world is far more dynamic and intricate, and its history, for at least ten thousand years, has been more entwined with human history than notions of natural balance allow for.

12. The more a notion of nature is touted as free of culture, the more likely it is to be a successful product of it.

13. Animals are individuals, and not carbon copy mechanistic entities. The have cognitive abilities, personalities and flexible behaviour, which is not to suggest that they exhibit distinctly human characteristics.

14. Anthropomorphism has long been guarded against in the field of zoology as an impediment to understanding animal behaviour in their own context. While a pitfall in ethology, artists may find the rich tradition of anthropomorphism too powerful a tool to surrender, particularly when probing the boundaries between humans and other animals.

15. 'The first thing you have to ask is, "Is it scientifically right?" This is still nothing but it is essential.' Ruskin.

16. The ivory tower of science is a ruin. Science is not a pure realm of truth beyond the taints of ideology and business, but a field of ideas enmeshed in a power struggle. Increasingly industry and economics dictate the direction and priorities of research. Whilst informed by science, we are ever vigilant against claims of scientific neutrality, and ever sceptical of the 'official story' of natural history presented by scientific institutions.

17. Taxonomy, i.e. the classification of the natural world, whilst a useful tool, is a system of order imposed by man and not an objective reflection of nature. Its categories are actively applied and contain the assumptions, values and associations of human society.

18. Our societies can afford wildlife conservation and the preservation of natural habitats.

19. The variety and variability of life is a wonder of infinite complexity. There is no more curious and uncanny topic than the biodiversity which surrounds us. The objective of the best art and science is not to strip nature of wonder but to enhance it. Knowledge and poetry are not in conflict.

20. We believe and affirm that human interaction with the natural world need not result in the degradation and homogenisation of natural habitats and landscapes. Cultures have a choice to determine the future of our relationship with the living world, as efficiently as the environment is destroyed it could also be protected.

Mark Dion, 2000, First published in *The Greenhouse Effect*, Serpentine Gallery, 2000. Reprinted here with permission of the artist.

Discussing the Manifesto

Giovanni Aloi: Your contribution to *The Greenhouse Effect* exhibition (2000) held at the Serpentine Gallery in London was the now famous handwritten text titled *Some Notes Towards a Manifesto for Artists Working With or About the Living World.* There is something in the title of this piece that suggests a beginning, a possibility for an open dialogue through the essence of a work in progress. This is mainly implied by the choice of words, like 'notes' and 'towards' featured in the title and both alluding to the revisable and open nature of the text. Why a manifesto, then?

Mark Dion: At the turn of the twentieth and twenty-first centuries the notion of a manifesto seemed an absurdity. After all, ours is a time of a decentred subject, in which dominant ideologies have been deligitimated, and if the art world of the moment is characterised by one thing, it would be a pervasive pluralism. The certainty of the avant-garde stance of a century before which produced manifestos seemed quaint and naive on one hand, and striving for tyranny on the other. Like most artists, I am deeply anti-authoritarian, yet not afraid to speak definitively. I read a good number of manifestos in preparation for the work, and found the declarative nature of the genre more than a little comic.

Giovanni Aloi: Which manifesto did you find most interesting?

Mark Dion: Perhaps the model I admired the most and borrowed the most from in tone was Sol LeWitt's *Sentences on Conceptual Art* (1969). This work changed my life when I first read it at Wadsworth Atheneum in Hartford Connecticut as a first-year art student in 1981.

I filled the title with qualifiers, to allow it to be clearly open and a work in progress, as you say, as though to invite others to collaborate on the final draft. It was also presented in a handwritten form so as to highlight the subjectivity of the statement, and yet the hand is intentionally not the author's, so as to further complicate the positioning of the piece. In some way it is intended as both a complex experiment and a shout-out to fellow artists who engage with the topic.

Giovanni Aloi: Has the manifesto in any way influenced your own work?

Mark Dion: The writing functioned as a remarkable tool for clarification of my positions for myself and thus was extremely important. The manifesto, which is a curious document in that it clearly voices contradictory positions and allows them to co-exist, a very unlikely thing in a manifesto, is both an artwork and an expression of purpose for me. I am writing both as the constructed public figure of the artist Mark Dion as well as the person Mark Dion. I know this may sound strange but in my artwork I am not always speaking my voice.

Giovanni Aloi: As in looking at the subject from different perspectives?

Mark Dion: My work sometimes expresses positions and views which are critical to my thematic, which is the culture of nature, but are not necessarily my perspective. This is why my work is perhaps in some ways close to fiction. Reading fiction, one learns not

to confuse the author with the voice of the characters. This applies to art as well. That said, in this case the manifesto is not ironic or fiction, I wrote only what I believe. The contradictions stand because they are contradictions in my own world-view.

Giovanni Aloi: Since the manifesto was written, the presence of animals in contemporary art has exponentially increased year after year. Just as it was being released in 2000, Eduardo Kac's fluorescent rabbit was taking the art world by storm, and since that first experiment, transgenic art has also become an increasingly popular art form, raising a range of key ethical issues. What is your take on transgenic art?

Mark Dion: In 1991, I produced an exhibition for Christian Nagel Gallery in Köln titled *Frankenstein in the Age of Biotechnology,* which proved important to me since it required an extensive amount of research and study in order to grasp the issues at hand in the genetic-engineering revolution we are still on the threshold of. I had a great deal to learn. As part of the artwork I produced a newspaper, an issue of Metropolis' *Daily Planet,* in which the experienced reporter Clark Kent (a hybrid of the military and the press) interviews the maverick geneticist Victor Frankenstein, who has vowed to abandon the industry. Through this interview I attempted to articulate my position on the issue, which was against a blind fear of genetics manipulation, which seemed like the logical extension of centuries of low-tech engineering through plant breeding and animal husbandry, but at the same time expressing an extreme concern and scepticism for who was directing this new industry and why, and what might be the unforeseen consequences. Who wants GMOs and why? We know that corporations like Dupont and Monsanto cannot be trusted to act with the public welfare in mind. This trust has time and again been violated. We also know the ideal of the university white tower of knowledge is a ruin and that pharmaceutical, agri-business, chemistry and military corporations drive university research programmes.

So we must be vigilant about who controls genetic-engineering technologies and what are their agendas and how do they violate public welfare and trust. The industry and academy must be carefully monitored and regulated and industrial accidents must be anticipated and the public must have both education and transparency. However, it seems wrong to me to block the field based on some vague sense of spiritual dread.

Giovanni Aloi: If you were to revise the manifesto, would you include this subject?

Mark Dion: I am wary of individual artists developing novel organisms, however I could imagine a manner in which intelligently executed with concern for animal health and ecological safety it could be done to encourage thoughtful discourse. Undoubtedly I would add to the manifesto a statement which would address the artists having full knowledge of the environmental consequences of novel organisms produced and the development of a protocol to assure they do not escape into nature causing economic, cultural or biological mayhem.

Giovanni Aloi: In point 4) of the manifesto you indeed state: 'Artists working with living organisms must know what they are doing. They must take responsibility for the plants' or animals' welfare. If an organism dies during an exhibition, the viewer should assume the death to be the intention of the artist.' Since the publishing of the manifesto, many works of art, most of which have been discussed in this book, capitalised on the killing of animals. This specific point in the manifesto is ambiguous in that it does not seem to directly condemn the killing of animals in the gallery space but appears to be more concerned with the signification of the death in question. Could you expand on this point?

Mark Dion: When considering artists working with organisms, what is critical is the question of control. Animals and plants are being used to produce meaning, like other art materials, and one would expect the artist to have a degree of mastery of their medium. Yet biological entities are very unlike paint, plaster, charcoal, film, clay and bronze. They possess will and respond often in unpredictable ways to demands.

Giovanni Aloi: Could you give us some examples?

Mark Dion: Some artists use this aspect of will and produce work that is more like a collaboration with the organisms. However, there is little less acceptable than an artist who produces a garden which does not grow, or exhibits a trained songbird who refuses to perform, or makes an aquarium in which all the fish die. As with any art form, viewers have the right to expect that the artists know what they are doing and that they have control of their materials and subject, unless of course the work is about the lack of control, failure and unpredictably.

The public death of plants or animals is a powerful spectacle, and some artists have been capable of harnessing that power to produce compelling environmental and ethical statements. Does that excuse the killing, or justify it? I do not really know, and I guess the question would have to be interrogated on a case-by-case basis. However, I do know that across the globe plants and animals are slaughtered or killed as by-products for far less important reasons than the making of art. I also assume for the artists who do kill there is no delight in this act. Those of us who overtly engage in biological issues are very like scientific professions working on these topics and thus we are motivated by a deep affection and passion for the topic. So, killing a butterfly for a work is a terrible contradiction, although not quite as horrible a purchasing one in a shop.

Giovanni Aloi: In the light of all the works of art involving the killing of animals that have been produced, would you make alterations to this point?

Mark Dion: The manifesto specifically does not condemn killing of animals for art largely because I think it impossible to rule out creative strategies. Even if I would find killing an animal in a gallery context an abomination, I can't exclude the act from other artists' toolboxes. Who makes a more compelling and thought-provoking case against animal cruelty, a Sue Coe painting or the artist who publicly beats a dog with a stick?

Giovanni Aloi: In Evaristti's *Helena*, the killing of goldfish in blenders was staged in order to unveil a range of human affairs relating to the meaning of power and ethical choices. It was clear that the work's focus did not revolve around the animal itself and that nature was not necessarily part of the discourse either, but that the goldfish instead stood in as a 'generic life' of some description. The opportunity to kill was offered to a member of the audience, therefore seemingly disentangling the artist from the ethical web of delegation he wove. What do you think of this work, and Evaristti's approach?

Mark Dion: I am not sure Evaristti would agree that he is off the ethical hook in this work. We were in an exhibition together at the Kunstraum Dornbirn in Austria where one of the gallery visitors diced the goldfish. Evaristti clearly felt an accomplice in the willfully destructive act, and one could feel the public sentiment turn against him at the exhibition's opening. He was snared in the web of relations he had woven.

Giovanni Aloi: Did you find the killing of the fish problematic?

Mark Dion: In many ways the death of one goldfish is a trivial event in the face of the millions of fish killed, through habitat loss, chemical pollution, or by catch each day, however what makes the case so different is that the act of killing is not merely intentional but that it also bestows no gain to the perpetrator. I agree with your notion that the goldfish is less of an individual than a stand-in for a generic life; the taking of this life is not part of a vast economic apparatus, nor does it provide material gain or glory onto the killer, rather it is an overt violent act of total destruction. To know that the person who would press the mix button is there in the gallery, to know that someone takes pleasure from such an act, does indeed seem something worth knowing. Fish die for less.

Giovanni Aloi: Do you think the moral and ethical considerations at stake should also be extended to the gallery spaces that present such works?

Mark Dion: I should imagine that those considerations are precisely the point of such works. They are produced to interrogate the moral and ethical boundaries of our society, our relations and obligations to the beings we share Earth with. In some contexts these endeavours would be unacceptable, while in others no objections would be raised. One of the things artists who work with animals quickly learn, is how dramatically the status of animals changes from country to country. Animals' ethical status is highly socially contingent.

Giovanni Aloi: In point 5) of the manifesto you state, 'Artists do not break international wildlife protection laws (unless those laws are irrational).' You have developed a reputation for being rather outspoken about malfunctioning institutionalised approaches to nature. Could you give us an example of 'irrational wildlife protection laws'?

Mark Dion: It is obvious that most artists who produce work engaging wildlife issues do so out of concern for their protection and out of a sincere and passionate commitment to conservation. It seems highly unlikely that they would violate the very laws put into place to protect animals. There are, however, numerous laws which control animal bodies and products, which while intended to protect animals and plants have wasteful and

unecological consequences. A simple example is the prohibition on picking up roadkill. Often the stuffed animals I use in my work are roadkill which my taxidermist or I find, the use of which is highly illegal and risky for the taxidermist.

Giovanni Aloi: Which animals do you find more problematic to acquire and why?

Mark Dion: I am as careful as possible with shells and insects, which, I fear, are even more of an issue with regard to trafficking in illegal species. I never buy shells from dealers and never purchase corals from professionals. The large specimens I have used like the European bison and European wolf come from decommissioned museum exhibits. They once had a place in a Neolithic exhibit.

As you mention, some artists attempt to get around wildlife laws. One simple way of doing that is of course to work with the institutions which are mandated to have a legal monopoly on wild-animal bodies, like zoos, natural-history museums and scientific laboratories. Collaborations of this kind can be complex and bureaucratic beyond belief, but can result in powerful exhibitions. I think the Snæbjörnsdóttir/Wilson project in which they borrowed polar bear taxidermy from British institutions is an excellent example of how productive these kinds of collaborations can be.

Giovanni Aloi: Taxidermy has become increasingly popular in contemporary art. What is your take on this development?

Mark Dion: There is an amazing book on this topic by Petra Lange-Berndt titled *Animal Art: Präparierte Tiere in der Kunst, 1850–2000*, which is certainly an authoritative work on taxidermy in art, where she has traced the artists' use of animals well beyond the modern period, showing that this is a constant obsession in art. In America, it can be traced to the painter Charles Wilson Peale, while the French Animaliers of the nineteenth century clearly struggle to imagine taxidermy as an art form. Taxidermy enters the domestic environment exactly at the moment when contact with actual animals and plants diminishes, and it seems entirely outside art production as a separate field of craft. The Surrealists rediscover and employ animal bodies in entirely different ways, as does Rauschenberg.

I understand the use of taxidermy today as an expression of the power of the uncanny aspect of nature, which has strengthened as our everyday contact with wild places and beings has greatly diminished. Needless to say, there is enormous cultural anxiety around the category of nature, which for so long has been something we measured ourselves against, which formed us in opposition, mistakenly of course. What does it mean when nature and animals seem such irrelevant features in many people's perceived experience? Artists are quick to pick up on and work with these anxieties and contradictions.

Giovanni Aloi: You have frequently incorporated taxidermy in your work. How are the animal bodies used in your installations sourced?

Mark Dion: There are a number of different types of taxidermy animals I employ in my work, and there are a number of very different ways they are sourced and acquired. I attempt to know as much as possible about the specimens and I am careful to assure that they

are all legal. The most clear-cut way I find taxidermy is by purchasing antique specimens from flea markets. As should be obvious to anyone who knows my body of work, I spend absurd amounts of time combing flea markets worldwide. This can be a difficult way to acquire specimens, since you can never be certain what will be available, and the animals can be in extremely poor condition. On the other hand, I often find things I never expected in flea markets and it results in producing unexpected new works. Also I may be covering the animals with tar or bandages, so they need not be in pristine condition.

I also commission work from taxidermists. I have a number of craftsmen of high quality who I have employed to make me taxidermy from real animals, or to make one thing from another, such as a bear from goat skins, or to make entirely artificial animals. Some taxidermists have specimens in stock, others need to acquire dead animals. For example, the cats and dogs I have used come from the pound where they kill hundreds a month.

Giovanni Aloi: How easy is it to reclaim unwanted taxidermy from natural-history museum displays?

Mark Dion: Not really. Once I was working at the Carnegie Museum in Pittsburgh. Due to a shortsighted and aesthetically challenged director of natural history, the curators were forced to dismantle the huge historic bird hall, with its remarkable dioramas and taxonomic displays. I met them pulling out the glass eyes from hundreds of perfect taxidermy birds. Glass eyes are expensive, and they wanted to save them. However, since they could not give the birds away or sell them by law, they were all to be incinerated. These were hundreds of expertly crafted specimens, all wasted. I had asked for them, as did Kiki Smith. Imagine what could have been done with such material. Instead they ended up as just so much ash.

Giovanni Aloi: Have you ever commissioned animals to be killed for one of your works?

Mark Dion: It is very rare that I have had animals killed for specimen production, but it has certainly happened, and always for the works about introduced pest species such as rats, pigeons, starlings, grey squirrels etc. I would hunt them myself if this was efficient, but it is not, since I do not have the proper permits.

Giovanni Aloi: In my discussion of Guillermo Vargas's *Exposición No 1*, I argue the possibility that, contrary to public belief, the whole event may have been a staged occurrence and that Natividad, the stray dog, effectively never died. However, the conviction that the dog indeed died as part of the exhibit went unquestioned through the discussion generated on the net. Whether the animal physically died or not, are there, in your opinion, ethical implications related to the 'simulation of animal killing'? Let's say, for instance, that the animal only died in the representative realm of the work, rather than in the gallery. What considerations are there to apply?

Mark Dion: Art is a discursive and symbolic realm. What matters is that viewers are convinced that the dog died. This must be real to them in order for the dog's death to have meaning. It is not important that the dog dies in an actual sense, as long as it is believed to have

died. Much art is sleight-of-hand, and like each great magician, each artist will never give away the secret of the illusion.

Animals die all the time for a wide range of reasons: to make food and handbags, as by-products of industrial process, killed as pests, killed by accidents, as a consequence of our voracious need for more land, for sport, for experimentation. However, when it comes to exterminating animals for the production of art, it seems entirely inexcusable and morally wrong.

Giovanni Aloi: Why do you think that is?

Mark Dion: It may be because we imagine all those other things as necessary and meaning-making as a luxury or non-essential aspect of culture? Why is killing an animal for art more of a lightning rod then killing it for any of these other reasons?

Giovanni Aloi: In point 6) of the manifesto we read, 'The relationship we have to living organisms is a passionate one. Our subject rules our lives. We live, breathe, and eat our field of investigation. This passion is essential for the production of compelling artwork.' Could you mention some examples of contemporary artists you see fitting in this inclusive 'our'?

Mark Dion: When I say 'our', I am speaking for a diverse group of artists' work in a wide range of media and coming from a variety of locations on the political spectrum, but unified in a complex and passionate commitment to an examination of our relationship to the living things which we share to earth with. My 'our' would include Alexis Rockman, Rachel Berwick, Helen and Newton Harrison, Henrik Håkansson, Rosemarie Trockel, Lynne Hall, Fritz Haeg, Alan Sonfist, James Prosek, Walton Ford, Bob Braine, Mark Thompson, Natalie Jeremijenko, Snæbjörnsdóttir/Wilson, Art Orientè Objet, Dieter Buchhart, Catherine Chalmers, Annette Messager, Roxy Paine, Tony Metelli, the Weinbergers and Marcus Coates.

These are the artists who I focus on and learn from and who I also have in my mind when considering an audience. I could include dozens more names, and were one to look at the work of all these artists they would find little formal similarity. I could also easily cast the net wider to include my friends and collaborators from the discipline of landscape design and architecture.

Giovanni Aloi: One of the most meaningful statements concerning artistic practice in general is featured in point 7), where we read, 'Artists who produce work about biology or who collaborate with fungi, plants or animals are not bound by form or materials.' From the perspective of aesthetics, what are the implications of such a shift from traditional practice and to what degree does this shift entail a need to develop a new methodological approach to the discussion of these works?

Mark Dion: The focus of the manifesto is not merely for artists using plants and animals as material or as collaborators, but it also addresses those who make 'work about' the natural world. While obviously an artist deeply implicated in the use of nontraditional practices, I saw this statement as one attempting to embrace and encompass traditional

practices such as drawing, painting and photography. When I survey the landscape of artists working on issues of the culture of nature, my eye wanders widely and I include things like scientific illustration, sporting art, taxidermy, nature films, landscape design. I do not want to make a circle around a number of practices and say, 'Everything outside of this circle does not count or is uninteresting'.

Giovanni Aloi: What does your personal approach entail, then?

Mark Dion: I am most interested in a highly intellectual and critical practice that is often best exemplified by contemporary visual art, but I understand the culture of nature and its politics of representation in a much broader way. I also do not see the value of privileging one form of expression or media.

To some extent, I group artists more around the problems of thematics or concerns than I do around media or approach. To put it very simply, I think what one is trying to do is more important than the form of expression you choose to express it in.

Giovanni Aloi: So it's a matter of research first?

Mark Dion: Most artists I am interested in develop the problem first and then decide which medium to tackle it in; sometimes making a film is most appropriate, or producing a drawing, or developing an installation. What motivates me to look closely at an artist is conviction and focus over longer periods of time to a complex of ideas or issues. I realise this is all far afield from your question, however I really do not see why we would need to shift the criteria of aesthetics. I would hold any non-traditional practices to the same aesthetic acid tests.

Giovanni Aloi: How is your work influenced by 'the past's traditions of nature, in folk culture, science, aesthetics, philosophy and religion', as mentioned in point 8) of the manifesto?

Mark Dion: I am a person who holds the world of science in high esteem; it is my cosmology, it shapes my world-view. Yet it is clear to me that in the discourse which produces the culture of nature, science does not have a monopoly, nor do I feel it should. In producing work about and with living things, it seems necessary to take into consideration the richness of other traditions, many of which better articulate a wise and progressive attitude to environmentalism. The culture of nature is a messy ball of string made of numerous coloured strands, to borrow from Donna Haraway's metaphor. No one strand dominates the form. The job of the cultural critic is to tease out, lift and separate, and trace these threads to see how they are linked, where they come from and to appreciate and articulate the tangle. No one field gets to determine for society what gets to stand for Nature, rather it is a composite of dramatically different traditions: folk tales, hunting stories, origin myths, biology classes, industry, food etc.

In my own work I attempt to ally myself with aspects of all these traditions which share my voice, my point of view, that is one which promotes environmental justice, which is committed to wildlife conservation but feels in the end that we, as a society will in fact not really be able to work it out. In the end, I am extremely pessimistic.

Giovanni Aloi: In Chapter 5 of this book, I discuss at length the challenges posed by an anthropomorphic approach to animals. Could you provide an example of productive use of anthropomorphism in either your work or those of other artists?

Mark Dion: I am interested in the strategic deployment of anthropomorphism as I frame it in the manifesto. I want to imagine the category of animals as one which affirms humans as being firmly a part of the category. I want to fight against the model of the mechanistic animal, the hard-wired being guided by instinct alone. Animals are individuals, and seeing them so allows us to bestow more respect and agency to them. Our obligations to them are more complex.

In a number of projects I have produced an absurd situation in which a number of birds, usually finches, live in, on and around a massive tree, which has been turned into a library. It's branches are the various branches of knowledge, which might be helpful to bird health and longevity, like geography, chemistry, hunting, ecology etc. Anyone who spends time with these works, which are essentially aviaries, begins to see individual difference within the bird community. Since the work's fulcrum is the conceit that birds can or should read, one ascribes to the birds an anthropomorphic intelligence, and projects onto the individual birds preferences based on knowledge. Certainly the people who spend a great deal of time with these works begin to see the birds as individuals rather then little clockwork copies of each other, and the birds of course are individuals. However, seeing animals as individuals is different from seeing them as human.

Giovanni Aloi: Point 16) of the manifesto states that 'The ivory tower of science is a ruin.' As a multidisciplinary practitioner who is consistently involved with scientific institutions, how has the relationship between art and science evolved over the past ten years?

Mark Dion: Artists ally themselves with science, which seems to be an easy way to garner power. Since science represents knowledge and truth, appearing to have command of it bestows upon the artist authority. We should be very careful of how and why artists use science. At the same time I see the authority of science slipping as culture backslides to conservatism.

The most important aspect of science I have confronted in the past decade is how the scientific academy will so easily sell itself out to business interests and how it can be so clearly politically subservient. Science seems to have no voice whatsoever outside of the academy and seems to utterly lack the influence it should possess. This is acutely felt here in the USA, where scientific knowledge is outmanoeuvred by the corporate culture at every turn. The resurgence of faith, the marginalising of intellectuals, the marriage of the right-wing press and political wing, all make things look pretty grim for both science and art and any truth-seeking enterprise. What good is possessing knowledge if you cannot do anything whatsoever with it? The climate debate is an excellent case study. I am increasingly pessimistic about the future. In each area I care about, I see nothing but discouraging developments. My work in general is right now more fuelled by anger than by hope.

Giovanni Aloi: If you were to rewrite the manifesto today, what alterations would you make?

Mark Dion: If I were to write the manifesto again today, I would try to tease out a difference between those who work with plants and animals in a progressive manner and those who are reactionary and oppressive. There is nothing inherently progressive in working around these issues. It is just possible to imagine artwork being produced which affirms the domination and degradation of nature using living organisms. Indeed I think many artists today who work with plants and animals arrive at conclusions which support our separation from the natural world and increase our degradation of it. Some artists obviously hector animals and plants to interrogate the boundaries between us, and thus attempt to reach a productive conclusion by negative methods. I find this compelling but misguided in the end. Were I to write the manifesto again, I think coming up with a taxonomic approach to the artists and their goals would be the most interesting and instructive way to proceed.

Notes

Preface: Why Look at Animals Now?

1. Jacques Derrida (1997), 'The animal that therefore I am (more to follow)', in *The Animal that Therefore I Am*, ed. Marie-Louise Mallet, Fordham University Press, New York, 2008, p.29.
2. Samuel Johnson (1758–60), *The Works of Samuel Johnson*, vol.4: *The Adventurer, The Idler*, Kessinger Publishing, Whitefish, MT, 2004.
3. Fiachra Gibbons, 'Tate Modern awakes to Dane's rising sun', *Guardian*, 16 October 2003, http://www.guardian.co.uk/uk/2003/oct/16/arts.artsnews1/print, retrieved 22 February 2009.
4. Ibid.
5. Donna Haraway, 'A cyborg manifesto: science, technology and socialist-feminism in the late twentieth century', in *Simians, Cyborgs and Women: The reinvention of nature*, Routledge, New York, 1991.
6. Laurie Schneider Adams, *The Methodologies of Art: An introduction*, Westview Press, Boulder, CO, 1996, p.5.
7. Ibid., p.10.
8. Peter Rowland, *Bowerbirds*, Australian Natural History Series, CSIRO Publishing, Collingwood, Australia, 2008.
9. Giorgio Agamben, *The Open: Man and animal*, trans. Kevin Attell, Stanford University Press, Palo Alto, CA, 2004, p.16.
10. Ibid., pp.41–42.
11. Ibid., p.42.
12. Georges Bataille (1973), *Theory of Religion*, trans. Robert Hurley, Zone Books, New York, 1992, p.19.
13. Ron Broglio, *Surface Encounters: Thinking with animals and art*, University of Minnesota Press, Minneapolis, MN, 2011.
14. Jean-François Lyotard, *The Postmodern Condition*, Manchester University Press, Manchester, 1984.
15. Agamben, *The Open*, p.37.
16. Bertrand Russell (1913), *Theory of Knowledge*, Routledge, London and New York, 1992.
17. Derrida, 'The animal that therefore I am (more to follow)', p.29.

Chapter 1: Caught up in Representation

1. Rainer Maria Rilke, *Der Panther*, trans. Cliff Crego, 1907.
2. Carol Vogel, 'Swimming with famous dead sharks', *New York Times*, 1 October 2006, retrieved 23 February 2010.
3. Jean Clottes and Jean Courtin, *The Cave Beneath the Sea: Palaeolithic images at Cosquer,* trans. Marilyn Garner, Harry N. Abrams, New York, 1996.
4. Harriet Rivo, *The Animal Estate: The English and other creatures in the Victorian age*, Harvard University Press, Cambridge, MA, 2002.

5. Paul Crowther, *Critical Aesthetics and Postmodernism*, Oxford University Press, Oxford, 1993.

6. Lynn Barber, 'Bleeding art', *Observer*, 20 April 2003, http://www.guardian.co.uk/artanddesign/2003/apr/20/thesaatchigallery.art6, retrieved 1 September 2010.

7. Warren Buckland, *Directed by Steven Spielberg: Poetics of the contemporary Hollywood blockbuster*, Continuum, London and New York, 2006, p.103.

8. Barber, 'Bleeding art'.

9. René Descartes (1641), *Meditations and Other Metaphysical Writings*, Penguin Classics, London, 2003.

10. Vogel, 'Swimming with famous dead sharks'.

11. Rosalind E. Krauss, 'Richard Serra/Sculpture', Museum of Modern Art, New York, 1986.

12. David Seidner, 'Richard Serra', interview with the artist, *Bomb Magazine* 42 (Winter 1993).

13. Lynne Cooke, 'Richard Serra: a case study', *Tate Papers* 8 (2007).

14. Loris Schermi, 'La Salita, storia di una galleria', Merzbau, http://www.merzbau.it/appunti.php?mrcnsn=0000000013, retrieved 12 March 2010.

15. Malcolm Warner and Robin Blake, *Stubbs and the Horse*, Kimbell Art Museum, Fort Worth, TX, 2004, p.13.

16. Steve Baker, *The Postmodern Animal*, Reaktion Books, London, 2000, p.82.

17. Karl Kerényi, 'The trickster in relation to Greek mythology', in Paul Radin (ed.), *The Trickster: A study in American Indian mythology*, Bell Publishing, New York, 1956, p.185.

18. David Williams, 'Inappropriate/d others, or the difficulties of being a dog', *Drama Review* 51/1 (Spring 2007), New York University and Massachusetts Institute of Technology, p.98.

19. James Serpell, 'From paragon to pariah: some reflections on human attitudes to dogs', in J. Serpell (ed.), *The Domestic Dog*, Cambridge University Press, Cambridge, 1995.

20. Uwe M. Schneede, 'Joseph Beuys die aktionen', *Kommentiertes Verzeichnis mit fotografischen Dokumentationen*, Gerd Hatje Verlag, Ostfildern-Ruit bei Stuttgart, 1998, p.330.

21. Caroline Tisdall, *Joseph Beuys: Coyote*, Schirmer-Mosel, Munich, 1980, pp.26–28.

22. Thomas Nagel, 'What is it like to be a bat?', *Philosophical Review* 83/4 (October 1974), pp.435–50.

23. John Berger, 'Why look at animals?', in John Berger, *About Looking*, Pantheon Books, New York, 1980.

24. Cynthia Chris, *Watching Wildlife*, University of Minnesota Press, Minneapolis, MN, 2006, p.10.

25. Steven Watts, *The Magic Kingdom: Walt Disney and the American way of life*, University of Missouri Press, Columbia, MO, 2001, p.305.

26. Ibid., p.304.

27. Berger, 'Why look at animals?'

28. Carsten Höller, 'In conversation with Carsten Höller', interview by Giovanni Aloi, *Antennae* 12 (Spring 2010).

29. Diana Donald, *Picturing Animals in Britain: 1750–1850*, Yale University Press, New Haven, CT, 2007.

30. Diana Donald, *Endless Form: Charles Darwin, natural science, and the visual arts*, Yale University Press, New Haven, CT, 2009.

31. Baker, *The Postmodern Animal*.

32. 'It's art, says the naked woman who will hug a dead pig on stage', *Daily Mail*, 18 August 2006, p.17.

33. Kira O'Reilly, 'Falling asleep with a pig', interview by Snæbjörnsdóttir/Wilson, *Antennae* 13 (Summer 2010), p.41.

34. Ibid., p.43.

35. Ibid., p.47.

36. George Gessert, 'On exhibiting hybrids', *Art and Technology Supplement of CIRCA*, 1990, pp.8–9.

37. Mark Dion, 'Towards a manifesto for artists working with or about the living world', in *The Greenhouse Effect*, exhibition catalogue, Serpentine Gallery, London, 2000, p.66.

38. Ralph Rugoff, 'Signs and wonders', in *The Greenhouse Effect*, exhibition catalogue, Serpentine Gallery, London, 2000, p.15.

39. Ibid., p.15.

40. Immanuel Kant (1790), *The Critique of Judgement*, Cosimo, New York, 2007, p.213.

41. Jean-Jacques Rousseau (1754), *Discourse on Inequality*, Kessinger Publishing, Whitefish, MT, 2004, pp.72–73.

42. Dion, 'Towards a manifesto', p.66.

43. Rugoff, 'Signs and wonders', p.30.

44. Jean Baudrillard (1981), *Simulacra and Simulation*, trans. Sheila Faria Glaser, University of Michigan Press, Ann Arbor, MI, 1994, p.2.

Chapter 2: Taxidermy: Subjugated Wilderness

1. Pat Morris, *A History of Taxidermy: Art science and bad taste*, MPM Publishing, Ascot, 2010, p.iv.

2. Hiroshi Sugimoto, 'Dioramas', www.sugimotohiroshi.com/diorama.html, retrieved 2 February 2010.

3. Roland Barthes, *Camera Lucida: Reflections on photography*, Hill and Wang, New York, 1982, p.91.

4. Matthew Brower, 'Take only photographs: animals photography construction of nature love', *Antennae* 7 (Autumn 2008), pp.59–63.

5. John Berger, 'Why look at animals?', in John Berger, *About Looking*, Pantheon Books, New York, 1980, p.16.

6. Carla Yanni, *Nature's Museum: Victorian science and the architecture of display*, Princeton Architectural Press, New York, 2005, p.2.

7. Toby Kamps, *Small Worlds: Dioramas in contemporary art*, Museum of Contemporary Art, San Diego, CA, 2000, pp.6–11.

8. Stephen Quinn, *Windows on Nature: The great habitat dioramas of the American Museum of Natural History*, Abrams, New York, in association with the American Museum of Natural History, 2006, pp.8–23.

9. Donna Haraway, 'Teddy bear patriarchy: taxidermy in the garden of Eden', in Amy Kaplan and Donald Pease (eds), *Cultures of United States Imperialism*, Duke University Press, Durham, NC and London, January 1994, p.24.

10. Ibid., p.37.

11. Georges Bataille (1973), *Theory of Religion*, trans. Robert Hurley, Zone Books, New York, 1992, p.20.

12. Paula Findlen, *Possessing Nature: Museums, collecting and scientific culture in early modern Italy*, University of California Press, Berkeley, CA and London, 1994, pp.1–11.

13. Jorge Luis Borges, 'The analytical language of John Wilkins', trans. Eliot Weinberger, in *Selected Nonfictions: Jorge Luis Borges*, ed. Eliot Weinberger, Penguin Books, London, 1999, p.231. The essay was originally published as 'El idioma analítico de John Wilkins' in *La Nación*, 8 February 1942, and republished in *Otras Inquisiciones*.

14. Michel Foucault, *The Order of Things*, Routledge, London and New York, 1966, p.26.

15. Mark Dion, *L'Ichthyosaure, la Pie, et Autres Merveilles du Monde Naturel*, Images en Manœuvres Éditions, Marseille, 2003, p.122.

16. Mary Frances Griffiths and Christine Lynch, *Reflections on the Cottingley Fairies*, JMJ Publications, Paraparaumu, 2009.

17. Eva Wiseman, 'Who is cool now', *Observer*, 6 July 2008.

18. Anonymous, 'IQONS*|Idiots', 2006, online at http://www.iqons.com/idiots, retrieved 1 March 2010.

19. Idiots, 'Idiots: the alchemical vision', interview with Giovanni Aloi, *Antennae* 7 (Autumn 2008), p.43.

20. Jan Bondeson, *The Feejee Mermaid and Other Essays in Natural and Unnatural History*, Cornell University Press, Ithaca, NY, 1999.

21. Haraway, 'Teddy bear patriarchy', pp.36–37.

22. Bryndis Snæbjörnsdóttir, *Spaces of Encounter: Art and revision in human–animal relations*, University of Gothenburg, Gothenberg, 2009, p.57.

23. Garry Marvin, 'Perpetuating polar bears: the cultural life of dead animals', in B. Snæbjörnsdóttir and M. Wilson, *Nanoq: Flat Out and Bluesome: A cultural life of polar bears*, Black Dog Publishing, London, 2006, pp.157–58.

24. Snæbjörnsdóttir, *Spaces of Encounter*, p.3.

25. Ron Broglio, *Surface Encounters: Thinking with animals and art*, University of Minnesota Press, Minneapolis, MN, 2011.

26. Bryndis Snæbjörnsdóttir and Mark Wilson, *Nanoq: Flat Out and Bluesome: A cultural life of polar bears*, Black Dog Publishing, London, 2006, pp.115.

27. Steve Baker, *The Postmodern Animal*, Reaktion, London, 2000, p.73.

28. Steve Baker, 'Something has gone wrong again', *Antennae* 7 (Autumn 2008), p.4.

29. Joshua Reynolds (1790), *Discourses on Art*, Paul Mellon Centre for Studies in British Art, London and Yale University Press, New Haven, CT, 1975.

30. Immanuel Kant, *Critique of Judgment*, Section 1: 'Analytic of Aesthetic Judgment', Book I: 'Analytic of the Beautiful', Cosimo, New York, 2007.

31. Clement Greenberg, *The Collected Essays and Criticism*, vol.2, University of Chicago Press, Chicago, 1986, p.17.

32. Arthur Danto, *The Abuse of Beauty: Aesthetics and the concept of art*, Open Court Publishing, Chicago, 2003, p.119.

33. Julia Kristeva, *Power of Horror: An essay on abjection*, Columbia University Press, New York, 1982, p.4.

34. Ibid., pp.9–10.

35. Angela Singer, 'Animals Rights and Wrongs', interview with Giovanni Aloi, *Antennae* 7 (Autumn 2008), p.11.

36. Ibid., p.15.

37. Lea Vergine and Giorgio Verzotti, *Il Bello e le Bestie*, Skira, Milan, 2004, p.201.

38. TINKEBELL, 'Popple', artist's website, http://looovetinkebell.com/pages/popple, retrieved 20 February 2010.

39. TINKEBELL, 'My dearest cat Pinkeltje', artist's website, http://looovetinkebell.com/pages/my-dearest-cat-pinkeltje, retrieved 20 February 2010.

40. *One Hundred and One Dalmatians*, dir. Clyde Geronimi and Hamilton Luske, Walt Disney, 1961.

41. Erica Fudge, *Pets*, Acumen Publishing, Durham, 2008, p.48.

42. Berger, 'Why look at animals?', 1980, p.3.

43. Nina Katchadourian, 'Chloe', artist's website, http://www.ninakatchadourian.com/confusinganimals/chloe.php, retrieved 12 October 2009.

Chapter 3: Levels of Proximity

1. Francis Bacon, quoted in David Sylvester, *The Brutality of Fact: Interviews with Francis Bacon*, Thames and Hudson, London and New York, 1987, p.46.

2. Donna Haraway, *When Species Meet*, University of Minnesota Press, Minneapolis, MN, 2008, p.47.

3. David Harvey, *The Condition of Postmodernity: An inquiry into the origins of cultural change*, Blackwell, Cambridge, 1999, p.28.

4. Nicole Shukin, *Animal Capital: Rendering life in biopolitical times*, University of Minnesota Press, Minneapolis, MN, 2009, p.87.

5. Ibid., p.89.

6. Ibid., p.93.

7. Ibid., pp.93–94.

8. Carol J. Adams, *The Sexual Politics of Meat*, Continuum, London, 1990, p.27.

9. Mark Quinn, *Incarnate*, Booth-Clibborn Editions, London, 1998, p.52.

10. Georges Bataille, *Oeuvres Complètes*, vol.I: *Premiers Écrits 1922–1940*, Gallimard, Paris, 1970, p.237.

11. Gilles Deleuze and Félix Guattari (1988), *A Thousand Plateaus*, Continuum, London, 1987, p.19.

12. Ibid., p.71.

13. Deleuze and Guattari, *A Thousand Plateaus*.

14. Steve Baker, 'What does becoming animal look like?', in Nigel Rothfels (ed.), *Representing Animals*, Indiana University Press, Bloomington, IN, 2002, p.71.
15. Deleuze and Guattari, *A Thousand Plateaus*, p.237.
16. Ibid., pp.237–38.
17. Oleg Kulik, 'Oleg Kulik: artificial paradise', *Antennae* 8/2 (Winter 2008), p.37.
18. Victor Misiano, 'Oleg Kulik's animality', in *Antennae* 8/2 (Winter 2008), p.28.
19. Sarah Watson, press release, Deitch Project, 1997, http://www.deitch.com/projects/sub.php?projId=79, retrieved 23 March 2009.
20. Roberta Smith, 'Becoming a dog by acting like one', *New York Times*, 18 April 1997, http://www.nytimes.com/1997/04/18/arts/on-becoming-a-dog-by-acting-like-one.html, retrieved 12 March 2010.
21. Oleg Kulik, *Antennae* 8/2 (Winter 2008), p.34.
22. Baker, 'What does becoming animal look like?', p.71.
23. Donna Haraway, *Simians, Cyborgs and Women: The reinvention of nature*, Routledge, New York, 1991, p.150.
24. Marcus Coates, 'In conversation with Marcus Coates', in *Antennae* 4 (Winter 2007), p.19.
25. Haraway, *Simians, Cyborgs and Women*, pp.149.
26. Viv Groskop, 'Chirps with everything', *Guardian*, 25 January 2007.
27. Deleuze and Guattari, *A Thousand Plateaus*, p.18.
28. Coates, 'In conversation with Marcus Coates', p.19.
29. Gilles Deleuze and Félix Guattari, *Kafka: Toward a minor literature*, University of Minnesota Press, Minneapolis, MN, 1986.
30. Deleuze and Guattari, 1988, p.17.
31. René Descartes (1637), *Discourse on Method and Meditations*, Bobbs-Merrill, Indianapolis, IN, 1960, p.42.
32. Rob la Frenais, 'An artist between species: the work of Nicholas Primat', in *Nicholas Primat: Demo Bonobo*, Les Abattoirs, Château de Taurines, 2007.

Chapter 4: An Uncomforable Closeness

1. *Blade Runner*, dir. Ridley Scott, Warner Bros, 1982.
2. Philip K. Dick (1978), 'How to build a universe that does not fall apart in two days', speech published in Philip K. Dick, *I Hope I Shall Arrive Soon*, Doubleday, New York, 1985.
3. *The Fly*, dir. David Cronenberg, Twentieth Century Fox, 1986.
4. S. Anker and D. Nelkin, *The Molecular Gaze: Art in the genetic age*, Cold Spring Harbor Laboratory Press, Cold Spring Harbor, NY, 2004, p.164.
5. N. Slifkin, *Mysterious Creatures*, Targum/Feldheim, Southfield, MI, 2003, p.203.
6. Charles Darwin (1859), *The Origin of Species*, Oxford University Press, Oxford, 1998, p.16.
7. Unknown Author, 'Koen Vanmechelen: the cosmopolitan chicken project: ten generations', press release, Deweer Gallery, Otegem, Belgium, 2007, http://www.deweergallery.com/exhibitions/71, retrieved 12 March 2010.
8. Ronal J. Gedrim, 'Edward Steichen's 1936 exhibition of delphinium blooms: an art of flower breeding', *History of Photography* 17/4 (Winter 1993).
9. George Gessert, 'An introduction to genetic art – conflicts of interest jeopardize scientific integrity and public health', *GeneWatch* 17/2 (March/April 2004).
10. Eduardo Kac, 'GFP Bunny', *Leonardo* 36/2 (2003), MIT Press, Cambridge, MA, pp.97–102.
11. H.P. Roche, Beatrice Wood and Marcel Duchamp (eds), 'The Richard Mutt case', in *The Blind Man*, New York, 1917, N.2, p.5.

12. Eduardo Kac, *Telepresence and Bio Art*, University of Michigan Press, Ann Arbor, MI, 2005, p. 237.
13. Ibid., p. 237.
14. Jean Baudrillard, *Simulations*, trans. Paul Foss, Paul Patton and Philip Beitchman, Semiotexte, New York, 1983, p. 11.
15. Unknown Author, 'Chupacabra, mysterious vampire', *National Geographic*, http://channel.nationalgeographic.com/episode/chupacabra-4554/facts, retrieved 10 June 2010.
16. 'MonsterQuest – Montauk Monster – Myth of Monster?', http://www.history.com/shows/monsterquest/videos/montauk-monster---myth-of-monster#montauk-monster---myth-of-monster, retrieved 12 June 2010.
17. C. Herndon, 'Meanmouth bass lives up to its name', featured in Ichthyology at the Florida Museum of Natural history, http://www.flmnh.ufl.edu/fish/InNews/meanmouth2004.html, retrieved 13 June 2010.
18. Henry Harris, 'Cell fusion', *BioEssays* 2/4 (1985), Wiley Periodicals, pp. 176–79.
19. *The Fly*, dir. Kurt Neumann, Twentieth Century Fox, 1958.
20. Personal consultation with Dr Dick Vane-Wright, Scientific Associate at the Entomology Department, Natural History Museum, London, 23 August 2010.
21. Marta de Menezes, 'The artificial natural: manipulating butterfly wing patterns for artistic purposes', *Leonardo* 36/1 (2003), MIT Press, pp. 30.
22. TC&A, 'Victimless leather – a prototype of stitch-less jacket grown in a technoscientific "body"', artists' website, http://www.tca.uwa.edu.au/vl/vl.html, retrieved 12 April 2010.
23. TC&A, 'Semi-living food: disembodied cuisine', artists' website, http://www.tca.uwa.edu.au/disembodied/dis.html, retrieved 12 April 2010.
24. René Descartes (1641), *Meditations and Other Metaphysical Writings*, Penguin Classics, London, 2003.
25. Laura Fernandez Orgaz and Patricia Piccinini, 'The naturally artificial world', in *(Tender) Creatures*, exhibition catalogue, Artium, 2007.
26. Leonel Moura, *Robotarium X*, Creative Commons, Fenda, Lisbon, 2007, p. 58.
27. Ibid., p. 60.
28. Ibid., p. 88.
29. Ibid., p. 64.
30. Ibid., pp. 74–76.
31. M.E. Clynes and N.S. Kline, 'Cyborgs and space', *Astronautics*, September 1960.
32. Donna Haraway, 'A cyborg manifesto: science, technology and socialist-feminism in the late twentieth century', in Donna Haraway, *Simians, Cyborgs and Women: The reinvention of nature*, Routledge, New York, 1991, p. 149.
33. Ibid., p. 150.
34. Ibid., p. 152.
35. Robert Pepperell, *The Posthuman Condition: Consciousness beyond the brain*, Intellect, Bristol, 2003, p. 15.

Chapter 5: The Animal that Therefore I am Not

1. Cary Wolfe, *Animal Rites: American culture, the discourse of the species, and posthumanist theory*, University of Chicago Press, Chicago, (2003), p. 6.
2. *Avatar*, dir. James Cameron, Twentieth Century Fox, 2009.
3. Kinji Imanishi (1941), *A Japanese View of Nature: The world of living things*, Routledge Curzon, London and New York, 2002, p. 7.
4. Fred Attevil, 2 June 2007, on correction to 'World's First Creationist Museum Opens in Kentucky', *Guardian*, http://www.guardian.co.uk/usa/story/0,,2090664,00.html, retrieved 8 December 2007.
5. William Paley (1802), *Natural Theology*, Oxford University Press, Oxford, 2006.

6. Gaetano Vallini, 'Avatar, James Cameron's new film: special effects wrapped around emptiness, scares and harmless pantheism', *L'Osservatore Romano*, Vatican City, 10 January 2010.

7. Luca Pellegrini, 'Avatar, il nuovo film di James Cameron: effetti speciali e innocuo panteismo', http://storico. radiovaticana.org/it1/storico/2010-01/348073_avatar_il_nuovo_film_di_james_cameron_effetti_speciali_e_ innocuo_panteismo.html, 9 January 2010, retrieved 11 June 2010.

8. Genesis, 1:28 (Original Latin Vulgate).

9. Andreas Trewavas, 'Aspects of plant intelligence', *Annals of Botany* 92 (2003), pp. 1–20.

10. F. Baluška, S. Mancuso, D.S. Volkmann and W.P. Barlow, 'The "Root-brain" hypothesis of Charles and Francis Darwin, revival after more than 125 Years', *Plant Signaling and Behavior* 4/12 (December 2009), pp. 1121–27.

11. Personal observations on Mimosa pudica plants (Summer 2010).

12. David Stenhouse, *The Evolution of Intelligence: A general theory and some of its implications*, George Allen and Unwin, London, 1974.

13. Baluška, Mancuso, Volkmann and Barlow, 'The "Root-brain"', pp. 1125.

14. Jacques Derrida (1997), 'The animal that therefore I am (more to follow)', in *The Animal that Therefore I Am*, ed. Marie-Louise Mallet, Fordham University Press, New York, 2008.

15. Ibid., p. 12.

16. Rikke Hansen, 'An Animal Gazes', CD-ROM essay catalogue, November, 2008. Theodor Adorno, *Aesthetic Theory*, trans. Robert Hullot-Kentor, Athlone Press, London, 1997, p. 113.

17. George Hegel and Friedrich Wilhelm (1835–38), *The Philosophy of Fine Art*, trans. F.P.B. Osmaston, C. Bell and Sons, London, 1920, p. 206–7.

18. René Descartes, 'Letter to Plempius', 3 October 1637, K, p. 36, AT II, p. 414; cf. Replies to Objections VI, HR II, p. 244.

19. 'The paradox of morality: an interview with Emmanuel Levinas', conducted by Tamra Wright, Peter Hughes and Alison Ainley, in Robert Bernasconi and David Wood (eds), *The Provocation of Levinas: Rethinking the Other*, Routledge & Kegan Paul, London and New York, 1988, pp. 168–80.

20. Emmanuel Levinas, *Totality and Infinity: An essay on exteriority*, trans. Alphonso Lingis, Duquesne University Press, Pittsburgh, 1969, p. 111.

21. 'The paradox of morality: an interview with Emmanuel Levinas'.

22. Nicky Coutts, *Insectile*, Mantis in association with Royal College of Art, London, 2001.

23. Emmanuel Levinas, *Otherwise Than Being and Beyond Essence*, trans. Alphonso Lingis, Nijoff, The Hague and Boston, 1981, pp. 12–13.

24. Levinas, *Totality and Infinity*, p. 21.

25. Catherine Chalmers, 'An interview with Catherine Chalmers', interview with Giovanni Aloi and Chris Hunter, *Antennae* 3/2 (Autumn 2007), p. 29–30.

26. *The Yogi Bear Show*, J. Hanna and W. Barbera, Hanna Barbera Productions, USA, 1958.

27. Erica Fudge, *Animal*, Reaktion Books, London, 2002, p. 76.

28. Ibid., p. 76.

29. Richard Ryder, *Animal Revolution: Changing attitudes towards speciesism*, Berg, Oxford, 2000, p. 6.

30. Roger Scruton, 'Animal rights', *City Journal*, Manhattan Institute, Summer 2000, http://www.city-journal.org/ html/10_3_urbanities-animal.html, retrieved 10 June 2010.

31. Fudge, *Animal*, p. 76.

32. G. Deleuze and F. Guattari, *A Thousand Plateaus*, Continuum, London, 1987, p. 240.

33. Derrida, 'The animal that therefore I am (more to follow)', p. 41.

34. Ibid., p. 28.

35. Robert Elwood and Mirjam Appel, School of Biological Sciences at Queen's University Belfast, studied hermit crabs collected from rock pools in County Down, Northern Ireland: paper to be published in *Journal of Animal Behaviour*.

36. Immanuel Kant, *The Critique of Judgement*, Cosimo, New York, 2007.

37. Giorgio Agamben, *The Open: Man and animal*, trans. Kevin Attell, Stanford University Press, Palo Alto, CA, 2004, p. 40.

38. Fernanda Cardoso, 'Our lady of mimicry', interview with Sonja Britz, *Antennae* 11 (Autumn 2009), p. 24.

39. Susana Soares, 'Susana Soares: Pavlov's bees', interview with Zoe Peled, *Antennae* 11 (Autumn 2009), p. 53.

40. Kenneth Rinaldo, 'Augmented fish reality', online text, http://accad.osu.edu/~rinaldo/works/augmented/ augmented.html, retrieved 10 April 2010.

41. Culum Brown (ed.). *Fish Cognition and Behaviour,* Blackwell Publishing, Oxford, 2006.

42. Ken Rinaldo, 'Augmented fish reality', p. 9.

43. Thomas Nagel, 'What is it like to be a bat?', *Philosophical Review* 83 (October 1974), p. 323.

44. Ibid., p. 323.

45. Ibid., p. 324.

46. Antony Hall, 'ENKI – human to fish communication', *Antennae* 13 (Summer 2010), p. 29.

47. 'I'm a Celebrity D'Acampo and Manning face rat charges', BBC News, http://news.bbc.co.uk/go/pr/fr/-/1/hi/ entertainment/8397691.stm, published 12 June, 2010, retrieved 20 August 2010.

48. Ibid.

49. Tara Conlan, 'I'm a Celebrity: ITV apologises for killing of rat', *Guardian*, 7 December 2009.

50. Panchoballard, 'What about the insects?', comment on Margaret Davis, 'ITV Fined over I'm a celebrity rat killing', *Independent*, 8 February 2010.

51. Imanishi, *A Japanese View of Nature*, p. 7.

Chapter 6: The Death of the Animal

1. The Animal Studies Group, *Killing Animals*, University of Illinois Press, Urbana, IL and Chicago, 2006, p. 4.

2. Unknown author, 'Message from the first dog in space received 45 years too late', *Dogs in the News*, 11 March 2002, http://dogsinthenews.com/issues/0211/articles/021103a.htm, retrieved April 2010.

3. Unknown author, 'Suffering catfish', *Time*, http://www.time.com/time/magazine/article/0,9171,903152,00.html, retrieved 20 January 2008.

4. Jerry Saltz, 'More life: the work of Damien Hirst', *Art in America* 83/6 (1995), p. 84.

5. *Psycho*, dir. Alfred Hitchcock, Shamely Productions, USA, 1960.

6. Capitol News Company, 'PETA miffed at President Obama fly execution', Reuters, 18 June 2009, http://www. reuters.com/article/idUSTRE55H4Z220090618, retrieved 5 June 2010.

7. Damien Hirst, *The Agony and the Ecstasy: Selected works from 1989 to 2004*, Electa, Naples, 2005, p. 83.

8. Massimiliano Gioni, 'Where the wild things are', *Tate Etc* 11 (Autumn 2007).

9. 'Controversial animal art exhibit still at risk', CTV.ca news, www.ctv.ca/servlet/ArticleNews/print/CTVNews/ 20070410/exhibit_bc_070410/20070410/?hub=TopStories&subhub=PrintStory, updated 10 April 2007, retrieved 12 March 2010.

10. Gioni, 'Where the wild things are'.

11. 'Don't trust me', press release for exhibition curated by Hou Hanru, San Francisco Art Institute, March 2008.

12. Akira Mizuta Lippit, 'The death of an animal', *Film Quarterly* 56/1 (Autumn 2002), pp. 9–22.

13. Anna Karina Hofbauer, 'Marco Evaristti and the open work', 2007, http://www.evaristti.com/defaultF.html, retrieved 1 February 2008.

14. 'Liquidising goldfish "not a crime"', BBC News, http://news.bbc.co.uk/1/3040891.stm, updated 19 May 2003.

15. Ibid.

16. Martin Harres, 'Regarding the pain of rats Kim Jones's rat piece', *Drama Review* 51/1 (Spring, 2007), pp. 160–165.

17. Susan Swenson, 'Conversation with Kim Jones: April 25, 2005', *War Paint*, Pierogi Gallery, New York, exhibition catalogue, p. 14.

18. Harries, 'Regarding the pain of rats', p. 162.

19. Animal Studies Group, *Killing Animals*, University of Illinois Press, Urbana, IL and Chicago, 2006, p. 4.

20. Roland Barthes (1967), 'The death of the author' in *Image – Music – Text*, Fontana Press, London, 1977.

21. Artist's website, http://www.katarzynakozyra.com.pl/, retrieved 8 February 2008. Artur Żmijewski, 'Carrying buckets, trotting like pigs', interview with Katarzyna Kozyra and Grzegorz Kowalski, *Czereja* 4 (1993), p. 27–28, reprinted in catalogue, http://www.katarzynakozyra.com.pl/pyramid_txt.html, retrieved 21 January 2008.

22. Artist's website, http://www.katarzynakozyra.com.pl, retrieved February 2008.

23. Friends of Animals, http://www.friendsofanimals.org/actionline/spring-2004/killing-for-art.htmlKilling, retrieved January 2008.

24. Bonilla Ruiz Geiner, 'Perro y un polemico arte', *La Prensa*, http://archivo.laprensa.com.ni/archivo/2007/octubre/05/noticias/revista/219438.shtml, retrieved 15 May 2008.

25. Guillermo Vargas, 'Artist kills a dog', Facebook group, http://www.facebook.com/group.php?gid=11998316438, retrieved 20 July 2010.

26. Petition Online, http://www.PetitionOnline.com/mod_perl/signed.cgi?13031953, retrieved 21 July 2010.

27. Jean Baudrillard, *Simulations*, trans. P. Foss, P. Patton, P. Beitchman, Semiotext(e), New York, 1983, p. 11.

28. Erica Fudge, *Animal*, Reaktion Books, London, 2002, pp. 27–28.

29. Mary Frost, 'Artist apologizes for decades-old dog-killing incident', *Brooklyn Daily Eagle*, 14 April 2008.

30. John Isaacs, 'John Isaacs: wounded animals and icon-making', interview with Giovanni Aloi, *Antennae* 5 (Spring 2008), p. 12.

31. Kate Green, 'Roadkill statistic to be monitored', *Country Life*, http://www.countrylife.co.uk/news/country/article/382380/Roadkill-statistics-to-be-monitored.html, retrieved 12 July 2010.

32. Sue Coe, 'In conversation with Sue Coe', interview with Giovanni Aloi, *Antennae* 5 (Spring 2008), p. 57.

33. Ibid., p. 55.

Chapter 7: Conclusion: In Conversation with Mark Dion - The Culture of Nature

1. Mark Dion and Nato Thompson (2005), 'Interview with Mark Dion', in Nato Thompson et. al., *Becoming Animal: Contemporary art in the animal kingdom*, MIT Press, Cambridge, MA, 2005, p. 53.

Bibliography

Adams, J. Carol, *The Sexual Politics of Meat*, Continuum International Publishing, London, 1990

Adorno, Theodor, *Aesthetic Theory*, trans. Robert Hullot-Kentor, Athlone Press, London, 1997

Agamben, Giorgio, *The Open: Man and animal*, trans. Kevin Attell, Stanford University Press, Palo Alto, CA, 2004

The Animal Studies Group, *Killing Animals*, University of Illinois Press, Urbana, IL and Chicago, 2006

Anker, S. and D. Nelkin, *The Molecular Gaze: Art in the genetic age*, Cold Spring Harbor Laboratory Press, Cold Spring Harbor, NY, 2004

Attevil, Fred, on correction to 'World's First Creationist Museum Opens in Kentucky', *Guardian*, 2 June 2007, http://www.guardian.co.uk/usa/story/0,,2090664,00.html, retrieved 8 December 2007

Bacon, Francis, quoted in David Sylvester, *The Brutality of Fact: Interviews with Francis Bacon*, Thames and Hudson, London and New York, 1987

Baker, Steve, 'Something has gone wrong again', *Antennae* 7 (Autumn 2008)

Baker, Steve, *The Postmodern Animal*, Reaktion Books, London, 2000

Baker, Steve, 'What does becoming animal look like?', Nigel Rothfels (ed.), *Representing Animals*, Indiana University Press, 2002

Baluška, F., S. Mancuso, D.S. Volkmann and W.P. Barlow, 'The "Root-brain" hypothesis of Charles and Francis Darwin, revival after more than 125 Years', *Plant Signaling & Behavior* 4/12 (December 2009)

Barber, Lynn, 'Bleeding art', *Observer*, 20 April 2003, http://www.guardian.co.uk/artanddesign/2003/apr/20/the saatchigallery.art6, retrieved 1 September 2010

Barthes, Roland, *Camera Lucida: Reflections on photography*, Hill and Wang, New York, 1982

Bataille, Georges, *Oeuvres Complètes* vol. I: *Premiers Écrits 1922–1940*, Gallimard, Paris, 1970

Bataille, Georges (1973), *Theory of Religion*, trans. Robert Hurley, Zone Books, New York, 1992

Baudrillard, Jean, *Simulations*, trans. Paul Foss, Paul Patton and Philip Beitchman, Semiotexte, New York, 1983

Baudrillard, Jean (1981), *Simulacra and Simulation*, trans. Sheila Faria Glaser, University of Michigan Press, Ann Arbor, MI, 1994

Berger, John, *Ways of Seeing*, Penguin Modern Classics, London,1972

Berger, John, 'Why look at animals?', in John Berger, *About Looking*, Pantheon Books, New York, 1980

Bernasconi, Robert and David Wood (eds), *The Provocation of Levinas: Rethinking the Other*, Routledge & Kegan Paul, London and New York, 1988

Bondeson, Jan, *The Feejee Mermaid and Other Essays in Natural and Unnatural History*, Cornell University Press, Ithaca, NY, 1999

Borges, Jorge Luis, 'The analytical language of John Wilkins', trans. Eliot Weinberger, ed. Eliot Weinberger, in *Selected Nonfictions: Jorge Luis Borges*, Penguin Books, London 1999: originally published as 'El idioma analítico de John Wilkins', *La Nación*, 8 February 1942, republished in *Otras Inquisiciones*

Broglio, Ron, *Surface Encounters: Thinking with animals and art*, University of Minnesota Press, Minneapolis, MN, 2011

Brower, Matthew, 'Take only photographs: animals photography construction of nature love', *Antennae* 7 (2008)

Brown, C. (ed.), *Fish Cognition and Behaviour*, Blackwell Publishing, Oxford, 2006

Buckland, Warren, *Directed by Steven Spielberg: Poetics of the contemporary Hollywood blockbuster*, Continuum, London and New York, 2006

Cardoso, Fernanda, 'Our lady of mimicry', interview with Sonja Britz, *Antennae* 11 (Autumn 2009)

Chalmers, Catherine, 'An interview with Catherine Chalmers', interview with Giovanni Aloi and Chris Hunter, *Antennae* 3/2 (Autumn 2007)

Chris, Cynthia, *Watching Wildlife*, University of Minnesota Press, Minneapolis, MN, 2006

Clynes, M.E. and N.S. Kline, 'Cyborgs and space', *Astronautics*, September 1960

Clottes, Jean and Jean Courtin, *The Cave Beneath the Sea: Palaeolithic images at Cosquer*, trans. Marilyn Garner, Harry N. Abrams, New York, 1996

Coates, Marcus, 'In conversation with Marcus Coates', *Antennae* 4 (Winter 2007)

Coe, Sue, 'In conversation with Sue Coe', interview with Giovanni Aloi, *Antennae* 5 (Spring 2008)

Conlan, Tara, 'I'm a Celebrity: ITV apologises for killing of rat', *Guardian*, 7 December 2009

Cooke, Lynne, 'Richard Serra: a case study', *Tate Papers* 8 (2007)

Coutts, Nicky, *Insectile*, Mantis in association with Royal College of Art, London, 2001

Crowther, Paul, *Critical Aesthetics and Postmodernism*, Oxford University Press, Oxford, 1993

Danto, Arthur, *The Abuse of Beauty: Aesthetics and the concept of art*, Open Court Publishing, Chicago, 2003

Darwin, Charles (1859), *The Origin of Species*, Oxford University Press, Oxford, 1998

Darwin, Charles (1880), *The Power of Movements in Plants*, Kessinger Publishing Co, Whitefish, MT, 2004

Dawkins, Richard, *The God Delusion*, Bantam Books, New York, 2006

de Menezes, Marta, 'The artificial natural: manipulating butterfly wing patterns for artistic purposes', *Leonardo* 36/1 (2003), MIT Press

Deleuze, Gilles and Félix Guattari (1988), *A Thousand Plateaus*, Continuum, London, 1987

Deleuze, Gilles and Félix Guattari, *Kafka: Toward a minor literature*, University of Minnesota Press, Minneapolis, MN, 1986

Derrida, Jacques, *The Animal that Therefore I Am*, ed. Marie-Louise Mallet, Fordham University Press, New York, 2008

Descartes, René (1637), *Discourse on Method and Meditations*, Bobbs-Merrill, Indianapolis, IN, 1960

Descartes, René, 'Letter to Plempius', 3 October 1637, K, p.36, AT II, p.414; cf. Replies to Objections VI, HR II

Descartes, René (1641), *Meditations and Other Metaphysical Writings*, Penguin Classics, London, 2003

Dick, Philip K. (1978), 'How to build a universe that does not fall apart in two days', in Philip K. Dick, *I Hope I Shall Arrive Soon*, Doubleday, New York, 1985

Dion, Mark, *L'Ichthyosaure, la Pie, et Autres Merveilles du Monde Naturel*, Images en Manœuvres Éditions, Marseille, 2003

Dion, Mark, 'Towards a manifesto for artists working with or about the living world', in *The Greenhouse Effect*, exhibition catalogue, Serpentine Gallery, London, 2000

Dion, Mark and Nato Thompson, 'Interview with Mark Dion', in Nato Thompson et al., *Becoming Animal: Contemporary art in the animal kingdom*, MIT Press, Cambridge, MA, 2005

Donald, Diana (1750–1850), *Picturing Animals in Britain*, Yale University Press, New Haven, CT, 2007

Donald, Diana, *Endless Form: Charles Darwin, natural science, and the visual arts*, Yale University Press, New Haven, CT, 2009

Fernandez Orgaz, Laura and Patricia Piccinini, 'The naturally artificial world', in *(Tender) Creatures*, exhibition catalogue, Artium, Spain, 2007

Findlen, Paula, *Possessing Nature: Museums, collecting and scientific culture in early modern Italy*, University of California Press, Berkeley, CA and London, 1994

Foucault, Michel, *The Order of Things*, Routledge, London and New York, 1966

Frost, Mary, 'Artist apologizes for decades-old dog-killing incident', *Brooklyn Daily Eagle*, 14 April 2008

Fudge, Erica, *Animal*, Reaktion Books, London, 2002

Fudge, Erica, *Pets*, Acumen Publishing Limited, Durham, 2008

Gedrim, Ronal. J., 'Edward Steichen's 1936 exhibition of delphinium blooms: an art of flower breeding', *History of Photography* 17/4 (Winter 1993)

Genesis, 1:28 (Original Latin Vulgate)

Gessert, George, 'An introduction to genetic art – conflicts of interest jeopardize scientific integrity and public health', *GeneWatch* 17/2 (March/April 2004)

Gessert, George, 'On exhibiting hybrids', *Art and Technology Supplement of CIRCA*, 1990

Gibbons, Fiachra, 'Tate Modern awakes to Dane's rising sun', *Guardian*, 16 October 2003

Gioni, Massimiliano, 'Where the wild things are', *Tate Etc* 11 (Autumn 2007)

Green, Kate, 'Roadkill statistic to be monitored', *Country Life* online, http://www.countrylife.co.uk/news/country/article/382380/Roadkill-statistics-to-be-monitored.html, retrieved 12 July 2010

Greenberg, Clement, *The Collected Essays and Criticism*, vol. 2, University of Chicago Press, Chicago, 1986

Griffiths, Mary Frances and Christine Lynch, *Reflections on the Cottingley Fairies*, JMJ Publications, Paraparaumu, 2009

Groskop, Viv, 'Chirps with everything', *Guardian*, 25 January 2007

Hall, Antony, 'ENKI – human to fish communication', *Antennae* 13 (Summer 2010)

Hansen, Rikke, 'An Animal Gazes', CD-ROM essay catalogue, November 2008

Haraway, Donna, *Simians, Cyborgs and Women: The reinvention of nature*, Routledge, New York, 1991

Haraway, Donna, 'Teddy bear patriarchy: taxidermy in the garden of Eden', in Amy Kaplan and Donald Pease (eds), *Cultures of United States Imperialism*, Duke University Press, Durham, NC and London, 1994

Haraway, Donna, *When Species Meet*, University of Minnesota Press, Minneapolis, MN, 2008

Harres, Martin, 'Regarding the pain of rats Kim Jones's rat piece', *Drama Review* 51/1 (Spring 2007)

Harvey, David, *The Condition of Postmodernity: An inquiry into the origins of cultural change*, Blackwell, Cambridge, 1999

Hegel, George and Friedrich Wilhelm (1835–38), *The Philosophy of Fine Art*, trans. F.P.B. Osmaston, C. Bell and Sons, London, 1920

Herndon, C., 'Meanmouth bass lives up to its name', featured in Ichthyology at the Florida Museum of natural history, http://www.flmnh.ufl.edu/fish/InNews/meanmouth2004.html, 2004, retrieved 13 June 2010

Hirst, Damien, *The Agony and the Ecstasy: Selected works from 1989 to 2004*, Electa, Naples, 2005

Hofbauer, Anna Karina, 'Marco Evaristti and the open work', 2007, http://www.evaristti.com/defaultF.html, retrieved 1 February 2008

Höller, Carsten, 'In conversation with Carsten Höller', interview with Giovanni Aloi, *Antennae* 12 (Spring 2010)

Idiots, 'Idiots: the alchemical vision', interview with Giovanni Aloi, *Antennae* 7 (Autumn 2008)

Imanishi, Kinji (1941), *A Japanese View of Nature: The world of living things*, Routledge Curzon, London and New York, 2002

Isaacs, John, 'John Isaacs: wounded animals and icon-making', interview with Giovanni Aloi, *Antennae* 5 (Spring 2008)

Johnson, Samuel (1758–60), *The Works of Samuel Johnson*, vol. 4: *The Adventurer, The Idler*, Kessinger Publishing, Whitefish, MT, 2004

Kac, Eduardo, 'GFP Bunny', *Leonardo* 36/2 (2003), MIT Press, Cambridge, MA

Kac, Eduardo, *Telepresence and Bio Art*, University of Michigan Press, Ann Arbor, MI, 2005

Kamps, Toby, *Small Worlds: Dioramas in contemporary art*, Museum of Contemporary Art, San Diego, CA, 2000

Kant, I. (1790), *The Critique of Judgement*, Cosimo, New York, 2007

Katchadourian, Nina, 'Chloe', artist's website, http://www.ninakatchadourian.com/confusinganimals/chloe.php, retrieved 12 October 2009

Kerényi, Karl, 'The trickster in relation to Greek mythology', in Paul Radin (ed.), *The Trickster: A study in American Indian mythology*, Bell Publishing, New York 1956

Krauss, Rosalind E., 'Richard Serra/Sculpture', Museum of Modern Art, New York, 1986

Kristeva, Julia, *Power of Horror: An essay on abjection*, Columbia University Press, New York, 1982

Kulik, Oleg, 'Oleg Kulik: artificial paradise', *Antennae* 8/2 (Winter 2008)

La Frenais, Rob, 'An artist between species: the work of Nicholas Primat', *Nicholas Primat: Demo Bonobo*, Les Abattoirs, Château de Taurines, 2007

Levinas, Emmanuel, *Otherwise Than Being and Beyond Essence*, trans. A. Lingis, Nijoff, The Hague and Boston, 1981

Levinas, Emmanuel, *Totality and Infinity: An essay on exteriority*, trans. Alphonso Lingis, Duquesne University Press, Pittsburgh, PA, 1969

Lippit, A.M., 'The death of an animal', *Film Quarterly* 56/1 (Autumn 2002)

Lyotard, Jean-François, *The Postmodern Condition*, Manchester University Press, Manchester, 1984

Marvin, Garry, 'Perpetuating polar bears: the cultural life of dead animals', in B. Snæbjörnsdóttir and M. Wilson, *Nanoq: Flat Out and Bluesome: A cultural life of polar bears*, Black Dog Publishing, London, 2006

Morris, Pat, *A History of Taxidermy: Art, science and bad taste*, MPM Publishing, Ascot, 2010

Moura, Leonel, *Robotarium X*, Creative Commons, Mountain View, CA, 2007

Nagel, Thomas, 'What is it like to be a bat?', *Philosophical Review* 83/4 (October 1974)

O'Reilly, Kira, 'Falling asleep with a pig', interview with B. Snæbjörnsdóttir and M. Wilson, *Antennae* 13 (Summer 2010)

Paley, William (1802), *Natural Theology*, Oxford University Press, Oxford, 2006

Pellegrini, Luca, 'Avatar, il nuovo film di James Cameron: effetti speciali e innocuo panteismo', oecumene.radiovaticana.org, 9 January 2010, retrieved 11 June 2010

Pepperell, Robert, *The Posthuman Condition: Consciousness beyond the brain,* Intellect, Bristol, 2003

Quinn, Mark, *Incarnate*, Booth-Clibborn Editions, London, 1998

Quinn, Stephen, *Windows on Nature: The great habitat dioramas of the American Museum of Natural History*, in association with the American Museum of Natural History, Abrams, New York, 2006

Reynolds, Joshua (1790), *Discourses on Art*, Paul Mellon Centre for Studies in British Art, London and Yale University Press, New Haven, CT, 1975

Rinaldo, Ken, 'Augmented fish reality', online text, http://accad.osu.edu/~rinaldo/works/augmented/augmented.html, retrieved 10 April 2010

Rivo, Harriet, *The Animal Estate: The English and other creatures in the Victorian age*, Harvard University Press, Cambridge, MA, 2002

Roche, H.P., Beatrice Wood and Marcel Duchamp (eds), 'The Richard Mutt case', in *The Blind Man*, New York, 1917, N, 2

Roots, Harris, 'Cell fusion' *BioEssays* 2/4, Wiley Periodicals, 1985

Rousseau, Jean-Jacques (1754), *Discourse on Inequality*, Kessinger Publishing, Whitefish, MT, 2004

Rowland, Peter, *Bowerbirds*, Australian Natural History Series, CSIRO Publishing, Collingwood, Australia, 2008

Rugoff, Ralph, 'Signs and wonders', in *The Greenhouse Effect*, exhibition catalogue, Serpentine Gallery, London, 2000

Russell, Bertrand (1913), *Theory of Knowledge*, Routledge, London, 1992

Ryder, Richard, *Animal Revolution: Changing attitudes towards speciesism*, Berg Publishers, London, 2000

Saltz, Jerry, 'More life: the work of Damien Hirst', *Art in America* 83/6 (1995)

Schermi, Loris, 'La Salita, storia di una galleria', Merzbau, http://www.merzbau.it/appunti.php?mrcnsn=0000000013, retrieved 12 March 2010

Schneede, Uwe M., 'Joseph Beuys die aktionen', *Kommentiertes Verzeichnis mit fotografischen Dokumentationen*, Gerd Hatje Verlag, Ostfildern-Ruit bei Stuttgart, 1998

Schneider Adams, Laurie, *The Methodologies of Art: An introduction*, Westview Press, Boulder, CO, 1996

Scruton, Roger, 'Animal rights', *City Journal*, Manhattan Institute, Summer 2000, http://www.city-journal.org/html/10_3_urbanities-animal.html, retrieved 10 June 2010

Seidner, David, 'Richard Serra', interview, *Bomb Magazine* 42 (Winter 1993), New Art Publications

Serpell, James, 'From paragon to pariah: some reflections on human attitudes to dogs', in J. Serpell (ed.), *The Domestic Dog*, Cambridge University Press, Cambridge, 1995

Shelley, Mary (1818) *Frankenstein*, Penguin Classics, London, 2003

Shukin, Nicole, *Animal Capital: Rendering life in biopolitical times*, University of Minnesota Press, Minneapolis, MN, 2009

Singer, Angela, 'Animal rights and wrongs', interview with Giovanni Aloi, *Antennae* 7 (Autumn 2008)

Singer, Peter (1975) *Animal Liberation*, Pimlico, London, 1995

Slifkin, N., *Mysterious Creatures*, Targum/Feldheim, Southfield, MI, 2003

Smith, Roberta, 'Becoming a dog by acting like one', *New York Times*, 18 April 1997, http://www.nytimes.com/1997/04/18/arts/on-becoming-a-dog-by-acting-like-one.html, retrieved 12 March 2010

Snæbjörnsdóttir, Bryndis, *Spaces of Encounter: Art and revision in human–animal relations*, University of Gothenburg, Gothenburg, 2009

Snæbjörnsdóttir, Bryndis and Mark Wilson, *Nanoq: Flat Out and Bluesome: A cultural life of polar bears*, Black Dog Publishing, London, 2006

Stenhouse, David, *The Evolution of Intelligence: A general theory and some of its implications*, George Allen and Unwin, London, 1974

Sugimoto, Hiroshi, 'Dioramas', www.sugimotohiroshi.com, retrieved 2 February 2010

Swenson, Susan, 'Conversation with Kim Jones: April 25, 2005', *War Paint*, exhibition catalogue, Pierogi Gallery, New York, pp.4–18

TC&A, 'Victimless leather – a prototype of stitch-less jacket grown in a technoscientific "body"', artists' website, http://www.tca.uwa.edu.au/vl/vl.html, retrieved 12 April 2010

TC&A, 'Semi-living food: disembodied cuisine', artists' website, http://www.tca.uwa.edu.au/disembodied/dis.html, retrieved 12 April 2010

TINKEBELL, 'Popple', artist's website, http://looovetinkebell.com/pages/popple, retrieved 20 February 2010

TINKEBELL, 'My dearest cat Pinkeltje', artist's website, http://looovetinkebell.com/pages/my-dearest-cat-pinkeltje, retrieved 20 February 2010

Tisdall, Caroline, *Joseph Beuys: Coyote*, Schirmer-Mosel, Munich, 1980

Trewavas, Andreas, 'Aspects of plant intelligence', *Annals of Botany* 92 (2003)

Vallini, Gaetano, 'Avatar, James Cameron's new film: special effects wrapped around emptiness, scares and harmless pantheism', *L'Osservatore Romano*, Vatican City, 10 January 2010

Vergine, Lea and Giorgio Verzotti, *Il Bello e le Bestie*, Skira, Milan, 2004

Vogel, Carol, 'Swimming with famous dead sharks', *New York Times*, 1 October 2006, http://www.nytimes.com/2006/10/01/arts/design/01voge.html, retrieved 23 February 2010

Warner, Malcolm and Robin Blake, *Stubbs and the Horse*, Kimbell Art Museum, Fort Worth, TX, 2004

Watson, Sarah, Deitch Project press release, 1997, http://www.deitch.com/projects/sub.php?projId=79, retrieved 23 March 2009

Watts, Steven, *The Magic Kingdom: Walt Disney and the American way of life*, University of Missouri Press, Columbia, MO, 2001

Wells, Herbert George (1897), *The Island of Dr Moreau*, Penguin Classics, London, 2005

Williams, David, 'Inappropriate/d others, or the difficulties of being a dog', *Drama Review* 51/1 (Spring 2007), New York University and Massachusetts Institute of Technology

Wiseman, Eva, 'Who is cool now', *Observer*, 6 July 2008

Wolfe, Cary, *Animal Rites: American culture, the discourse of the species, and posthumanist theory*, University of Chicago Press, Chicago, 2003

Yanni, Carla, *Nature's Museum: Victorian science and the architecture of display*, Princeton Architectural Press, New York, 2005

Zmijewski, Artur, 'Carrying buckets, trotting like pigs', interview with Katarzyna Kozyra and Gzegorz Kowalski, *Czereja* 4 (1993), pp.27–28, http://www.katarzynakozyra.com.pl/pyramid_txt.html, retrieved 21 January 2008

Filmography

Avatar, dir. James Cameron, Twentieth Century Fox, 2009

Battleship Potemkin, dir. Sergei M. Eisenstein, Goskino, 1925

Blade Runner, dir. Ridley Scott, Warner Bros, 1982

City of Lost Children, dir. Marc Caro, Jean-Pierre Jeunet, Club d'Investissement Média, 1995

The Fly, dir. Kurt Neumann, Twentieth Century Fox, 1958

The Fly, dir. David Cronenberg, Twentieth Century Fox, 1986

Gattaca, dir. Andrew Niccol, Columbia Pictures Corporation, 1997

Gojira (*Godzilla*), Ishirô Honda, Toho Film (Eiga) Co. Ltd, 1954

The Island of Lost Souls, dir. Erle C. Kenton, Paramount Pictures, 1932

Jaws, dir. Steven Spielberg, Universal Pictures, 1975

Jurassic Park, dir. Steven Spielberg, Universal Pictures, 1993

Metropolis, dir. Fritz Lang, Universum Film, 1927

One Hundred and One Dalmatians, dir. Clyde Geronimi and Hamilton Luske, Walt Disney, 1961

Psycho, dir. Alfred Hitchcock, Shamely Productions, 1960

Twelve Monkeys, dir. Terry Gilliam, Universal Pictures, 1995

White Wilderness, dir. James Algar, Walt Disney Productions, 1958

Index